IMAGES
of America

ELIZABETHTOWN

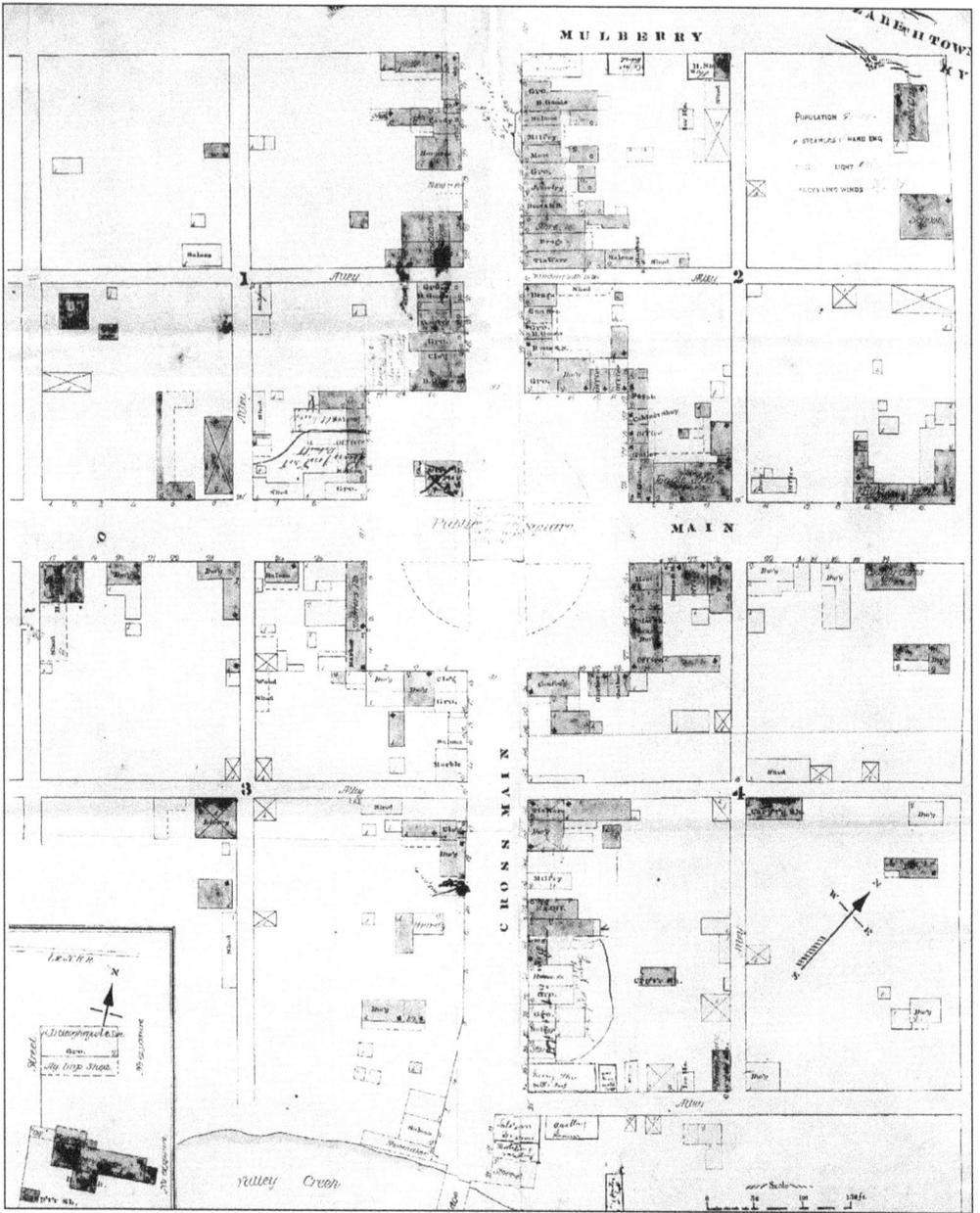

Pictured is an Elizabethtown map dated about 1871, before the arrival of Gen. George Custer. General Custer resided at the Hills Hotel on the corner of North Main and Poplar Street. The Hills Hotel (today the Brown-Pusey House) and the school building on Poplar Street are the only surviving buildings from this map. Notice that the courthouse was moved to the center of the map. Cross Street was the main thoroughfare. Today Cross Street is 31 West, or Dixie Highway, also called the Louisville and Nashville Turnpike. The Louisville and Nashville Railroad is located on the other side of the bridge and Valley Creek. In 1869, the 1870s, and the 1880s, devastating fires destroyed most of the buildings on the Public Square and some of the surrounding area. (Courtesy of Brown-Pusey House.)

IMAGES
of America

ELIZABETHTOWN

Meranda L. Caswell

ARCADIA
PUBLISHING

Published by Arcadia Publishing
Charleston, South Carolina

Library of Congress Catalog Card Number: 2004117865

For all general information contact Arcadia Publishing at:
Telephone 843-853-2070
Fax 843-853-0044
E-mail sales@arcadiapublishing.com
For customer service and orders:
Toll-Free 1-888-313-2665

Visit us on the Internet at www.arcadiapublishing.com

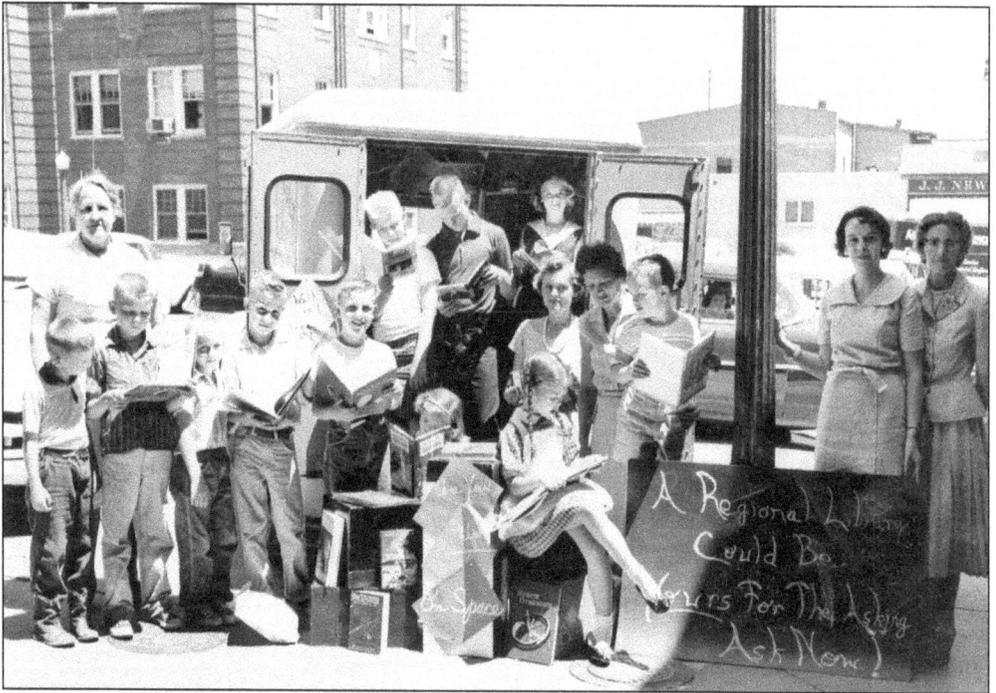

The first free public library in Elizabethtown and Hardin County was located in the Brown-Pusey House from 1923 to 1959. The library was funded by the Puseys and the community. When Lena Johnson, the librarian, retired in 1959, the public library was moved to the building adjacent to the Brown-Pusey House until 1967. Children and volunteers tried to find a home for the public library as well as funding from 1959 to 1967. Hardin County finally found a home for the public library—the old post office on West Dixie Avenue—in 1967 and funded the library. Today the Hardin County Public Library is located in a new building on Jim Owen Drive off St. John Road in Elizabethtown. (Courtesy of Brown-Pusey House.)

CONTENTS

ACKNOWLEDGMENTS

The community support of this project by the following individuals and organizations is greatly appreciated: Helen Glasgow, Mary Jo Jones, Mike Sisk, Edith Dupin, Kenny Tabb, the Brown-Pusey House, Hardin County Historical Society, and the Elizabethtown Woman's Club. The Brown-Pusey House, organized in 1923, continues as a 501(C)3 non-profit private foundation. This charitable organization is an archival center and genealogy library as well as a community house. The historic house museum and formal garden are utilized by the public for weddings, receptions, parties, meetings, and community events. Enjoy a tour, at no charge, of the Pusey Room Museum and the Historic House Museum. Organized in the 1930s, the Hardin County Historical Society continues as a 501(C)3 non-profit organization and sells over 30 Hardin County publications. This society assisted the Brown-Pusey House with the creation of the genealogy library in the 1960s.

This book is dedicated to the memory of Alice Miller, my maternal great-grandmother, who kept a written family record; to my mother, a storyteller of the family; and to my daughter.

Newborn

Today, I'll flower a newborn into my life.
A baby is a ceaseless light; brightening.
My child laughs—and talks, beginning to walk.
The little one grows with a fiery spirit;
Learning of this world and others.
"Let's go, car; the child awaits you to carry my littler one."
I abide the news of my arrival . . . a child one day.

—Meranda Caswell

INTRODUCTION

In 1996, downtown Elizabethtown was registered as a historic district. The Public Square, the city cemetery, and many buildings on East and West Dixie Avenue as well as North Main Street are included in the historic district.

The Elizabethtown area was first known to white settlers in the late 1700s as Severns Valley Station. Elizabethtown was organized in 1797 and became the county seat of Hardin County, Kentucky. Probably about 20 pioneers and their families settled in Severns Valley Station prior to 1800. Three of the earliest pioneers, Capt. Thomas Helm, Samuel Haycraft, and Col. Andrew Hynes, built the first forts in Elizabethtown. These forts formed a triangle, being spaced equidistant a mile apart in order to resist Native American attacks, wildlife, and harsh weather, as well as to become a permanent community. Col. Andrew Hynes, a settler of this area, donated 30 acres of land to be designated as a town in the center of Severns Valley in 1797. The townspeople called the town "Elizabeth-Town" in honor of the wife of Andrew Hynes. Andrew Hynes left Elizabethtown and became the sheriff of Nelson County, Kentucky. In 1800, Andrew Hynes died and was buried in Nelson County. Questions asked immediately by many visitors are, "Why was the town called Elizabethtown? Was Mrs. Elizabeth Hynes a famous woman? Did she do something heroic or worthy of attention?" This unanswered question continues to baffle visitors.

President Abraham Lincoln's parents, Thomas Lincoln and Nancy Hanks, had their first child, Sarah, in Elizabethtown on February 10, 1807. Abraham Lincoln, the 16th President, was born in Hardin County on February 12, 1809. Today, the area where Abraham Lincoln was born is located near Hodgenville in Larue County, Kentucky. Larue County split off from Hardin County in 1843. Thomas Lincoln was a carpenter and built Haycraft's Mill about 1800. Historic records of the Lincoln family can be found at the Brown-Pusey House and the Hardin County Clerk's Office.

Jenny Lind, known as the "Swedish nightingale," stayed a night in Elizabethtown at the Eagle Hotel. On April 5, 1851, she sang from the steps of the Hill House (now the Brown-Pusey House). The Brown-Pusey House and the Public Square are still used as community areas for festivals and other exciting community events.

The building of the Louisville and Nashville (L&N) Railroad in 1852 increased business activity for Elizabethtown. The Louisville and Nashville Turnpike, today commonly known as 31 West, was the major thoroughfare in the 1800s.

During the Civil War, Elizabethtown was raided and attacked by Confederate general John Hunt Morgan, who stationed himself in the present-day Elizabethtown City Cemetery.

General Morgan captured a regiment of Illinois troops in December 1862. Gen. H.B. Lyons's Confederate force attacked Union forces in Elizabethtown in December 1864. One "famous" Civil War cannonball can still be seen today in the wall of a building in the Public Square. Gen. Ben Hardin Helm, a native of Elizabethtown, was killed at Chickamauga in 1863. Nineteen years after his death, his family re-interred him in the Helm Cemetery. The grave marker is housed at the Brown-Pusey House, along with other local Civil War items.

On August 7, 1869, a disastrous fire broke out and ruined most of Elizabethtown's business section. The fire coincided with the occurrence of a total solar eclipse.

From 1871 to 1873, Gen. George Armstrong Custer was stationed in Elizabethtown to disband the Ku Klux Klan, moonshiners, and carpetbaggers. Grand Duke Alexis of Russia visited Elizabethtown and traveled and hunted with General Custer in 1872. General Custer and Elizabeth, his wife, boarded at the Hill House. General Custer was killed in the Dakota Territory in 1876.

In the 1870s, Philip Arnold returned to Elizabethtown and built the Gilded Age Building, located on the Public Square. Philip Arnold and John Slack had salted mines with diamonds and other precious gems in the West and then sold these claims to interested investors and buyers.

Nineteen-twenty-two was a booming year for Elizabethtown. The Puseys restored the Hill House as a community center. Several new residences and buildings, Hotel Joplin, First Hardin National Bank, Woodard and Brown Garage, and S. Goldnamer and Son were built and opened for business in 1922. Other businesses as well as residences were remodeled in the same year. In 1932, there were 2,565 whites listed in the city limits and 454 African Americans. An additional 327 people of both races lived outside the city limits. There are 3,346 names in the 1932–1933 city directory. Ben (a laborer), Ree, Ethel, and Aline Miller were living on Glendale Hill, which was considered outside city limits, in 1932. Today the population of Elizabethtown is about 30,000.

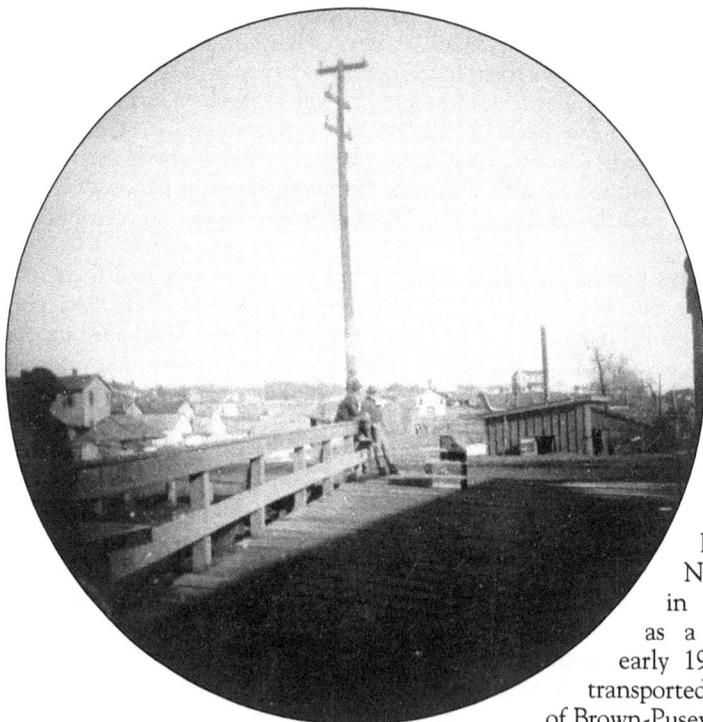

Sometime between 1888 and 1889, Dr. Robert Burns Pusey and William Allen Pusey wait at the Elizabethtown Railroad Station. William Allen Pusey was attending college and traveling to Europe. The Louisville and Nashville Railroad began in the 1850s and continued as a passenger line until the early 1960s. Today, only cargo is transported on this railroad. (Courtesy of Brown-Pusey House.)

One

Public Square

This rare postcard of the courthouse in the center of the Public Square is postmarked 1907. This courthouse burnt in 1932. No Hardin County records were burnt. The first courthouse was made of log and was not in the center of the Public Square. (Courtesy of Meranda Caswell.)

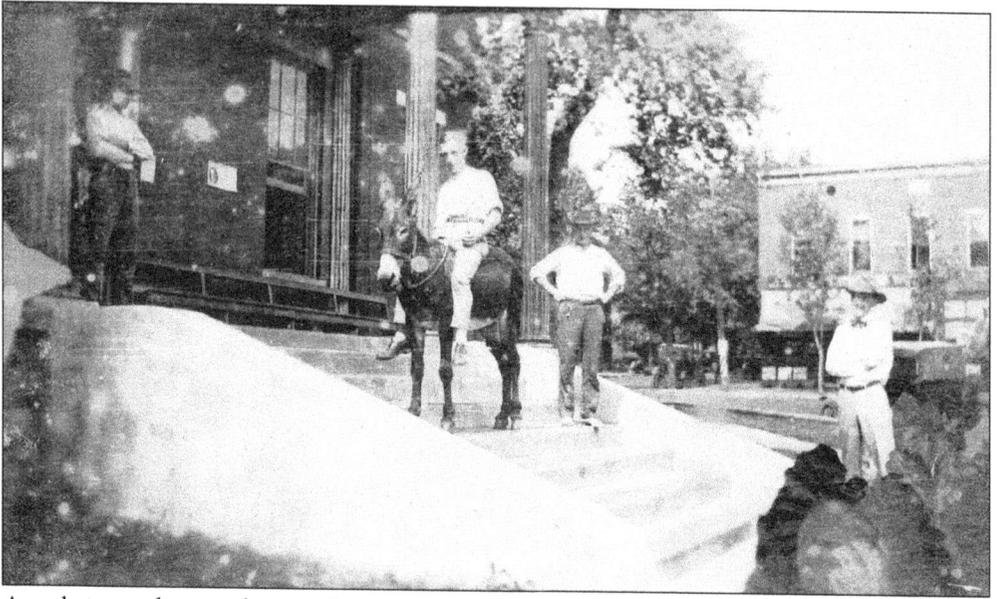

A mule is standing on the courthouse steps in the early 1900s, ridden by Weed Chelf. From the late 1800s to the mid-1900s, the mule industry was a profitable business. Some of the residents of Elizabethtown used to ride their mules through the courthouse, not without penalty. (Courtesy of Mike Sisk.)

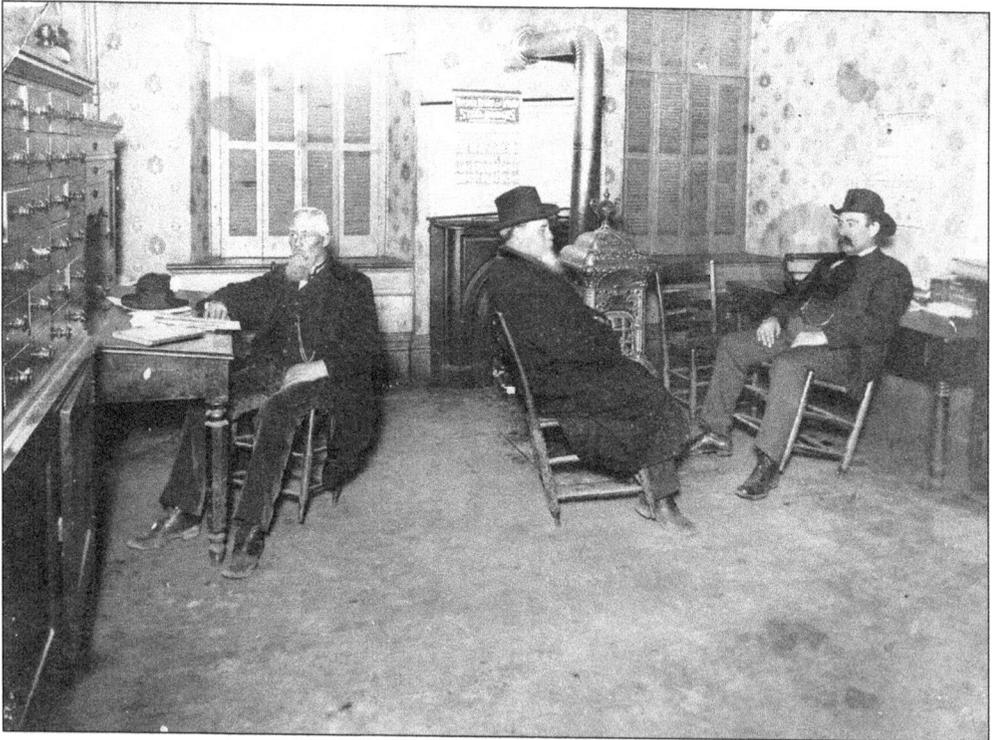

Some Hardin County officials are sitting in a room in the courthouse in January 1904. Pictured from left to right are Marcus Berry, deputy sheriff in 1886; Judge English ?, county judge from 1889 to 1901; and Dave Rider, county judge in 1901. (Courtesy of Mary Jo Jones.)

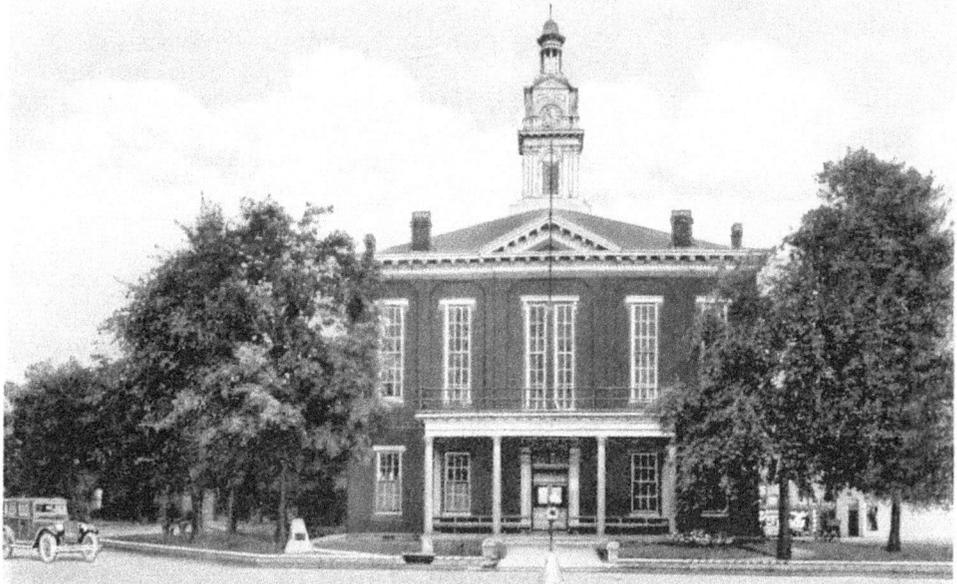

COURT HOUSE, ELIZABETHTOWN HARDIN COUNTY, KY.

The courthouse is pictured between 1922 and 1932. Notice the obelisk in the courthouse yard. The large limestone marker, with a bronze tablet, was donated by Dr. William Allen Pusey and the Woman's Club to Elizabethtown in 1922 to commemorate Thomas Lincoln, the father of President Abraham Lincoln, who lived in Elizabethtown from 1806 to 1808. The whereabouts of this monument now are unknown. (Courtesy of Meranda Caswell.)

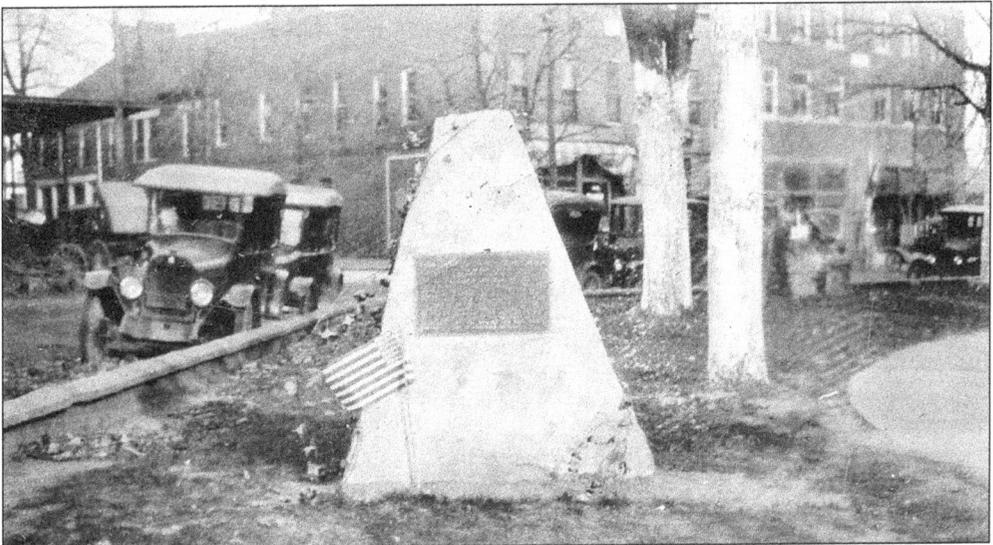

Dr. William Allen Pusey and the Woman's Club of Elizabethtown donated a monument in 1922 to stand in the courtyard of the Hardin County Courthouse. The memorial honored the parents of Abraham Lincoln. In June, a tablet was presented to honor Thomas Lincoln and Nancy Hanks, who resided in Elizabethtown. In October, another tablet was presented to honor the Elizabethtown marriage of Thomas Lincoln and Sarah Bush Johnston. (Courtesy of the Brown-Pusey House.)

11

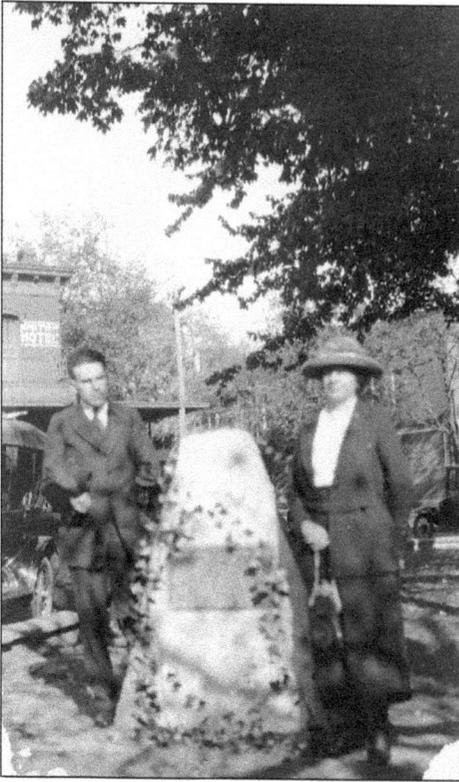

Dr. Louis A. Warren (at left), once pastor of the Christian Church, and Mrs. J. F. Albert (at right), president of the Woman's Club, presented a memorial to honor President Abraham Lincoln's parents. The tablet was fixed to a limestone base from the Mill Creek farm, the first home of Thomas Lincoln. The whereabouts of this memorial are unknown. (Courtesy of the Brown-Pusey House.)

Circus Day was a big event in the late 1800s and early 1900s. A parade of oxen is pictured walking around the courthouse. Barnum and Bailey's Circus, Hagenback and Wallace Circus, Cole Brothers Circus, and the Walter L. Main Circus were huge shows. Notice the sundries store, Showers and Hays, and a laundry cleaner. (Courtesy of Mary Jo Jones.)

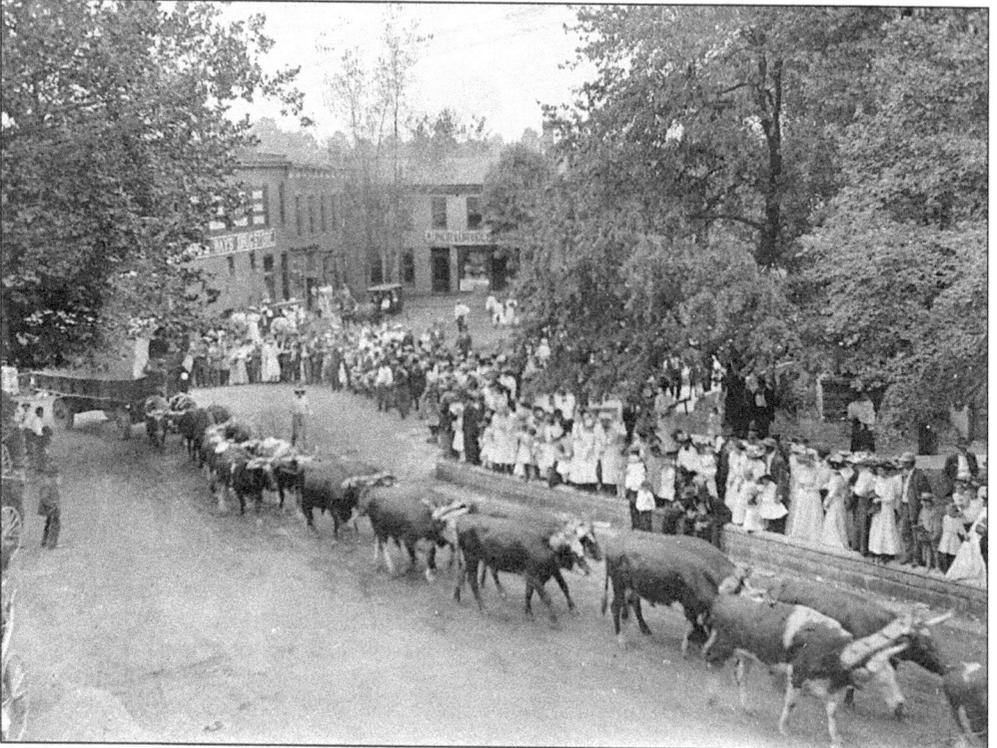

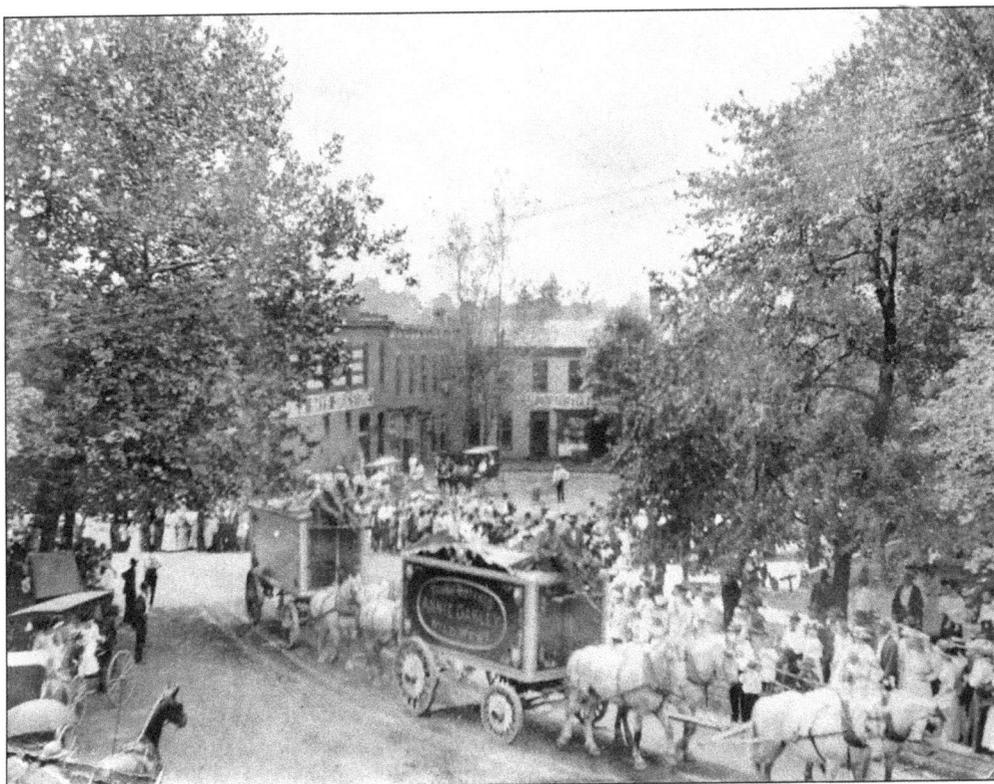

Circus Days in Elizabethtown were full of parades on the way to the fair grounds. The horses and ponies are pulling a cart labeled Annie Oakley. (Courtesy of Mary Jo Jones.)

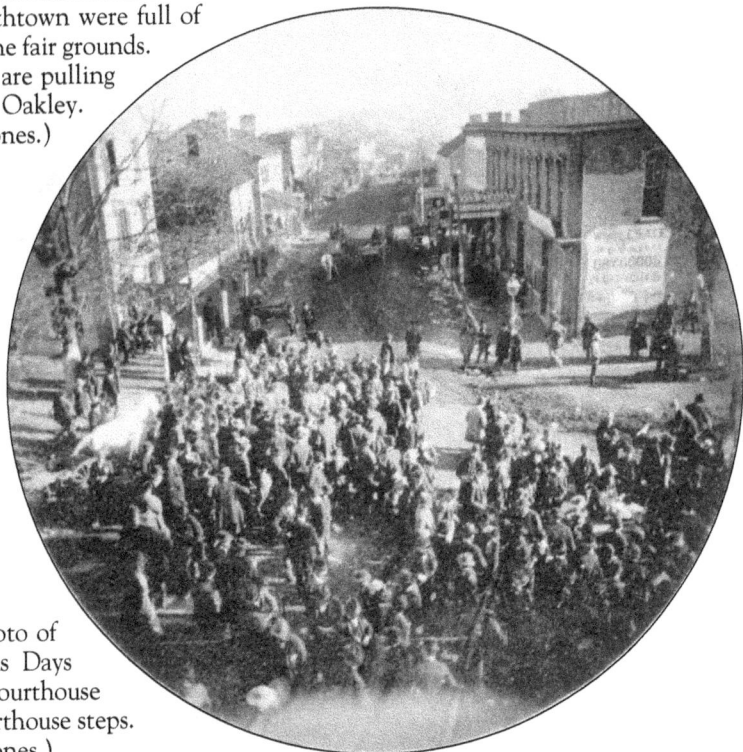

Pictured is another photo of a parade during Circus Days around the third courthouse taken from the the courthouse steps. (Courtesy of Mary Jo Jones.)

13

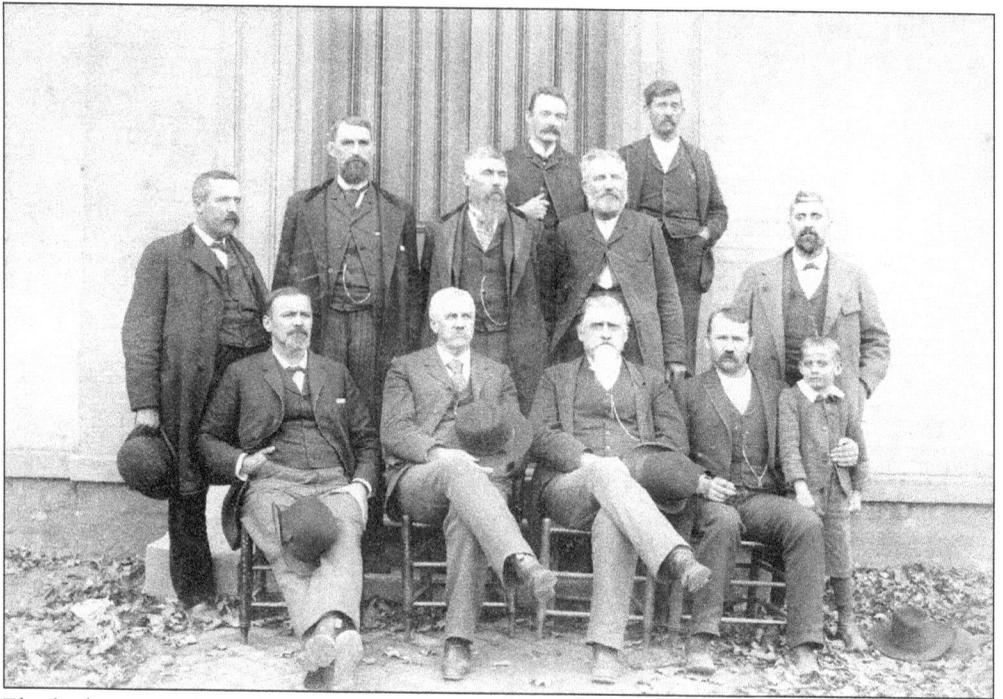

Elizabethtown and Hardin County officials, c. 1904, are, from left to right, (front row) Bill Gardiner, Judge McBeath, Judge English, J.D. Irwin, and an unidentified boy; (middle row) unidentified, Scott Branch, Marcus Berry, Chris Fraize, and John Wells; (back row) unidentified and John Sprigg. (Courtesy of Mary Jo Jones.)

A bond rally for World War I took place at the third courthouse in 1917. Residents of Elizabethtown and Hardin County served—and some died—in World War I. (Courtesy of Mary Jo Jones.)

14

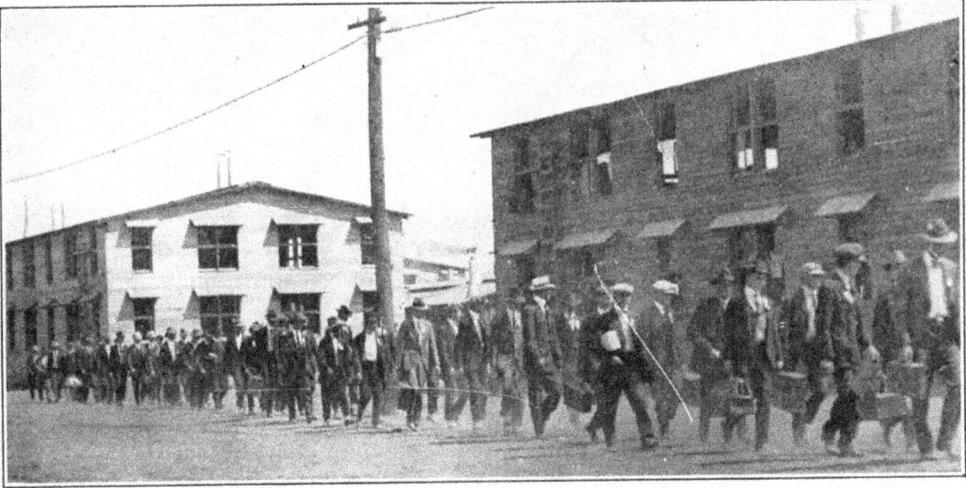

Arrival of Selectmen, Camp Zachary Taylor, Louisville, Ky.

The United States drafted soldiers into World War I in 1917. Individuals drafted into the military from Elizabethtown were registered in Camp Zachary Taylor in Louisville, Kentucky, and Fort Benjamin Harrison in Indianapolis, Indiana. Elizabethtown and Hardin County did not have a registration station. Perhaps one of the selectmen shown in this postcard is from Elizabethtown. (Courtesy of Meranda Caswell.)

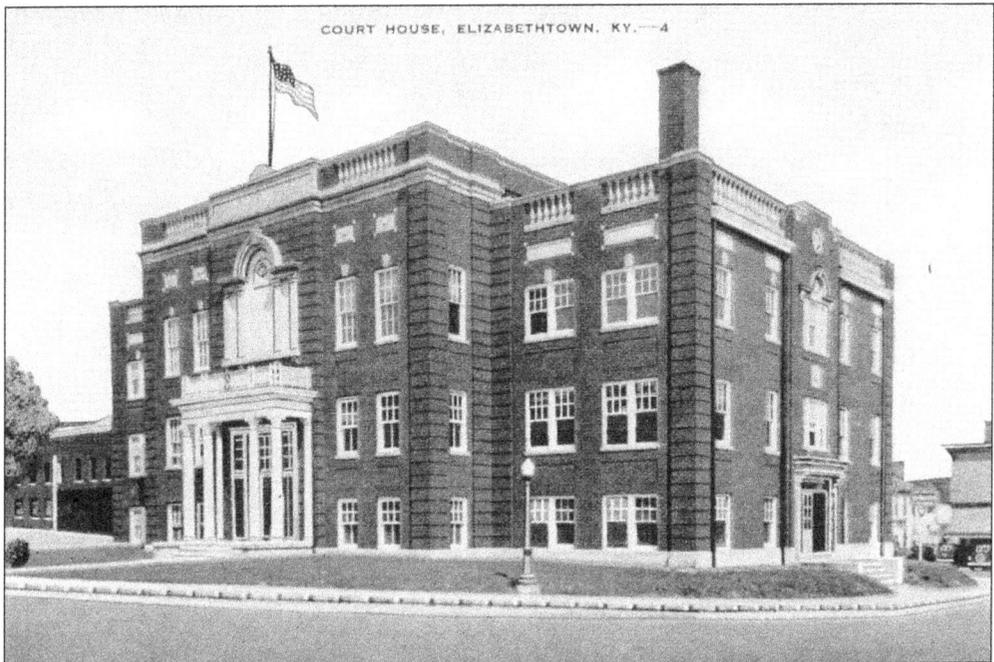

COURT HOUSE, ELIZABETHTOWN, KY.—4

This courthouse was built after 1932. It is now known as the H. Bernie Fife building, after a judge and deputy sheriff. It is not used as a courthouse today. A new, modern courthouse was built on East Dixie Avenue in 1997, where Jenkins and Essex used to be. (Courtesy of Meranda Caswell.)

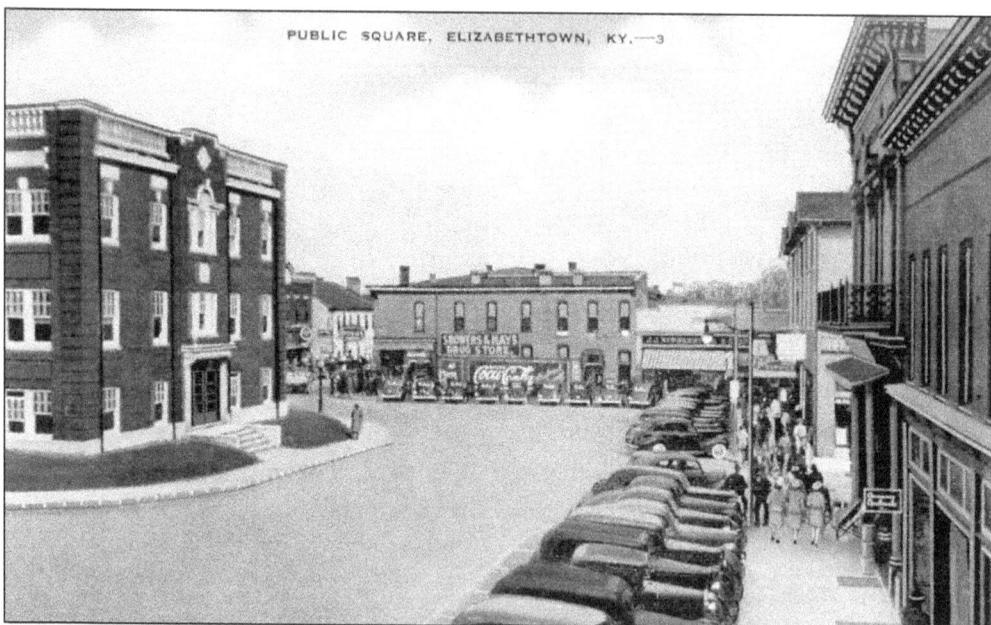

The Showers and Hays Drugstore and J.J. Newberry's were on the Public Square. The street to the side of Showers and Hays is East Dixie Avenue. The street between the two buildings on the right is South Main Street. The building closest to J.J. Newberry's is the Hotel Joplin. The building with the upper-level iron porch, called the Gilded Age Building, was built by Philip Arnold in 1872. (Courtesy of Meranda Caswell.)

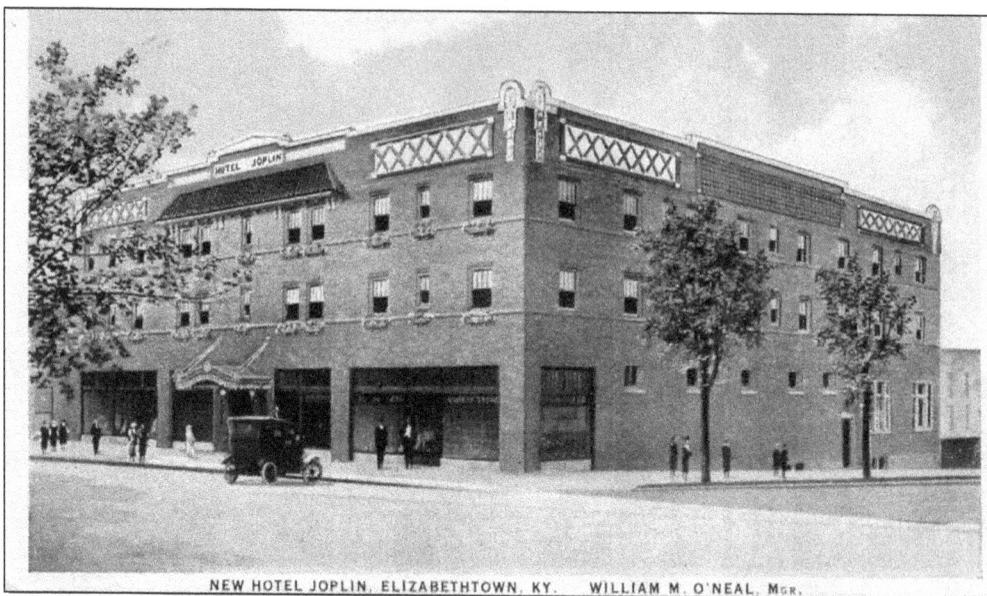

NEW HOTEL JOPLIN, ELIZABETHTOWN, KY. WILLIAM M. O'NEAL, MGR.

The Hotel Joplin, located at 65 Public Square, was built in 1922 and operated by William M. O'Neal. He also owned the New Dixie Hotel in Cave City, Kentucky. The three-story brick structure had 42 rooms and 18 baths. The Hotel Joplin housed the Progressive Barbershop and the Enterprise Printery. In 1932, the hotel, managed by W.T. Booker, was the largest in Elizabethtown, with 50 rooms and 40 baths, a coffee shop, a barbershop, and a printer. (Courtesy of Meranda Caswell.)

16

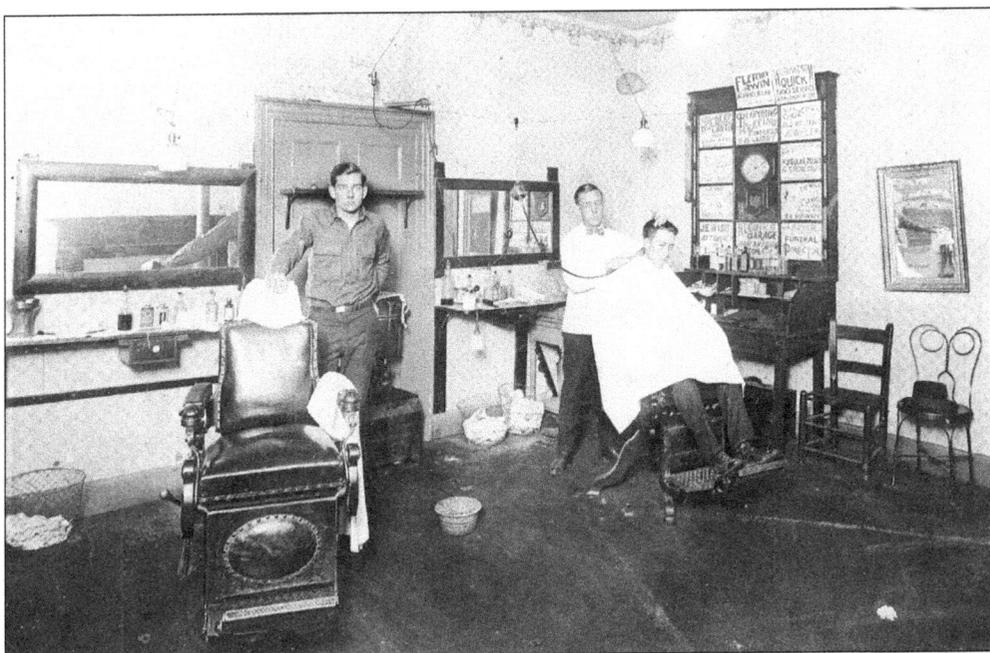

The Progressive Barbershop was located in the Hotel Joplin. Weed Chelf Jr., the barber on the right, was later a constable. In 1922, J.W. Vardeman was the proprietor of the barbershop. In a 1922 advertisement, the barbershop boasted three chairs and first-class workmen. (Courtesy of Mike Sisk.)

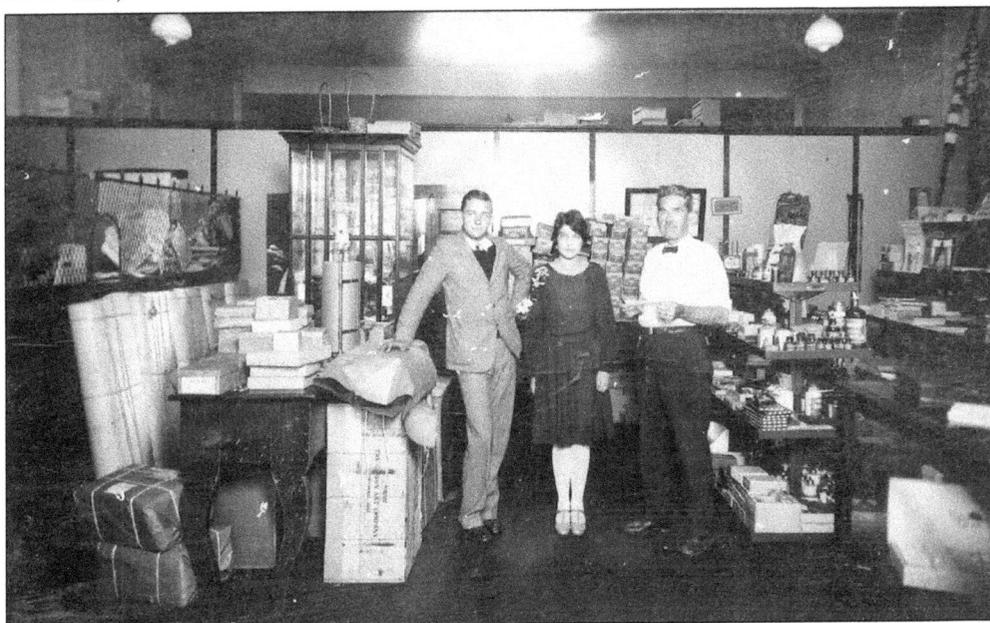

The Enterprise Printery was formed in February 1921 by C.M. Yates. In September 1922, C.J. Richerson purchased half interest. The office of the Enterprise Printery was located in the Hotel Joplin building. Pictured from left to right are Leonard Bean, Ruth Bale, and C.J. Richerson. The first known city directory was published and printed by the Enterprise Printery in 1922. By 1932, the business had become the Hardin County Enterprise. (Courtesy of Mary Jo Jones.)

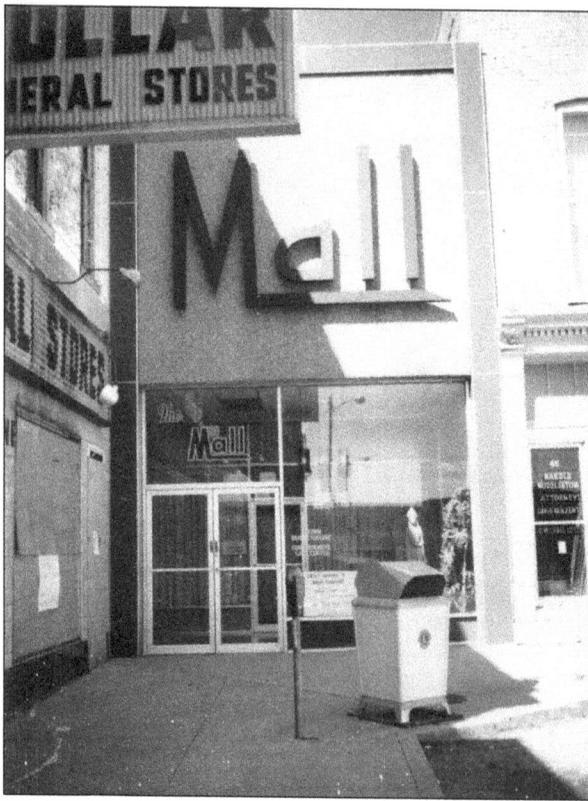

The mall burnt after 1976 and was not rebuilt. On the left, a Dollar General also burnt about 1976. On the right is the Old Vault Deli. The original vault from the private Thomas, Polk, and Company bank is still located inside the deli. During the 1873 depression, Philip Arnold furnished money to the suffering bank and became a partner. The bank became Arnold and Polk Bankers and later J.M. Polk and Company. (Courtesy of Edith Dupin.)

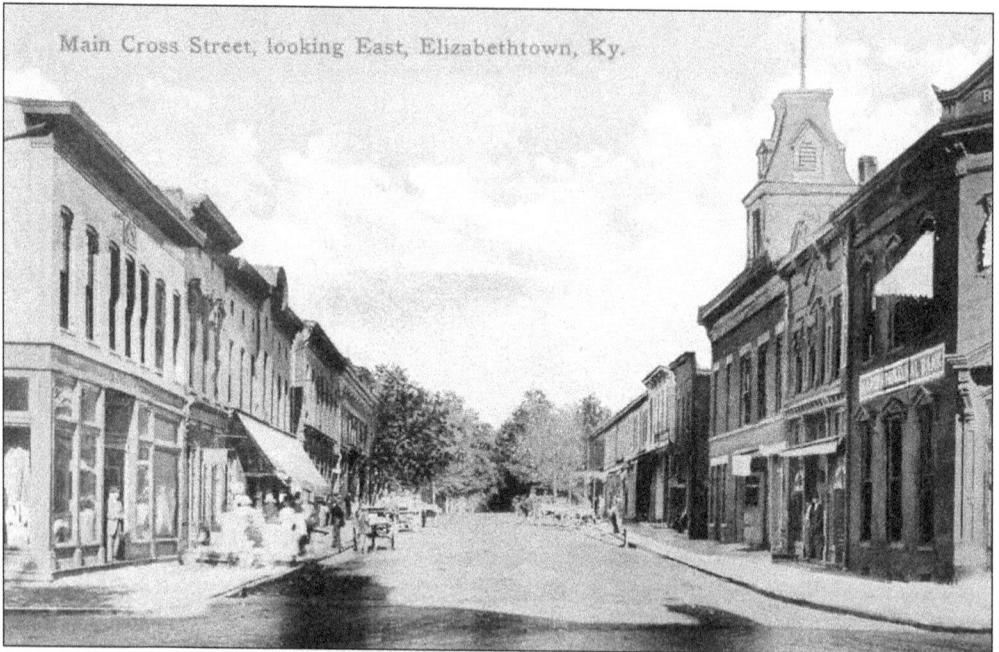

Main Cross Street, looking east, is known today as West Dixie. On the right was the Hardin National Bank, a corner building of the Public Square. (Courtesy of Meranda Caswell.)

Pictured is the residence of respected merchant A. Depp, which burnt on June 30, 1887. Several fires after 1869 devastated many businesses on the Public Square. Practically the entire Public Square is newer than 1869. A cannonball is embedded in the side of the present building in this location. (Courtesy of Mary Jo Jones.)

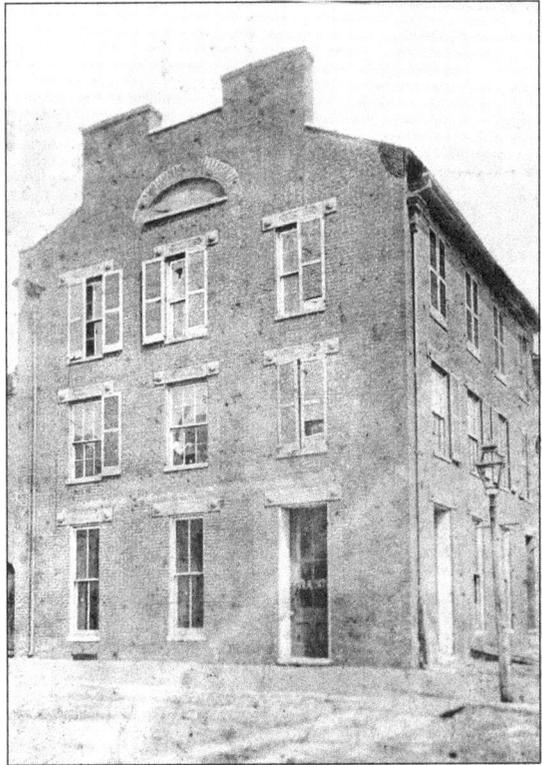

The Civil War cannonball in the wall of this corner building at 39 Public Square is a sight to see. Confederate Gen. John Hunt Morgan fired on the city in 1862. One cannonball was embedded in the wall of this building. After the fire of 1887, the cannonball was retrieved and reimbedded in the current building. (Courtesy of Mary Jo Jones.)

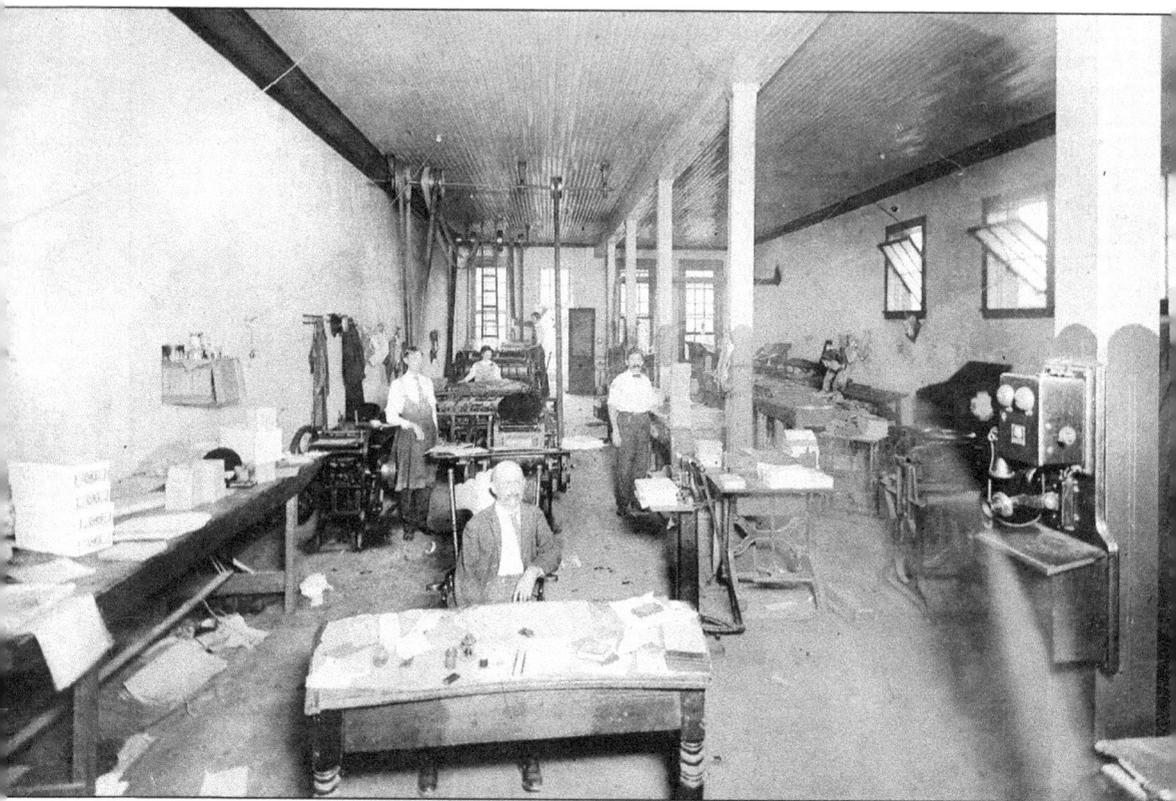

The office of the *Mirror*, a local newspaper, was in the right-hand downstairs room of the Stewart Opera House Building. Standing are C. Milt Yates (at left) and C.J. Richerson (at right), the man sitting in the front seat is Eli Dorsey, and the person in back is unidentified. Today, this is called the R.R. Thomas Building and houses license plate registration and the Hardin County original records. (Courtesy of Mary Jo Jones.)

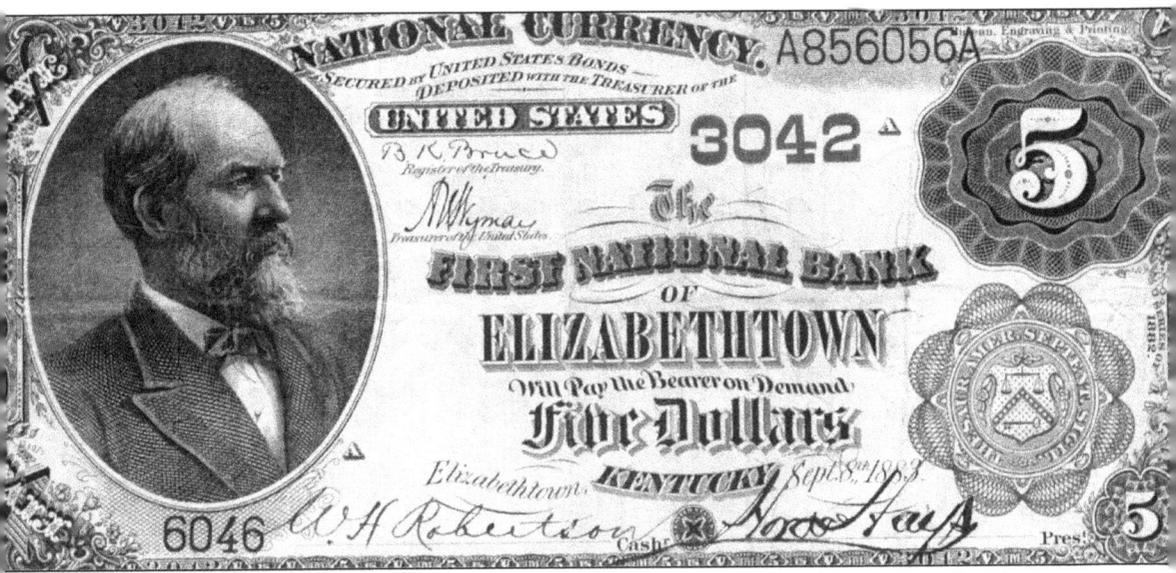

This $5 bill was issued from the First National Bank of Elizabethtown in 1883. The photo of President Garfield is unique because he was assassinated in 1881. The first bank to open was the Bank of Elizabethtown on April 19, 1883. A.B. Montgomery was the first president of the bank, located at 123 West Dixie Avenue until it moved to larger quarters on the corner where West Dixie enters the Public Square. On October 1, 1883, the First National Bank was organized. It was the first national bank in all of Kentucky south of Louisville. Hardin National Bank of Elizabethtown was the reorganization of Bank of Elizabethtown that was established on November 25, 1901. On July 1, 1911, Hardin National Bank and First National Bank consolidated to become First Hardin National Bank. This bank erected a building on the south side of Dixie Highway, west of the Public Square, in 1922. It has been called PNC Bank since 1994–1995. (Courtesy of the Brown-Pusey House.)

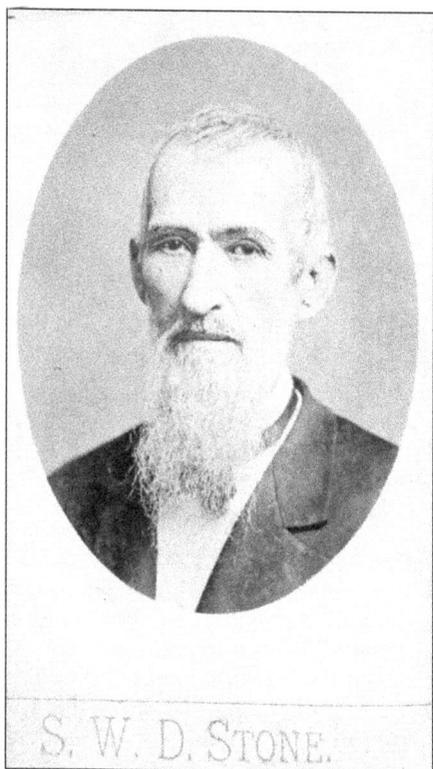

Stephen W.D. Stone was the Elizabethtown postmaster from 1841 to 1843 and the first county clerk of Larue County in 1843. He was also the uncle to "Aunt Beck" Rebecca Davis Stone Hill, the proprietor of the Hill House. Stephen Stone lived in a house where St. James Catholic School is today. (Courtesy of Brown-Pusey House.)

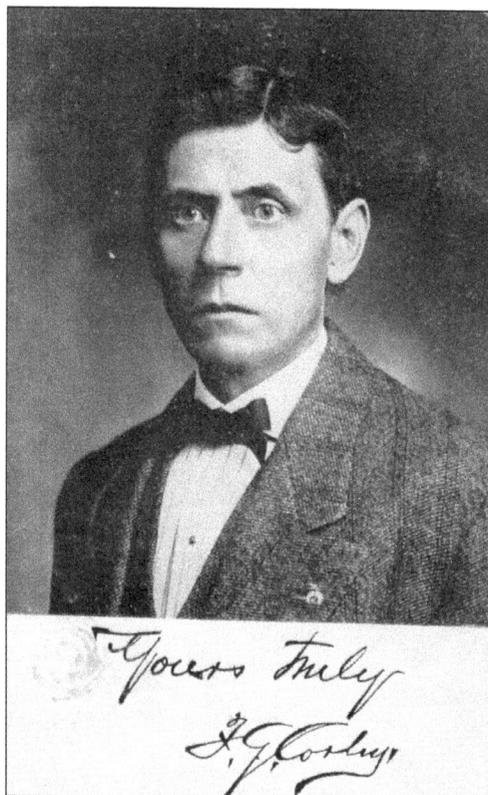

Hardin County clerk John H. Wells died in 1896, and Frank G. Corley, pictured, was appointed the county clerk and served until 1913. Frank Corley was an Elizabethtown and Cecilia railroad agent for the Illinois Central Railroad before he entered politics. (Courtesy of Mary Jo Jones.)

Allen Forest "Jack" Gross formed Gross Insurance Agency in 1940. He was a player in the Elizabethtown Coca-Cola amateur baseball team in the 1920s. He was employed as a station clerk with the Illinois Central Railroad and worked with the Corps of Engineers at Camp Knox and with the local telephone company. One of his greatest achievements was to get advanced service—the dial telephone—for his telephone customers. (Courtesy of Mary Jo Jones.)

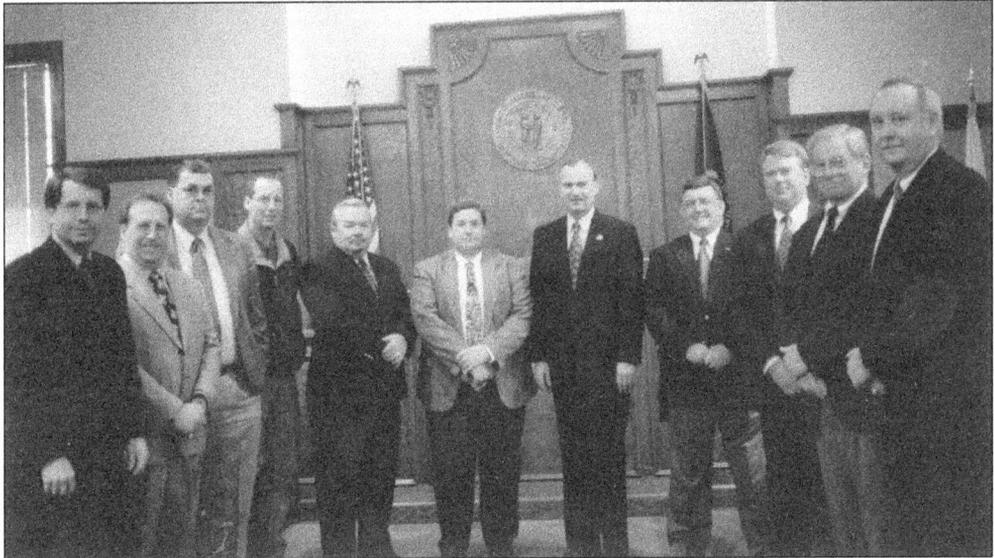

This photo shows the first day of the Hardin County Fiscal Court in the H.B. Fife Courthouse. From left to right are County Attorney Ken Howard, magistrates Doug Goodman, Bill Hay, John Wiseman, Roy Easter, and Philip Crady, Judge Executive Harry Berry, and magistrates Garry King, Tom Jaggers, Bill Brandenburg, and County Clerk Kenny Tabb. In November 2004, a new type of government was passed, to come into effect in 2007. Judge Executive Harry Berry is the first Republican in office since the Civil War. (Courtesy of Kenny Tabb.)

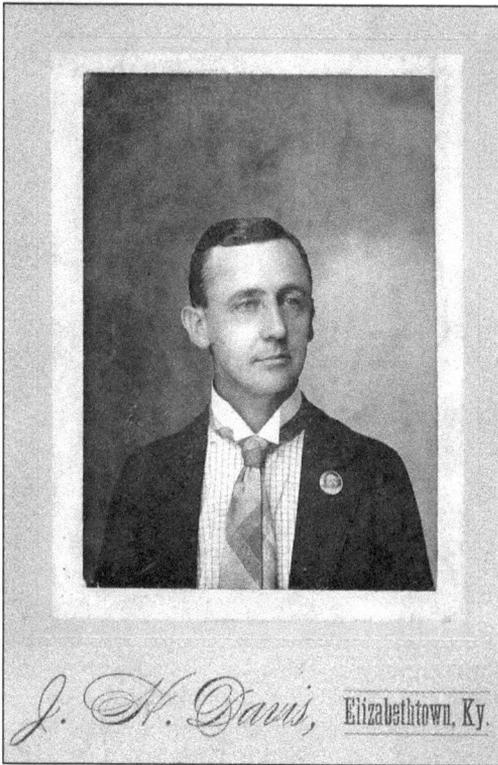

Judge Weed S. Chelf Sr. served as commonwealth attorney and circuit judge from 1892 to 1913. He was the father of Wrather, Loy, Glovie, Weed Jr., Henry, Mary, Walter, and Congressman Frank Chelf. Judge Weed Chelf was buried in the Elizabethtown City Cemetery with his wife, Hallie A. Chelf. (Courtesy of Mike Sisk.)

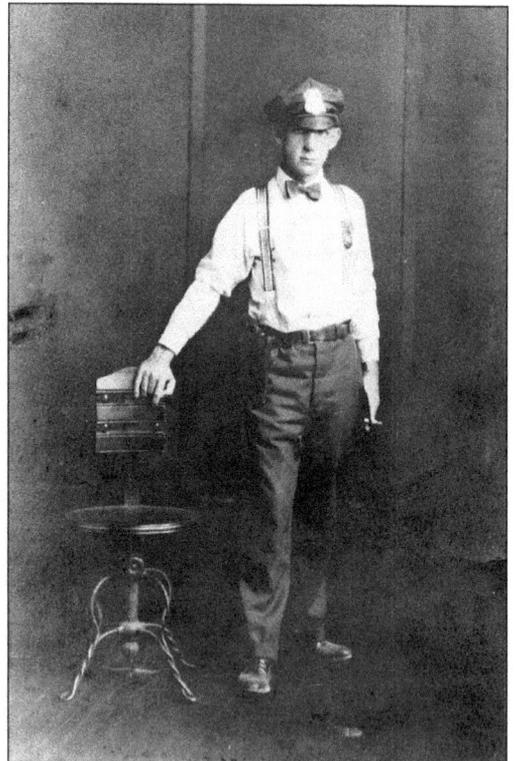

Weed S. Chelf Jr. worked in the barbershop at the Hotel Joplin before becoming a constable. (Courtesy of Mike Sisk.)

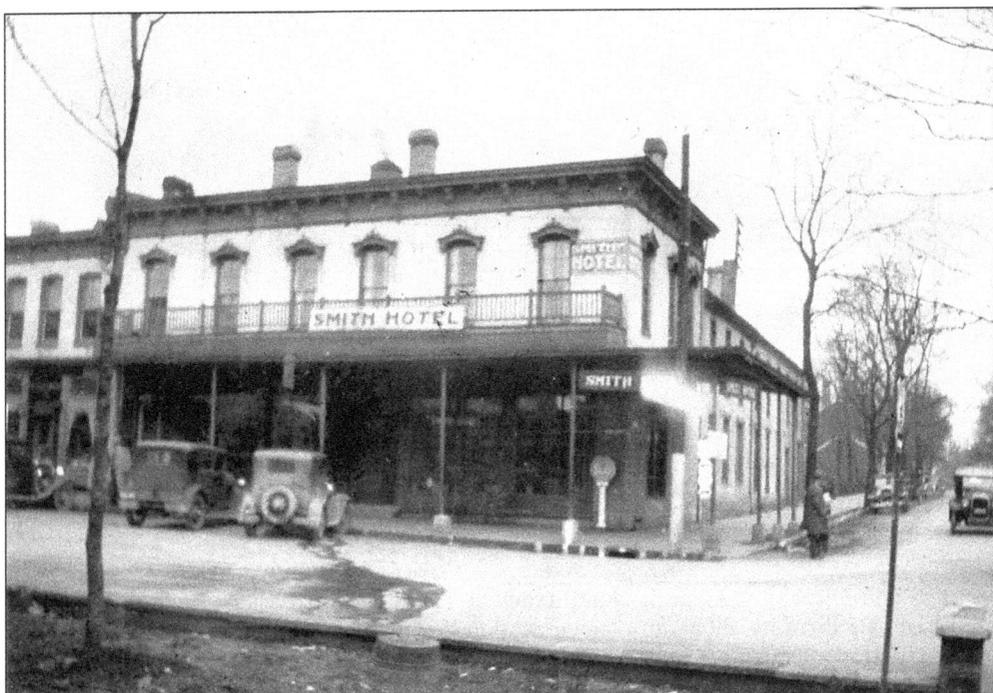

Smith Hotel, pictured in the 1920s, was formerly the Sign of the Lion Tavern and the Eagle House. Thomas and Carter's Stage Lines had offices in the building. One of the most historic landmarks in town, this building was built about 1888. The block, owned by the Pusey brothers, included Retail Grocery, a florist, electrical appliance store, barbershop, offices, and the hotel, which had rooms without baths. Next to the Smith Hotel was the Hardin County Jail. (Courtesy of the Brown-Pusey House.)

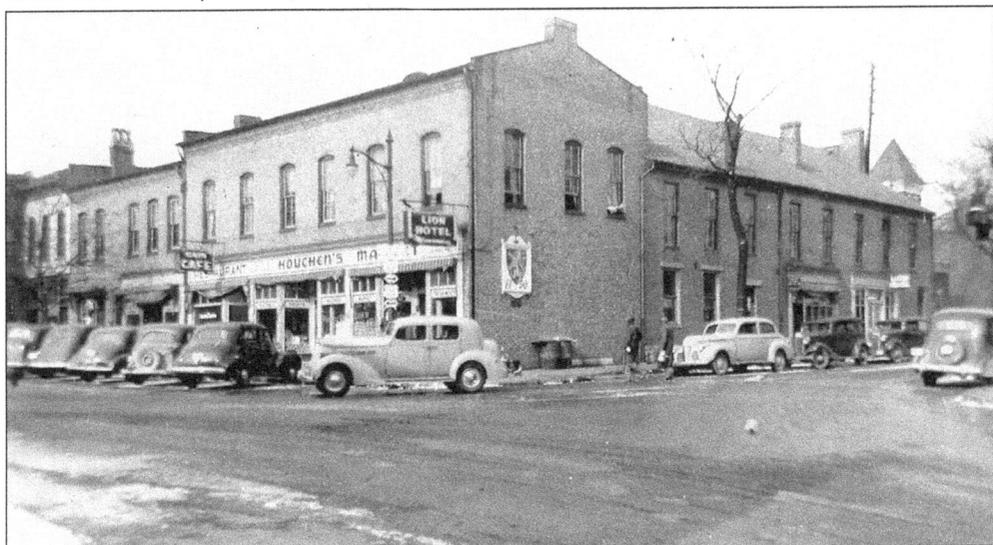

The Smith Hotel, pictured in the 1940s as Houchens Market, is located at 22–27 Public Square and 102–114 North Main Street. In the 1860s, Union soldiers were held prisoner in this building. In the 1870s, the building was the quarters for Company A of the 7th Cavalry. (Courtesy of Brown-Pusey House.)

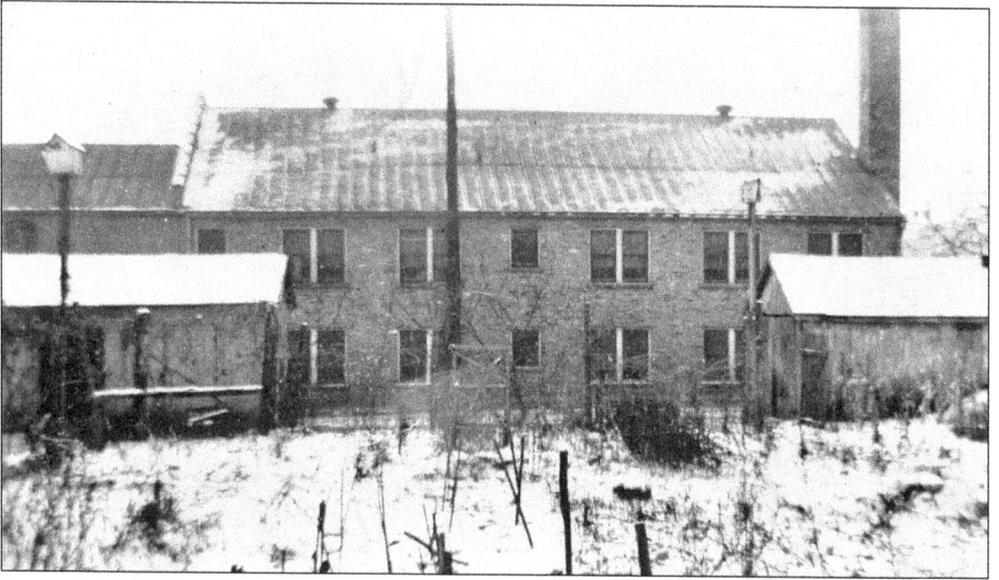

Pictured is the rear of the Smith Hotel annex at 112–114 North Main Street. An opening protected by a fire door allows for communication between the small, frame storage buildings and the hotel along Public Square. Built about 1930, the annex is no longer there. This land and building were bought by the Puseys in the 1930s. (Courtesy of the Brown-Pusey House.)

This is a photo of a garage and miscellaneous storage buildings at the rear of 111–114 North Main Street. The Puseys bought this land in the 1930s. The buildings no longer exist. (Courtesy of the Brown-Pusey House.)

Two

EAST DIXIE AVENUE

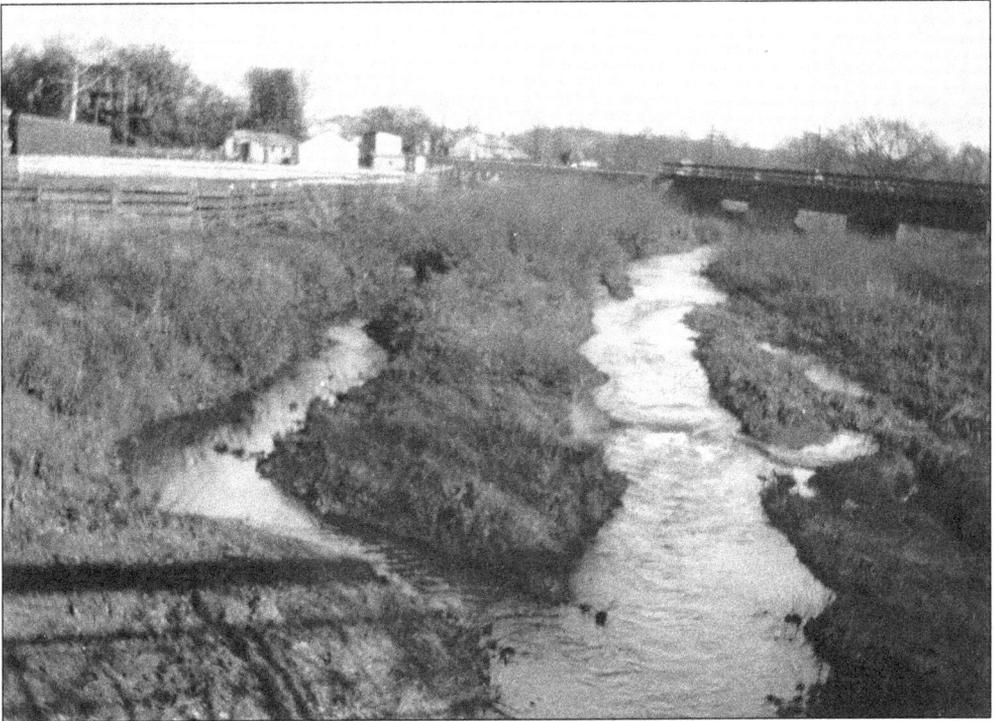

This view of Severns Valley Creek, a pioneer watercourse, is from the bridge located on East Dixie Avenue. Haycraft's Mill was located in the area just left of this view. Haycraft's Mill was built about 1797 by Samuel Haycraft Sr. and Thomas Lincoln, the father of President Abraham Lincoln. The mill is gone, and Herb Jones Automobile business operates on this site. This section of Valley Creek has been maintained by Greenspace as a park for over 30 years. (Courtesy of Meranda Caswell.)

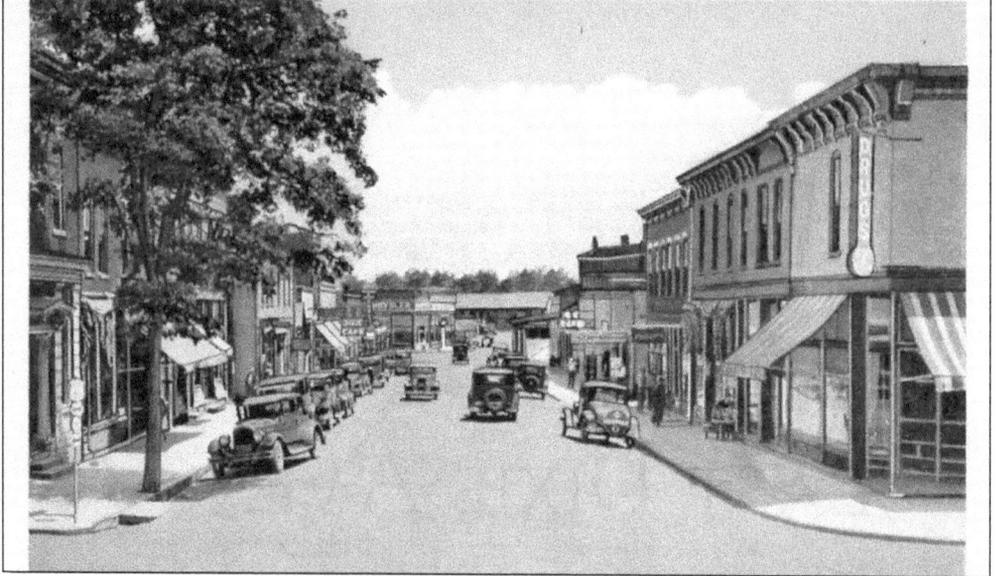

SOUTH MAIN STREET AND DIXIE HIGHWAY. ELIZABETHTOWN, KY.

This view of South Main Street and Dixie Highway shows Showers and Hays Drugstore on the right and Union Bank on the left. Dixie Café can be seen, as well as the Chrysler Building. The Chrysler Building was recently Herb Jones Automobile Sales. The new justice center was built on the site of the O.K. Café at right. In 1932, a bus station from Louisville to Paducah was located at the O.K. Café. (Courtesy of Meranda Caswell.)

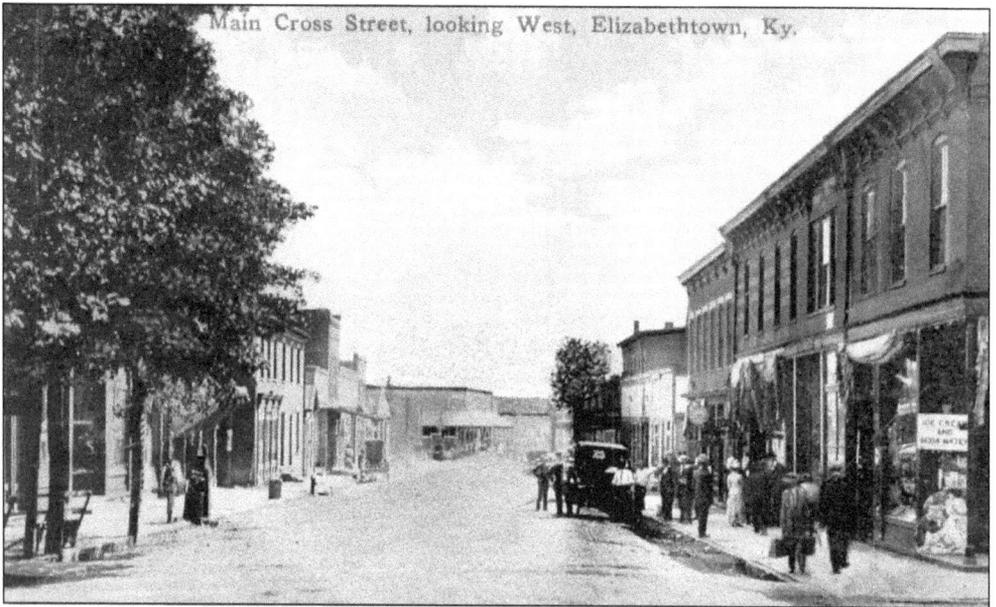

Main Cross Street, looking West, Elizabethtown, Ky.

This postcard of Main Cross Street, looking west, shows the East Dixie businesses c. 1922. Included are O.K. Café with a bus station, Farm Bureau Supply, South Side Motor, Ace Recreation Hall, Goldentip Gasoline, Jenkins-Essex, Dixie Café, Livers and Fryrear, Clark's Grocery, Curts Grocery, Forest Friend, Borders-Jones, Adams Grocery, Corbett Hardware, Rogers Meat Market, Walters's Coal, Phillips Jeweler, Showers and Hays, Elizabethtown Feed and Coal, and Larue Cofer Coal. (Courtesy of Meranda Caswell.)

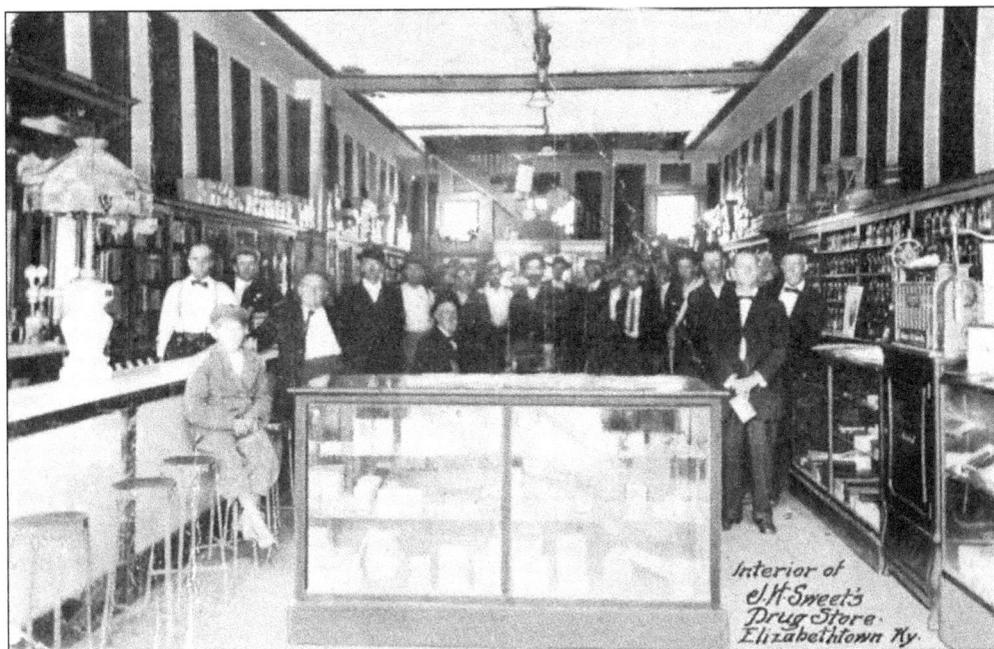

The interior of James Hays Sweets Drug Store (also known as Sweets and Donavan) is pictured in 1914. At one time, Hays was partners with Hugh Showers but later ran a store adjoining Shower and Hays known as Jimmie Sweets. It was not a real drugstore, as no prescriptions were filled; sundries and patent medicines were handled. J.H. Sweets printed and sold Elizabethtown postcards in his store. (Courtesy of Mary Jo Jones.)

Buried in the Pusey lot in the Elizabethtown City Cemetery were Alfred Mackenzie Brown, Mary Bell Stone Brown, Willie Davis Brown, Fannie M. Brown, Thomas Horace Hastings, William Allen Pusey, Alfred Brown Pusey, Robert Burns Pusey, and Bell Brown Pusey. Philip Arnold and his family were buried in the next lot. (Courtesy of the Brown-Pusey House.)

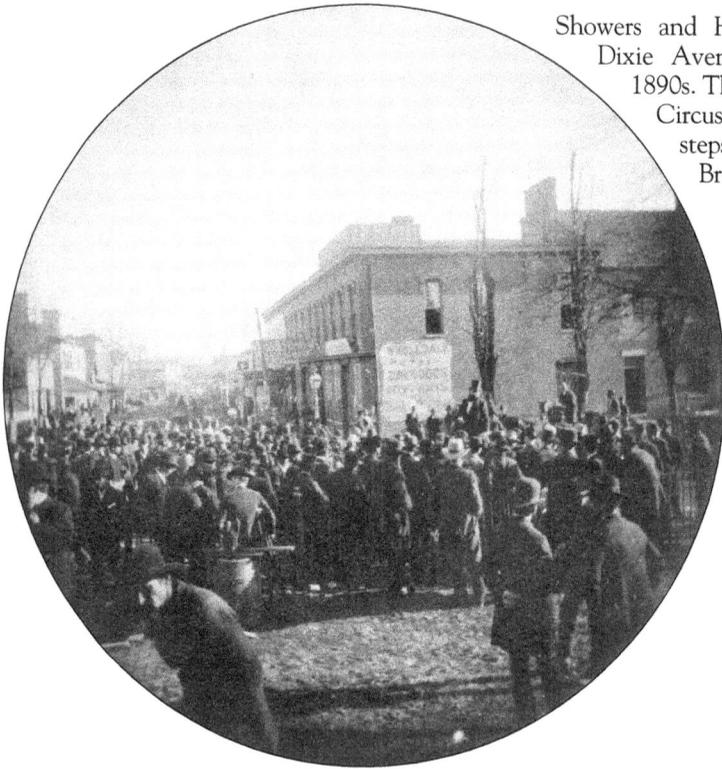

Showers and Hays Drugstore and East Dixie Avenue are pictured in the 1890s. This photo was taken during Circus Days from the courthouse steps. (Courtesy of the Brown-Pusey House.)

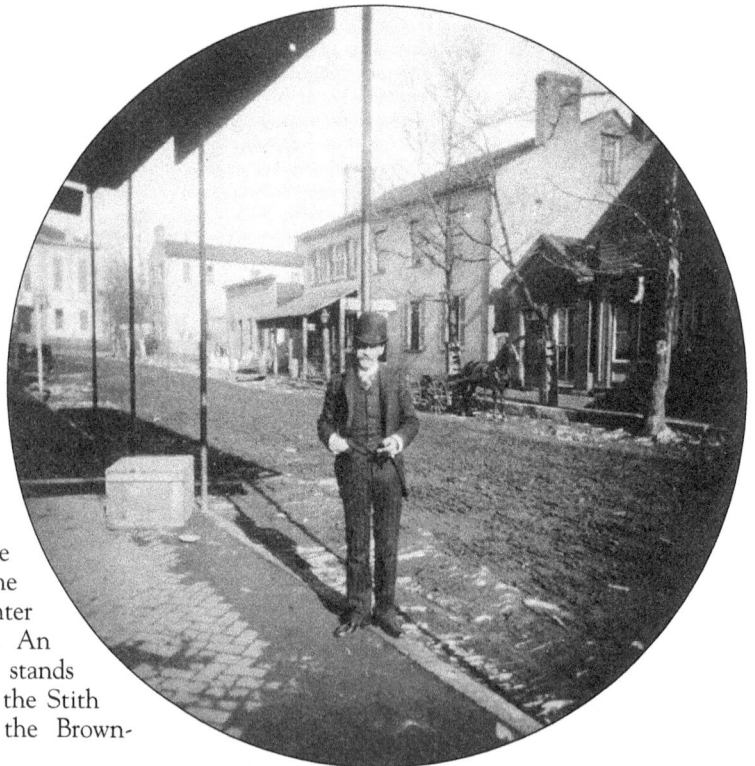

This photo of East Dixie Avenue looks towards the courthouse in the center of the Public Square. An unidentified man stands diagonally across from the Stith House. (Courtesy of the Brown-Pusey House.)

This 1890s view is from inside the doorway of Dr. Robert Burns Pusey's office, looking across street at the businesses of the time. (Courtesy of the Brown-Pusey House.)

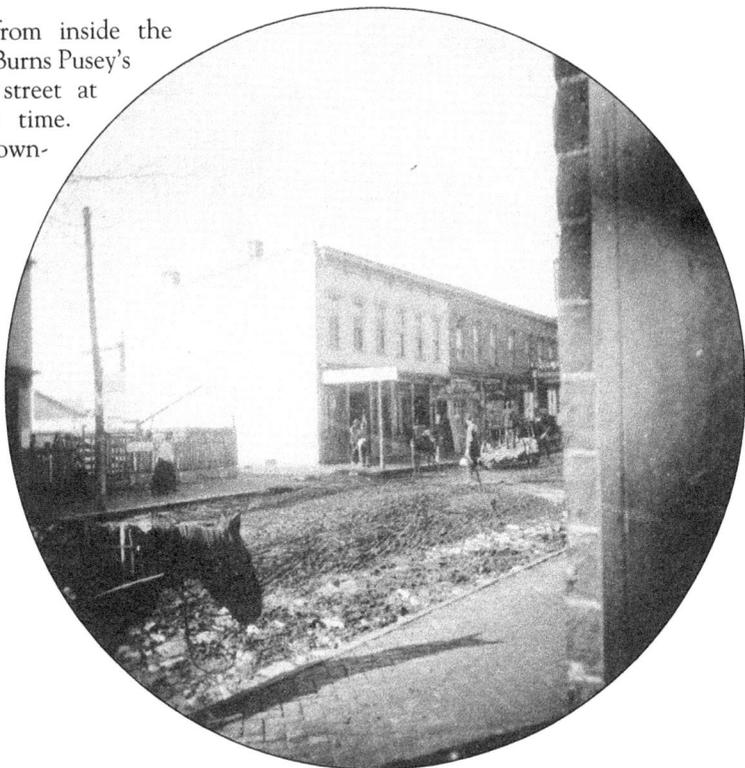

Pictured from left to right in this c. 1890 photo are the Stith House, Dr. Robert Burns Pusey's office, and Goranflo's Shoe Shop. Today, parking lots have replaced the Stith House and Goranflo's Shoe Shop. The doctor's office is still standing between the two parking lots. (Courtesy of the Brown-Pusey House.)

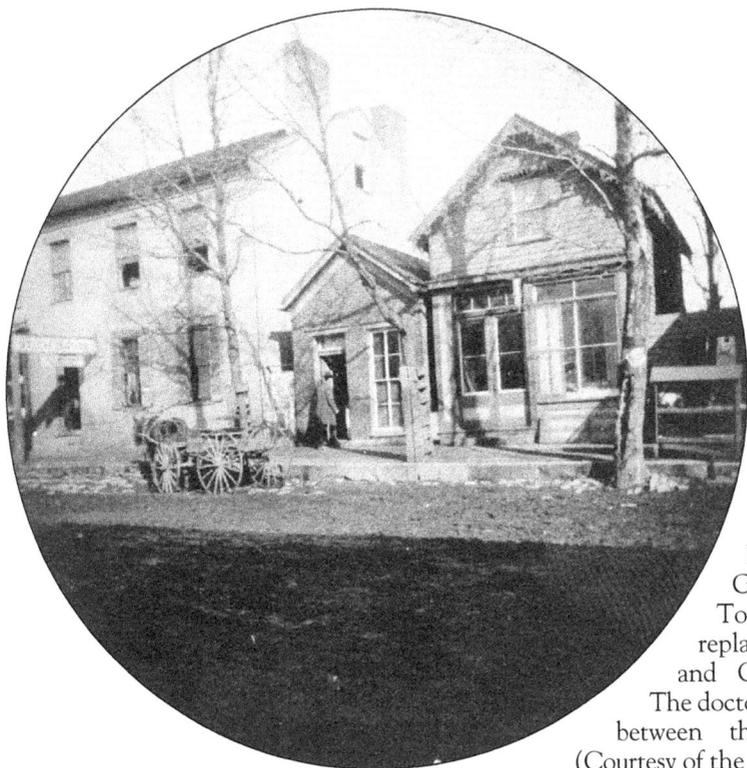

The Stith House, also called the Berry House, was razed, and a parking lot has taken its place. Carrie A. Nation stayed in this hotel. This building was Ace Bowling Alley in the early 1930s. (Courtesy of the Brown-Pusey House.)

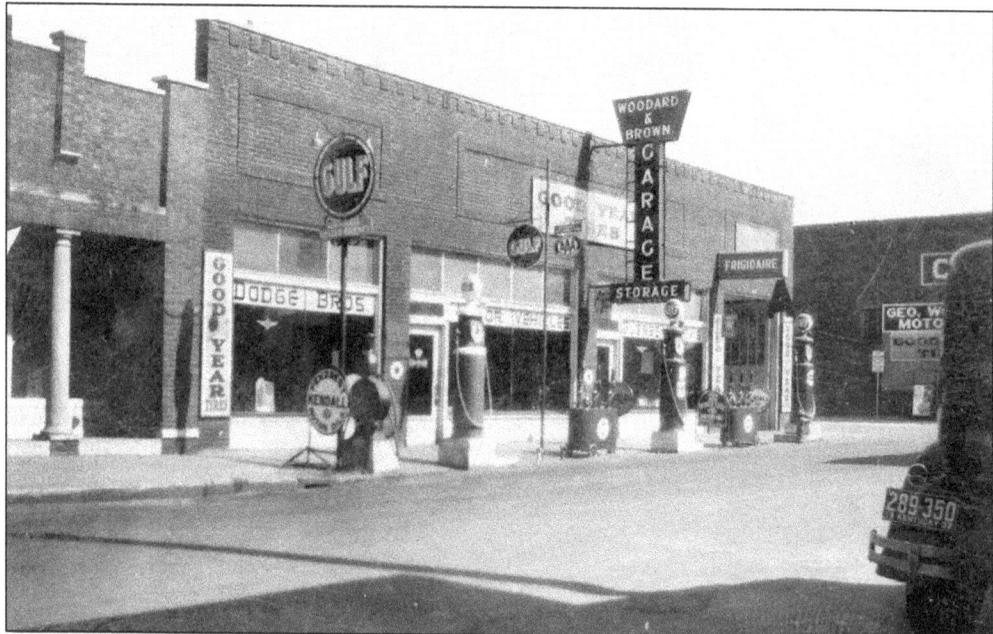

Woodard and Brown Garage and Storage, on the corner of Dixie Highway and Race Streets, opened around 1922. Today Herb Jones, recently merged with Nissan, operates on this site. (Courtesy of Mary Jo Jones.)

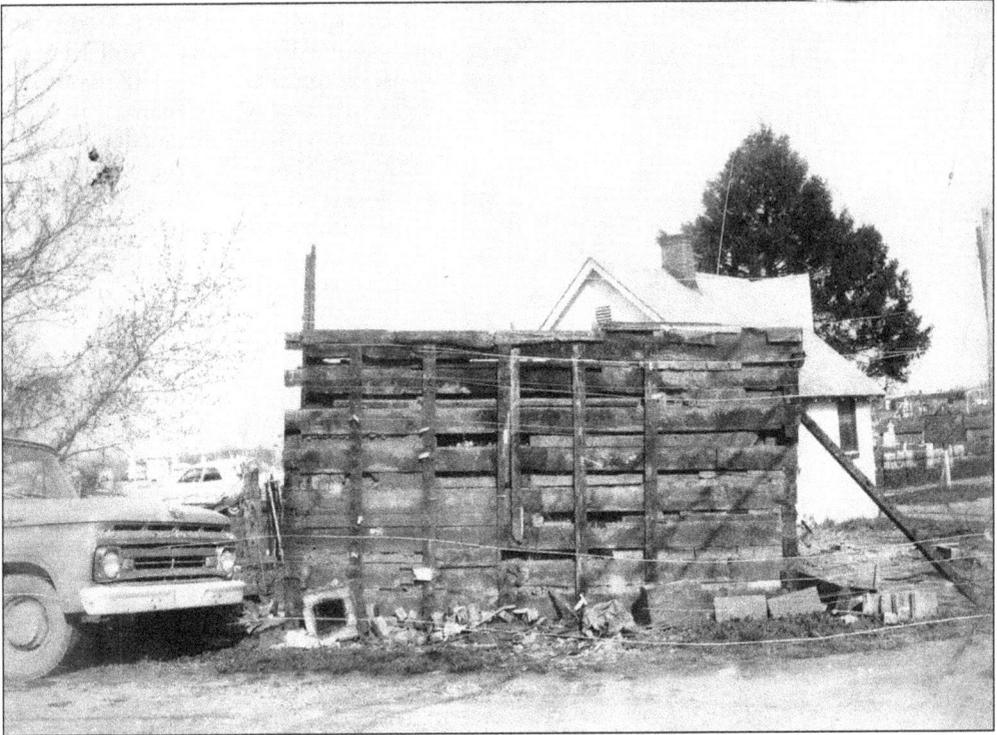

This is a house made of railroad ties across from the Elizabethtown City Cemetery entrance. The city cemetery is part of the historic district. The city began buying land in 1866 for the cemetery. Unmarked graves are located here from the 18th century. Confederate general John Hunt Morgan attacked Federal troops from the cemetery hill on December 27, 1862. The Sons of Confederate Veterans positioned a cannon on the cemetery hill to commemorate the attacks. (Courtesy of Mary Jo Jones.)

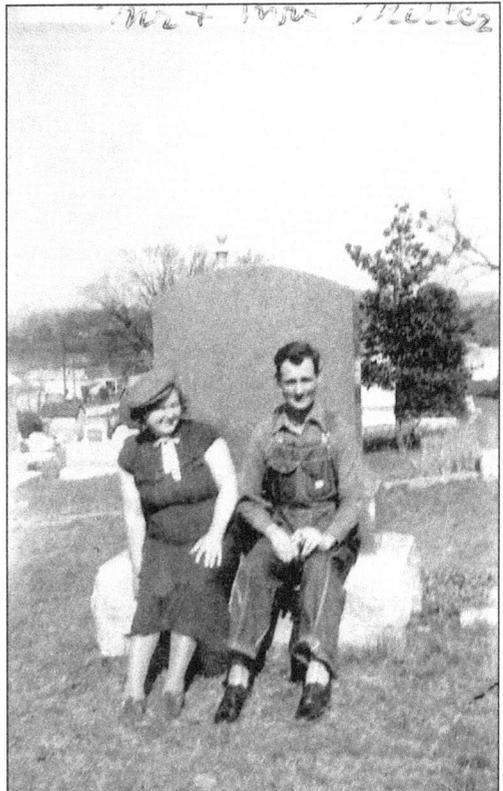

Elizabethtown City Cemetery is seen in the background prior to 1945. Past the Elizabethtown City Cemetery traveling out of town is a road that used lead to Glendale. Pictured are Margaret Alice (Tharp) Miller and World War I veteran William Alfred Miller. Early residents used this area, called Gallows Hill, to execute criminals. After the Civil War, this area became the home for the freed slaves and the black population. Desegregation caused uproar in this area. (Courtesy of Helen Glasgow.)

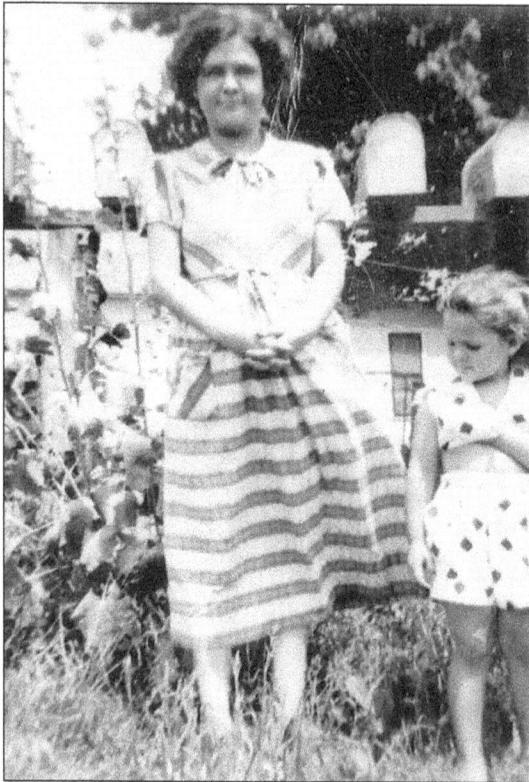

Joy Evelyn Miller and Brenda Cothern are standing in front of the Miller house on top of Glendale Hill prior to 1950. Margaret Alice (Tharp) Miller (1906–1999) and William Alfred Miller (1891–1945) moved to the top of Glendale Hill in the 1920s and built a house with military ammunition boxes as part of the structure. (Courtesy of Helen Glasgow.)

Arlene Kieta, Helen Cofer, Debbie Hornback, Anita Hornback, and Rita Hornback sit on the porch of a house on top of Glendale Hill in the late 1950s or early 1960s. In 1922, the Glendale Road extended south from Elizabethtown to Glendale. (Courtesy of Helen Glasgow.)

Mary Chelf, at six weeks old, is held by an unidentified woman in the vicinity of East Dixie Avenue. (Courtesy of Mike Sisk.)

Helen Church, Corinne Tolson, Louise Tolson, and Mary E. Chelf are pictured in the vicinity of East Dixie Avenue. (Courtesy of Mike Sisk.)

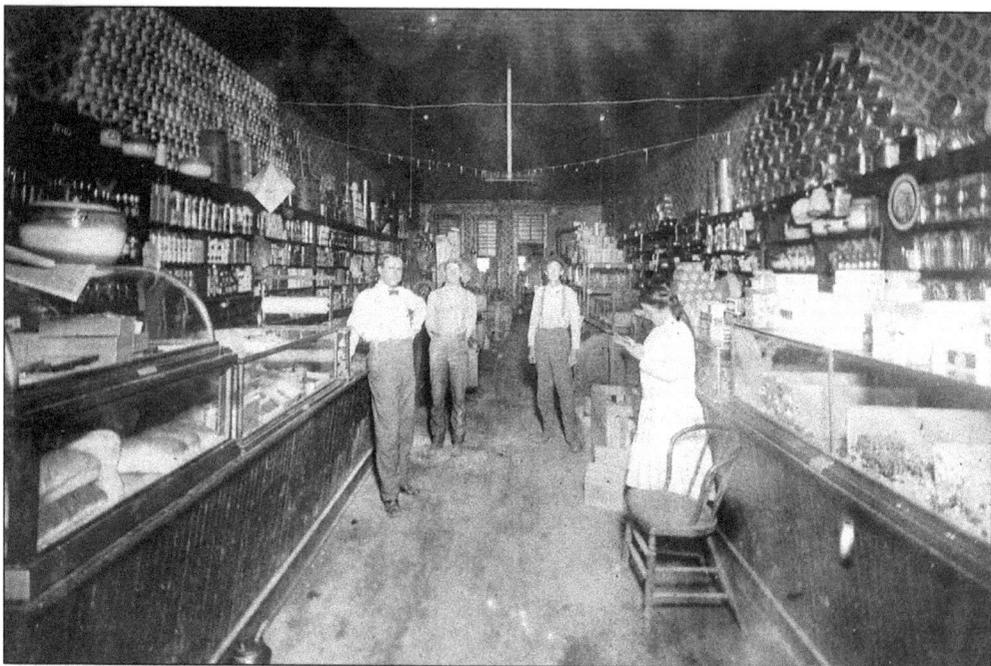

McMurtry's Grocery Store, pictured about 1900, was owned and operated by Robert Terry McMurtry (February 2, 1878, to December 13, 1914). McMurtry, serving as Hardin County sheriff, was killed in 1914 by Turner Graham Jr., who was electrocuted in Eddyville in 1915. McMurtry was the father of R. Gerald McMurtry, recognized as the leading authority on President Abraham Lincoln. (Courtesy of the Brown-Pusey House.)

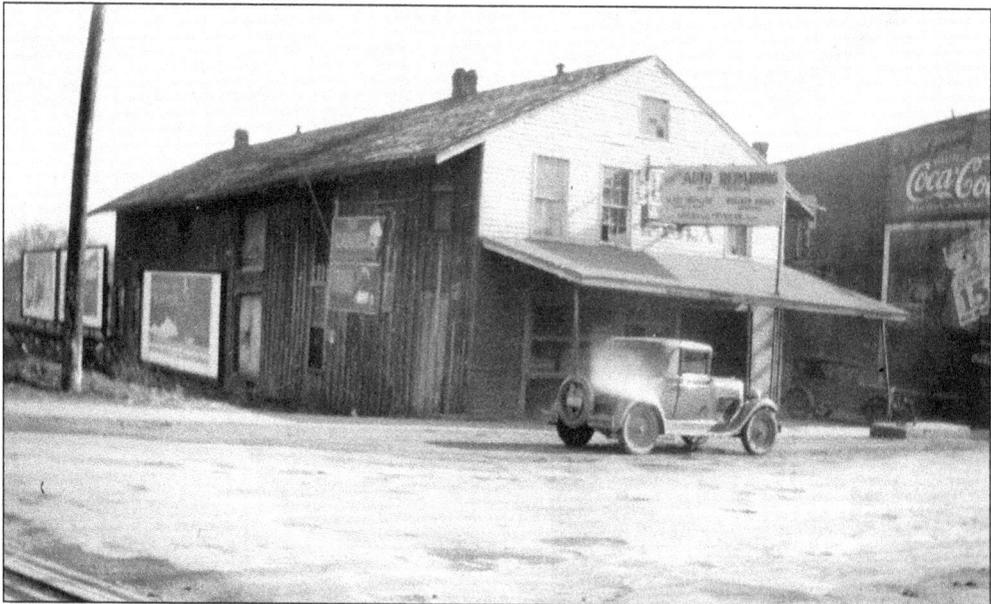

The Livers and Fryrear Auto Repairing (Old Wholesale Building), later known as Howard Monument, was located on East Dixie by Valley Creek. The stockade captured by General Morgan in December 1862 stood at the rear of this building. Federal troops were stationed there to guard the L&N Railroad Bridge. (Courtesy of the Brown-Pusey House.)

Three

WEST DIXIE AVENUE

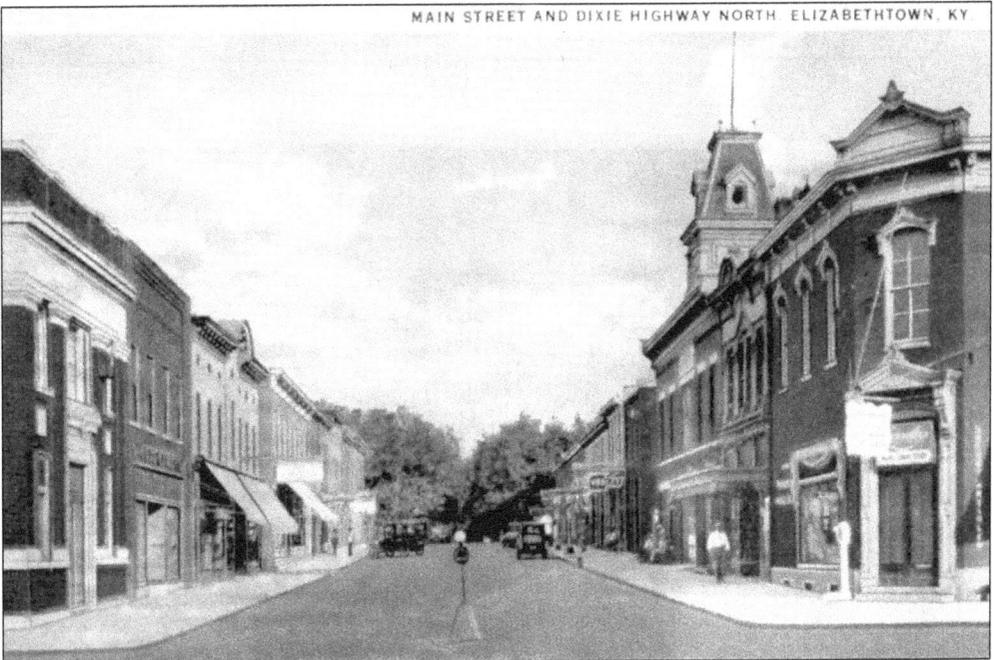

This postcard, showing Main Street and Dixie Highway, is dated about 1922. Dixie Highway, also known as 31 West, was called Cross Street. After 1912, Cross Street was Cross Main Street and later changed to East and West Main Street. Today the same street is East and West Dixie Avenue or East and West Dixie Highway. (Courtesy of Meranda Caswell.)

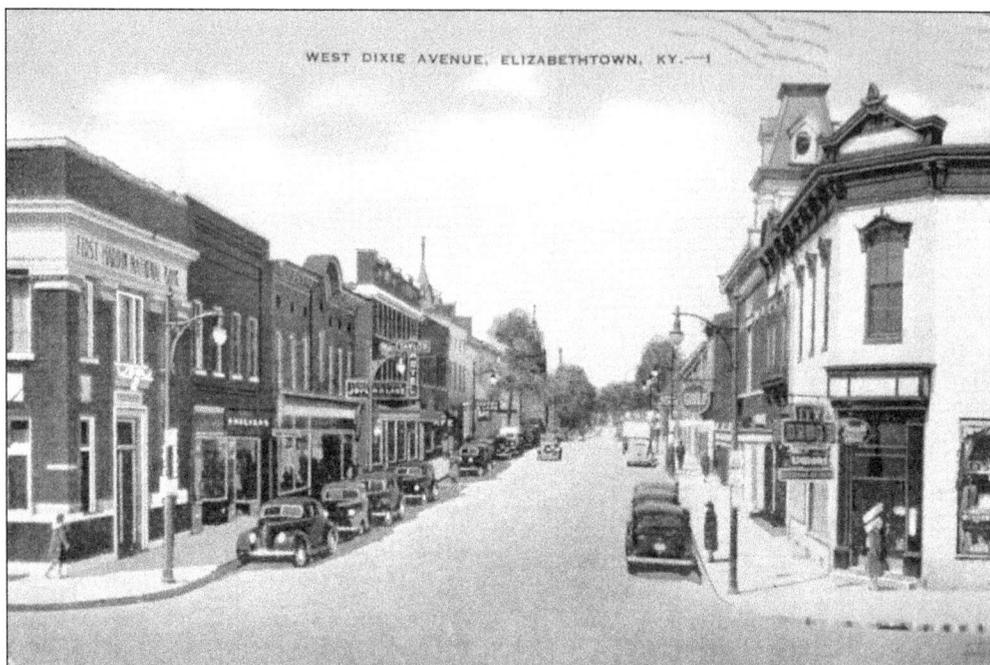

A postcard of West Dixie Avenue about 1945 shows the First Hardin National Bank on the left. The Joplin and Lanz store and the Taylor Hotel are also at left. The corner building was built after 1887. (Courtesy of Meranda Caswell.)

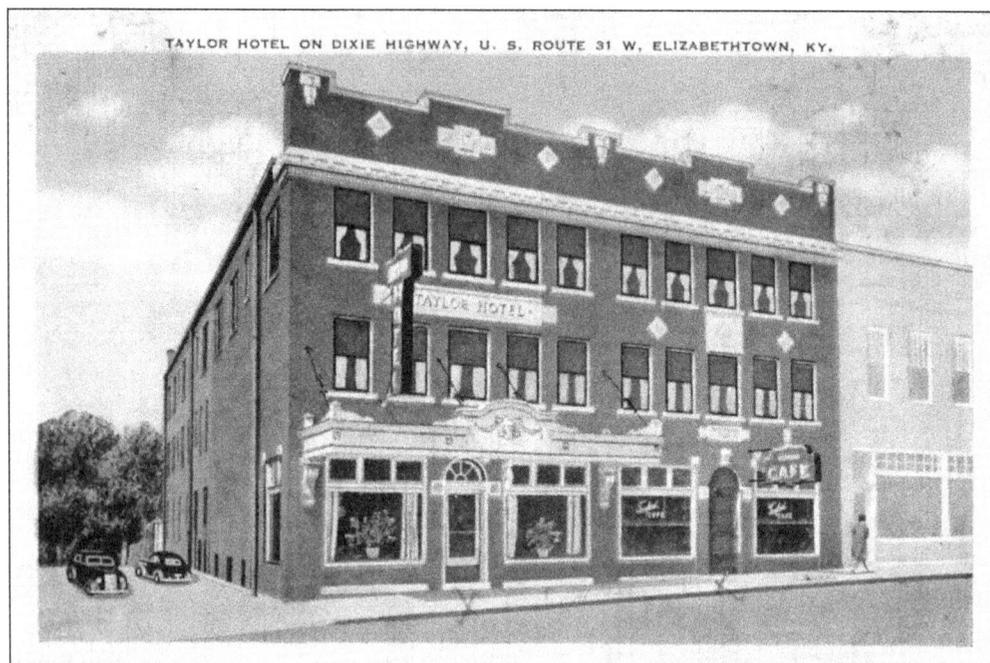

The Taylor Hotel is located on Dixie Highway, U.S. Route 31 West. (Courtesy of Meranda Caswell.)

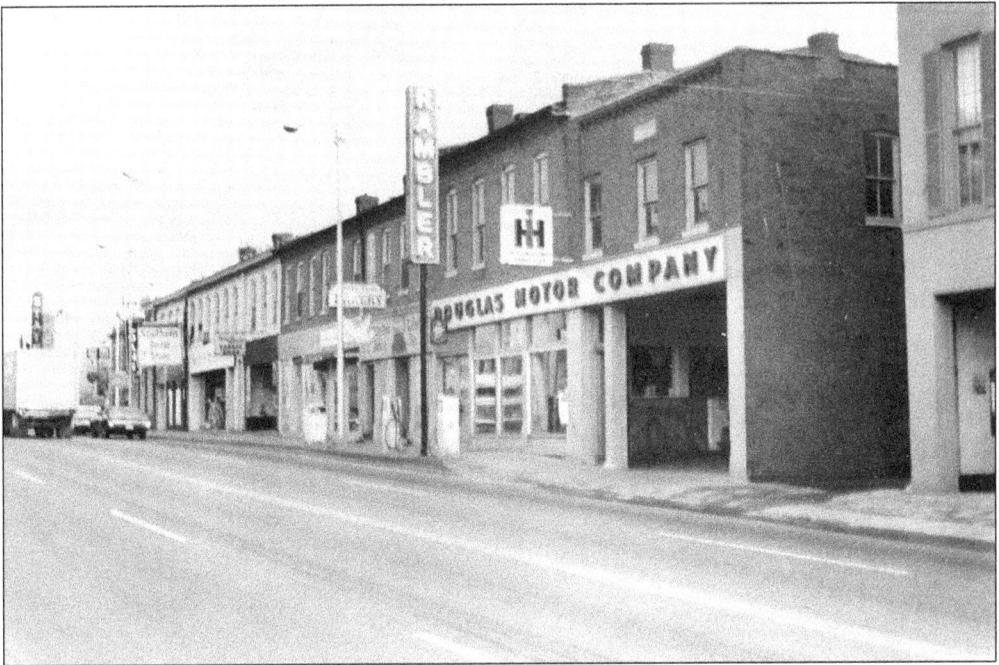

Douglas Motor Company, White Dove Bakery, a barbershop, Southern Dollar Store, and the State Theater were located on West Dixie Avenue. (Courtesy of Mary Jo Jones.)

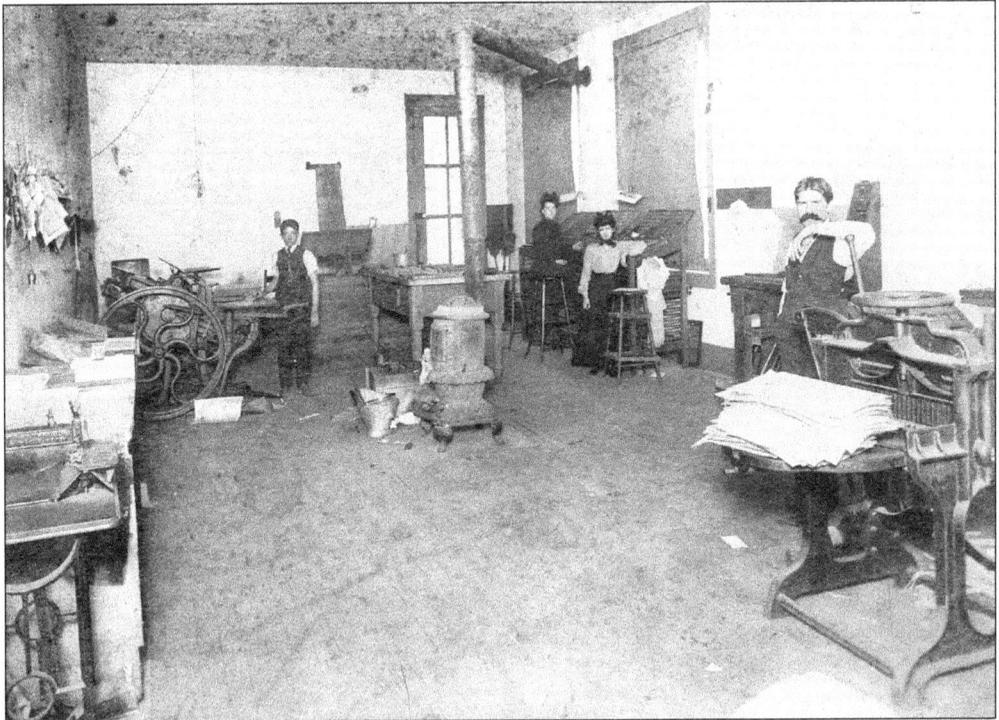

The office of the *Mirror*, a local newspaper, was located at 120 West Dixie Avenue. Pictured from left to right are unidentified, Mary Doyle, Elizabeth Lott, and C.J. Richerson. Later, the site was occupied by Factory Outlet Shoe Store. (Courtesy of Mary Jo Jones.)

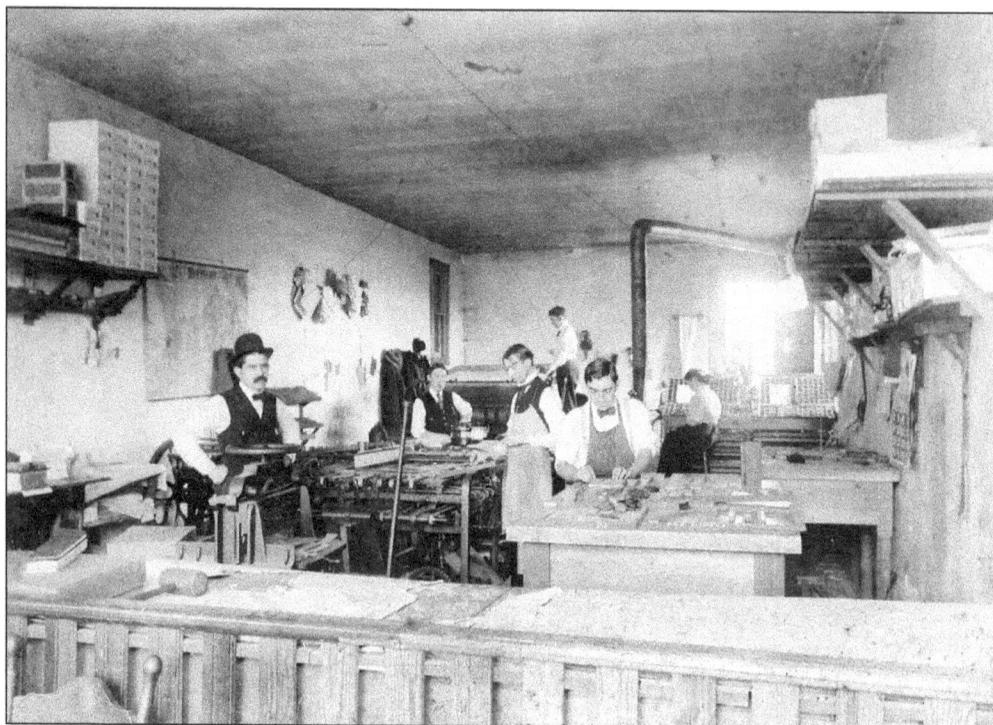

The office of the *Mirror*, a local newspaper, was located at 120 West Dixie Avenue. The owners were C.J. Richerson (far left) and Milton Yates. Two identified ladies are Annie Huffman and Mary Doyle. The others are unidentified. (Courtesy of Mary Jo Jones.)

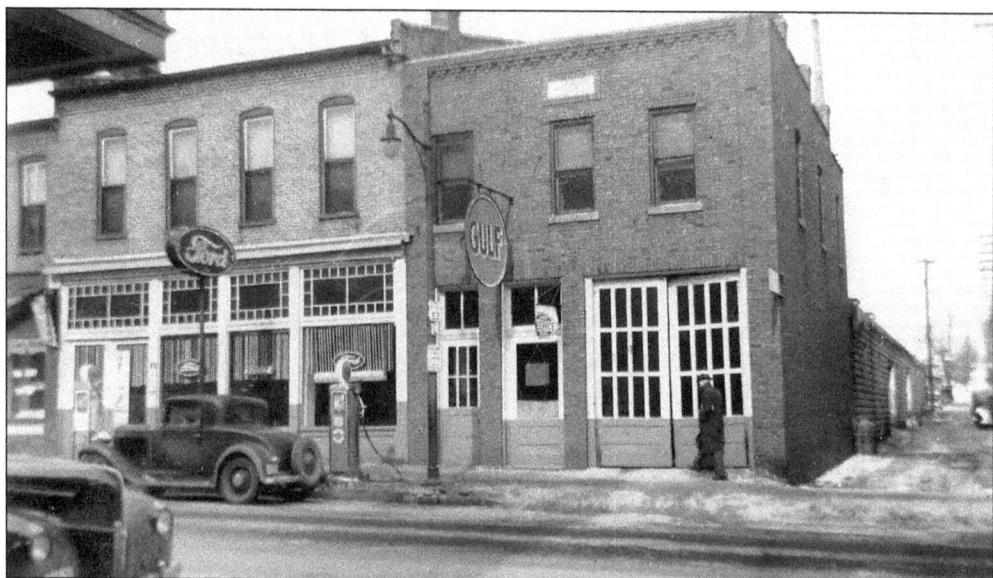

The Puseys owned 113–115 (125–127) West Dixie Avenue in the 1930s and 1940s. Notice the alley on the right that led to Poplar Street. The front section of this building was built about 1888. The rear section was built about 1908. (Courtesy of the Brown-Pusey House.)

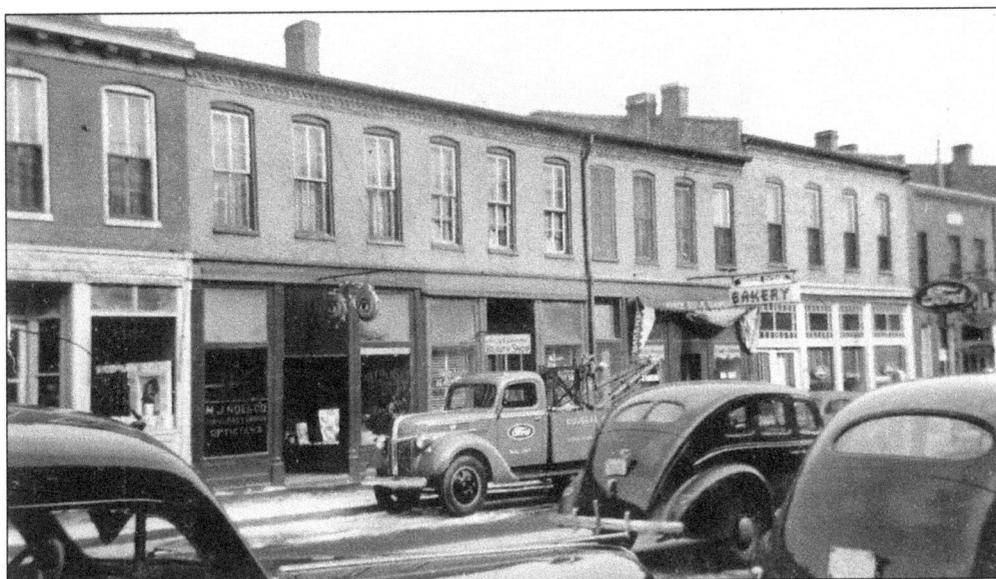

The Puseys also owned 117–123 (129–133) West Dixie Avenue in the 1930s and 1940s. Notice the White Dove Bakery store. This building was built about 1888. In the 1940s, the first floor was occupied by a bakery at 117–119, an office at 121, and an optician's office at 123. (Courtesy of the Brown-Pusey House.)

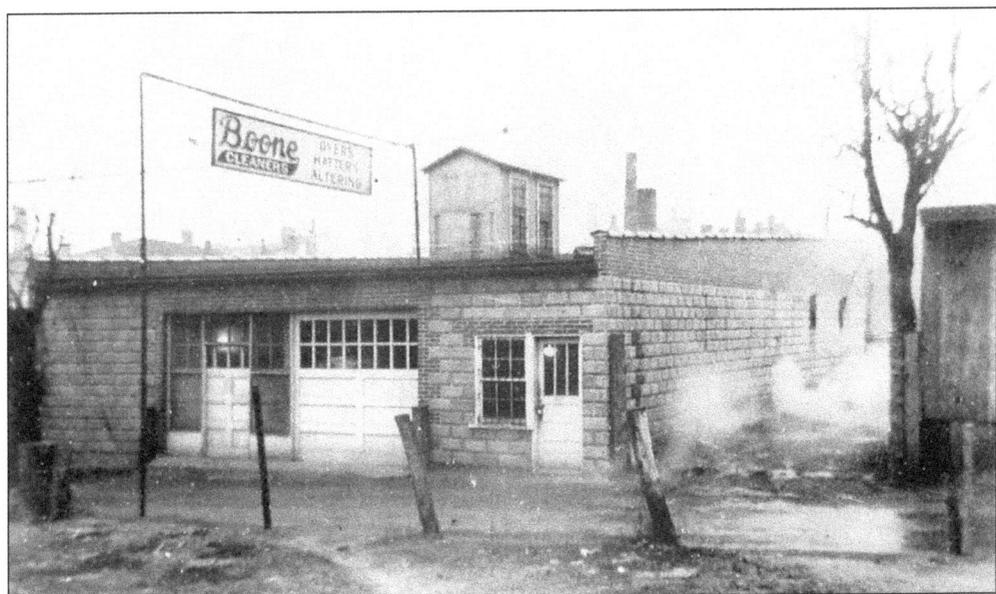

This rear view of 117–121 (129–131) West Dixie Avenue shows Boone Cleaners, a laundry business. This building was built about 1938. There was an auto body and paint shop located at the rear of 117–119. (Courtesy of the Brown-Pusey House.)

Perry and Alvey Funeral Home, currently occupied by Rider's Traditional Clothing Stores, was located at 136 West Dixie Avenue. This building is on the corner of West Dixie Avenue and North Mulberry Street. (Courtesy of Mary Jo Jones.)

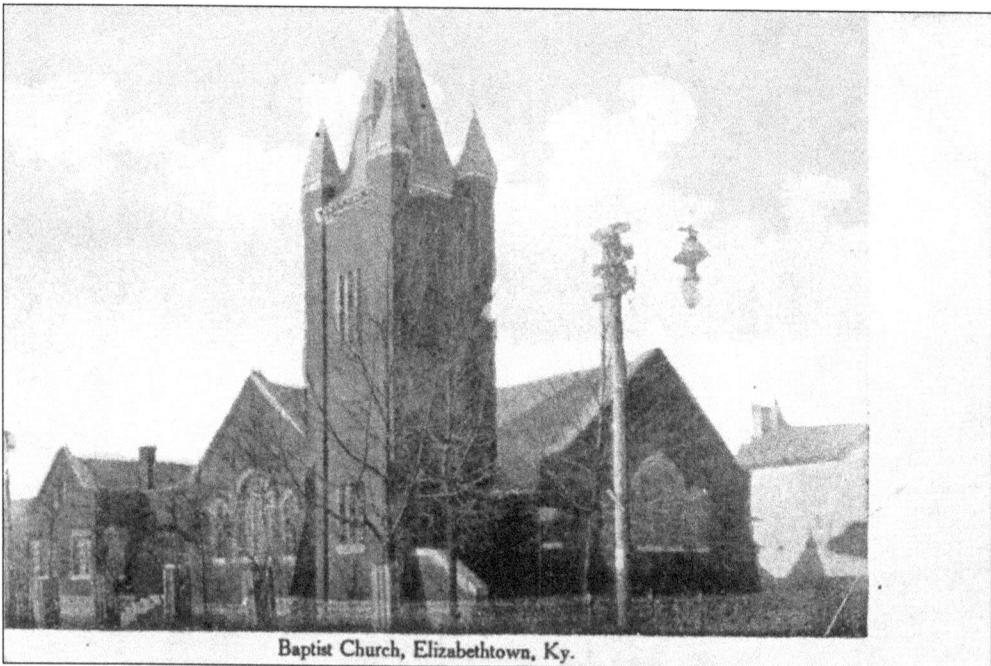

The second brick Severns Valley Baptist Church was located on West Dixie Avenue from 1896 to 1955. This church was the first in Elizabethtown to have a pipe organ, purchased in 1917 and partially funded by Andrew Carnegie. (Courtesy of Meranda Caswell.)

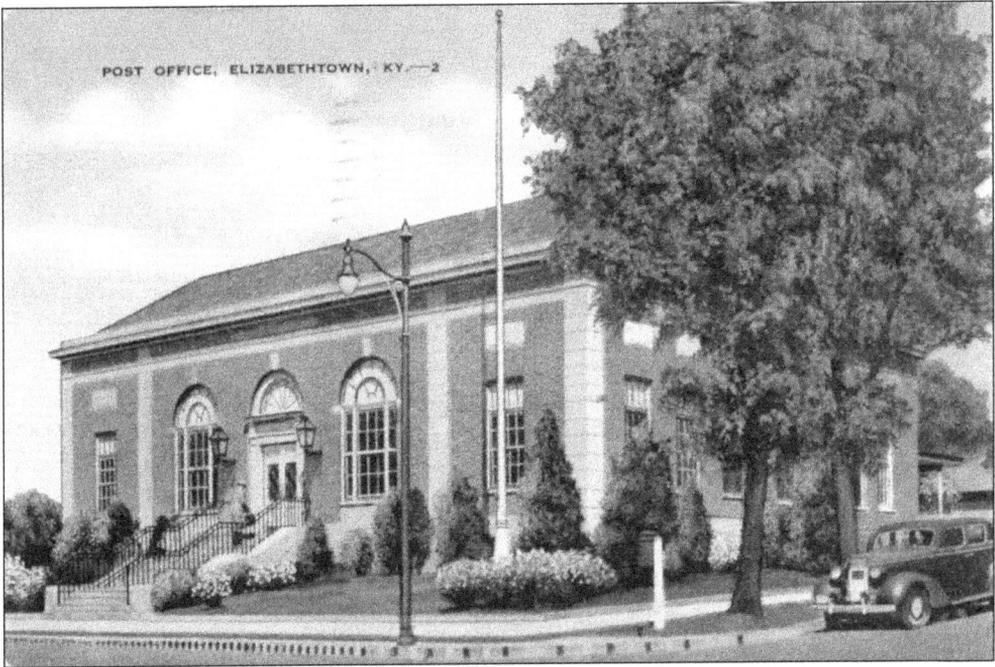

The Elizabethtown Post Office was built in 1931. In 1967, the post office moved, and the building housed the Hardin County Public Library until 2001. Today, this building houses the Hardin County History Museum and Ancestral Trails Historical Society. (Courtesy of Meranda Caswell.)

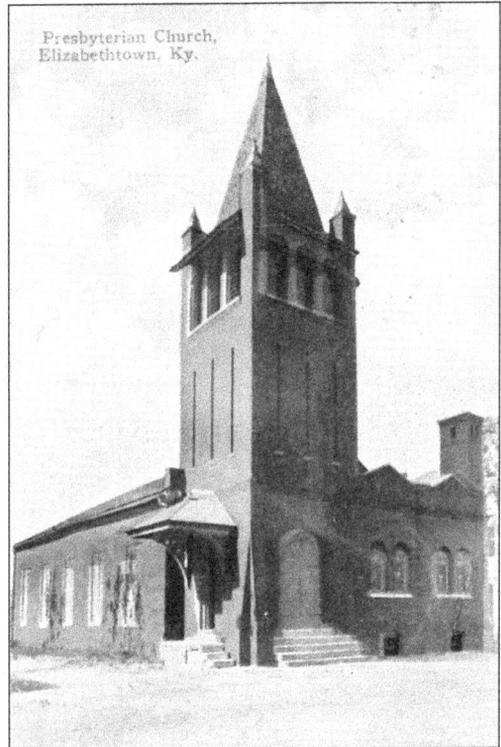

Presbyterian Church, Elizabethtown, Ky.

The 1915 postcard shows the Presbyterian Church. In 1922, Thomas Brewster was the pastor, with a church membership of 237. The church was organized in 1828. Today this building houses Helping Hand, an organization that provides for the needy and distressed. (Courtesy of Meranda Caswell.)

43

The Methodist Church, built in 1900, was named after Lucinda Barbour Helm, the daughter of Lucinda Barbour Hardin and Kentucky governor John Larue Helm. She was a leader in Southern Methodism. (Courtesy of the Brown-Pusey House.)

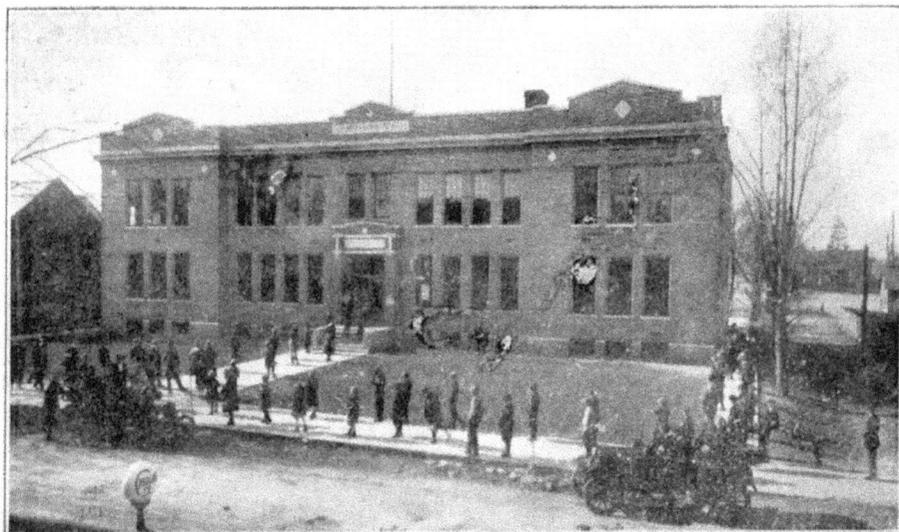

CITY SCHOOL BUILDING ELIZABETHTOWN. KENTUCKY

Elizabethtown City School was built in 1914 and destroyed by a boiler explosion in 1955. No one was hurt in the incident, but the building was considered unsafe. Today it is the city hall's parking lot. In 1922, the faculty included 13 teachers and a principal. (Courtesy of Mary Jo Jones.)

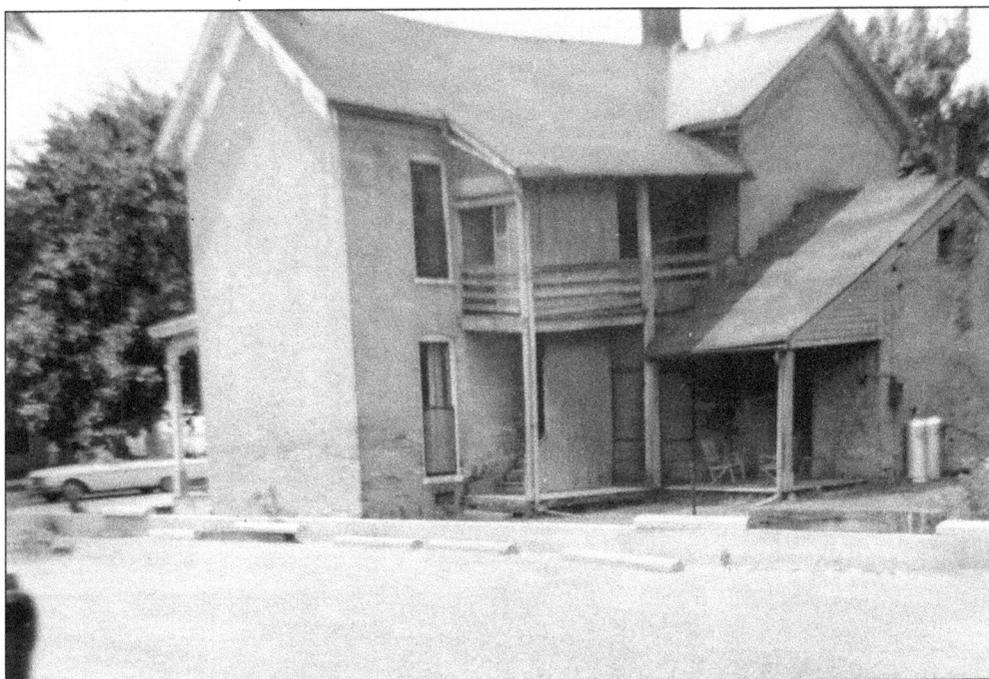

Lena Johnson was the librarian of the first free public library of Elizabethtown from 1923 to 1959. She resided in this house, once located on 231 West Dixie. PNC Bank and a parking lot replaced the house. (Courtesy of the Brown-Pusey House.)

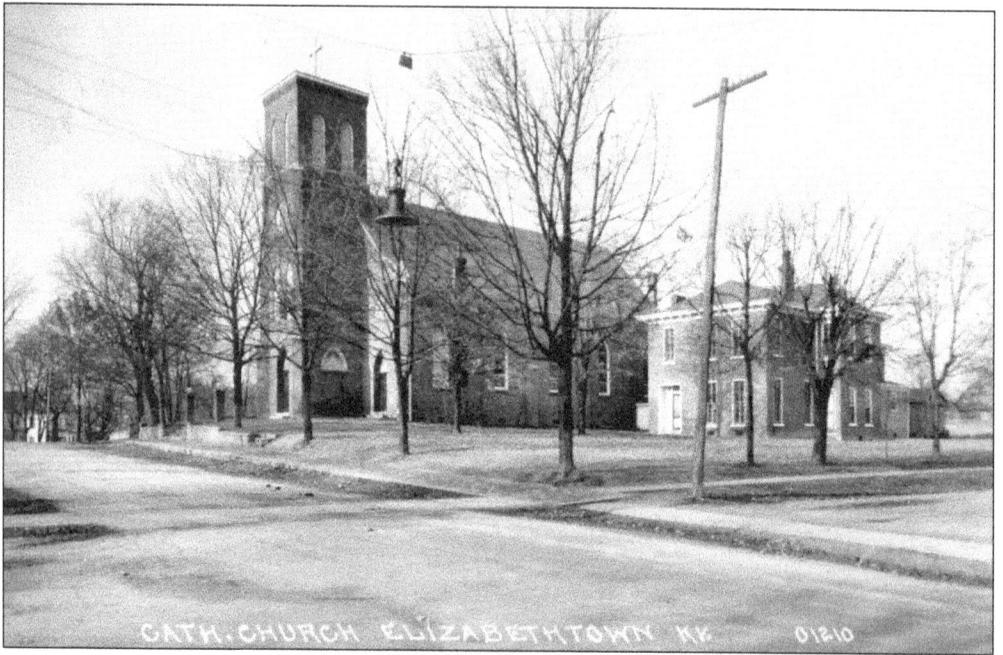

This postcard is an outside view of St. James Catholic Church, organized in 1840 by Fr. Charles I. Coomes. The first services were held in the house of Denton Geoghegan, later a sheriff of Hardin County. The first building, pictured here, was built in 1884 and razed in 1971. In 1922, Rev. P.M. Monahan had a membership of 475. (Courtesy of Mary Jo Jones.)

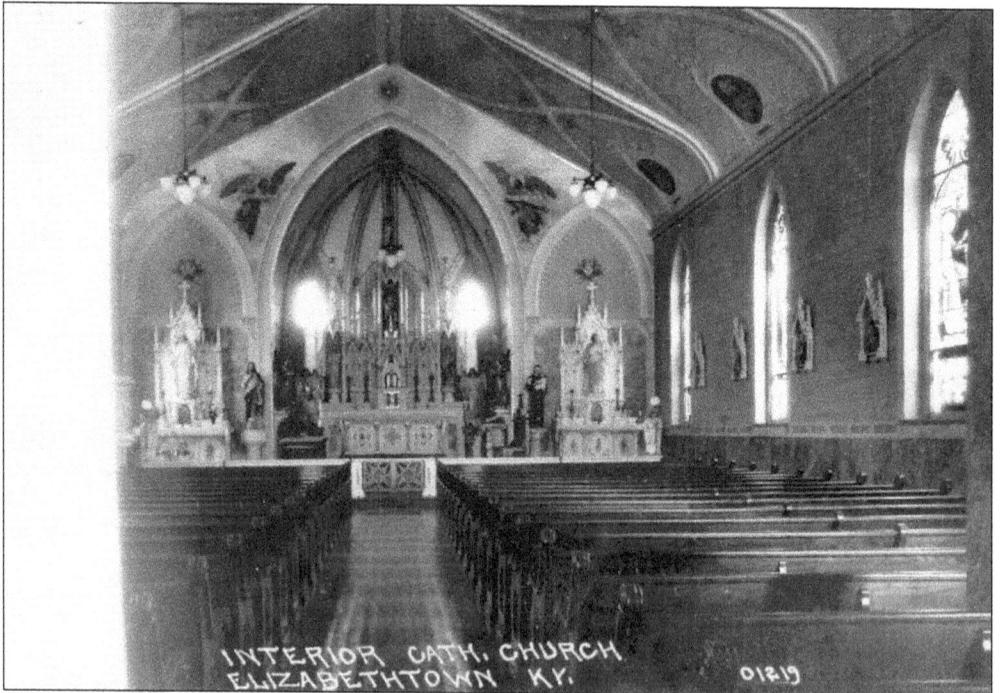

This postcard gives an interior view of St. James Catholic Church. All of the interior adornment pictured was sold after the new church was erected. (Courtesy of Mary Jo Jones.)

Rev. Augustine Degauquier was succeeded in 1868 by Rev. T.J. Disney, pictured, who started the school in 1869. Disney was succeeded by Rev. J. Ryan in 1874. (Courtesy of the Brown-Pusey House.)

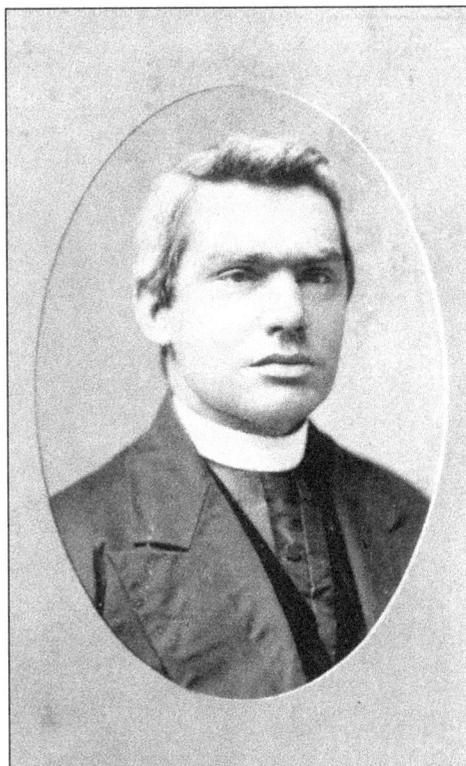

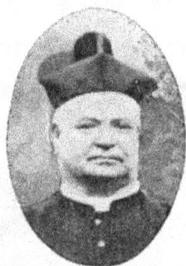

In Loving Remembrance

OF

VERY REV. DEAN HUGH DALY.

Born in Ireland, October 21st, 1838.
Ordained in Louisville, Dec. 24th, 1871.

Died at Elizabethtown, Ky., February 12,1919

My Jesus, Mercy !—100 days indulgence.

Merciful Jesus, grant him eternal rest.
—300 days indulgence.

May the soul of the departed one through the mercy of God rest in peace. Amen.

Rev. Dean Hugh Daly officiated at St. James Catholic Church beginning in 1888. He was buried in the St. James Cemetery, located on North Miles Street. (Courtesy of the Brown-Pusey House.)

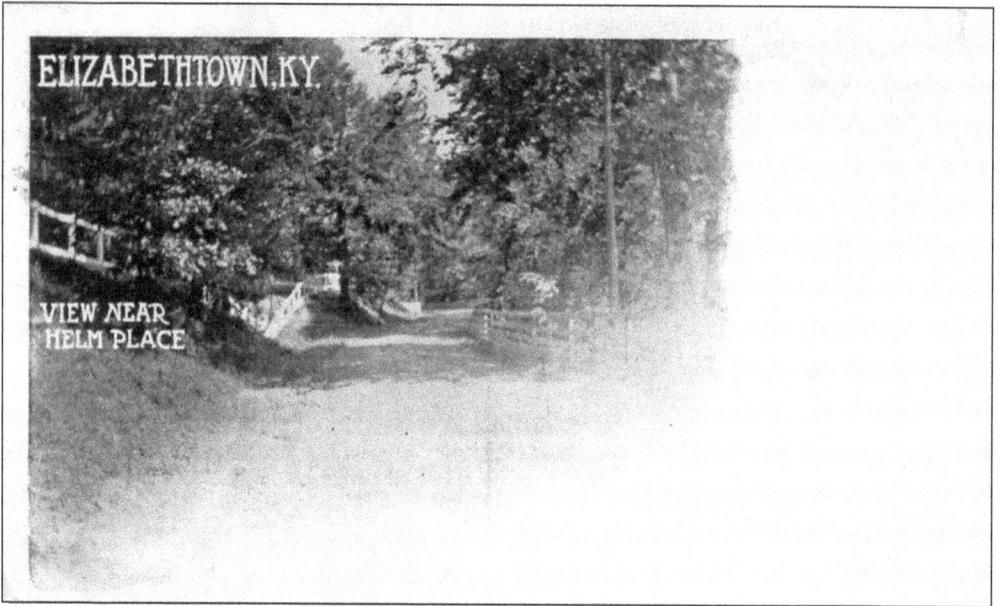

This postcard view near Helm Place was postmarked 1908. This area, once called Claysville, is near the historic Helm Cemetery. The United Daughters of the Confederacy disbanded prior to 1928 and donated many of the Helms' items to the Brown-Pusey House. (Courtesy of Meranda Caswell.)

Capt. Thomas Helm, a Revolutionary war veteran, married Jennie Pope. Their only child, George Helm, married Rebecca Larue. George and Rebecca Helm were the parents of future Kentucky governor John L. and Jane Helm (Norton). (Courtesy of the Brown-Pusey House.)

This is a photo of one of the children or grandchildren of Gov. John L. Helm. Helm married Lucinda Barbour Hardin, the eldest daughter of Ben Hardin, a noted pioneer. John and Lucinda Helm lived in a mansion in 1830 that the Sisters of Loretto had purchased to establish Bethlehem Academy. (Courtesy of the Brown-Pusey House.)

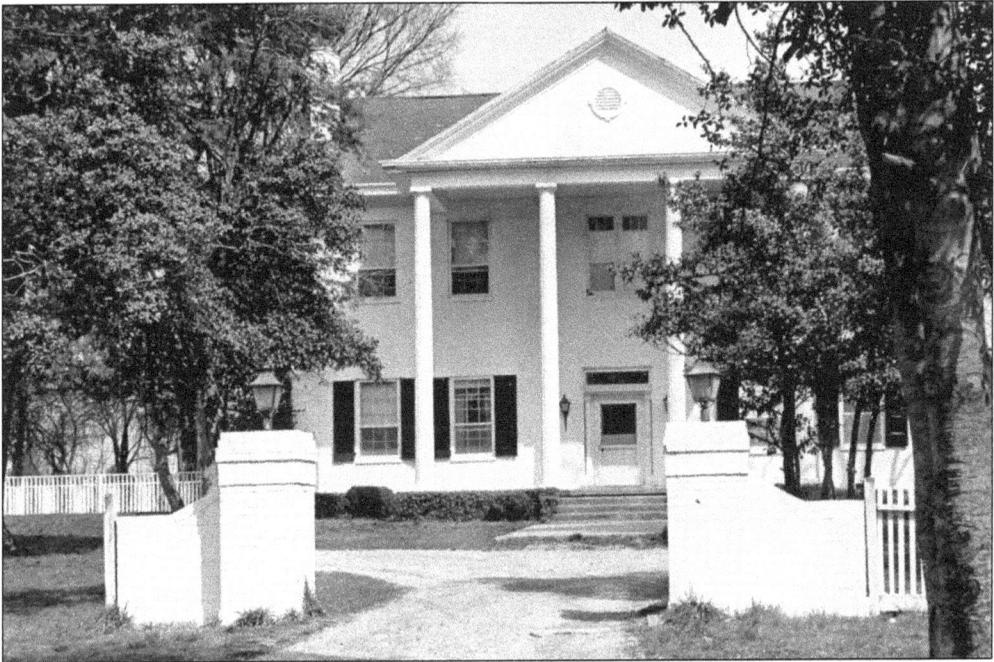

The Helm Place had been restored at least twice by 1940, when this picture was taken. The Helm House, originally constructed from 1832 to 1840, still stands on a hill on the site of the original Thomas Helm fort and homestead. The second owner, Kentucky governor John Larue Helm, resided here from 1867 to 1902. (Courtesy of the Brown-Pusey House.)

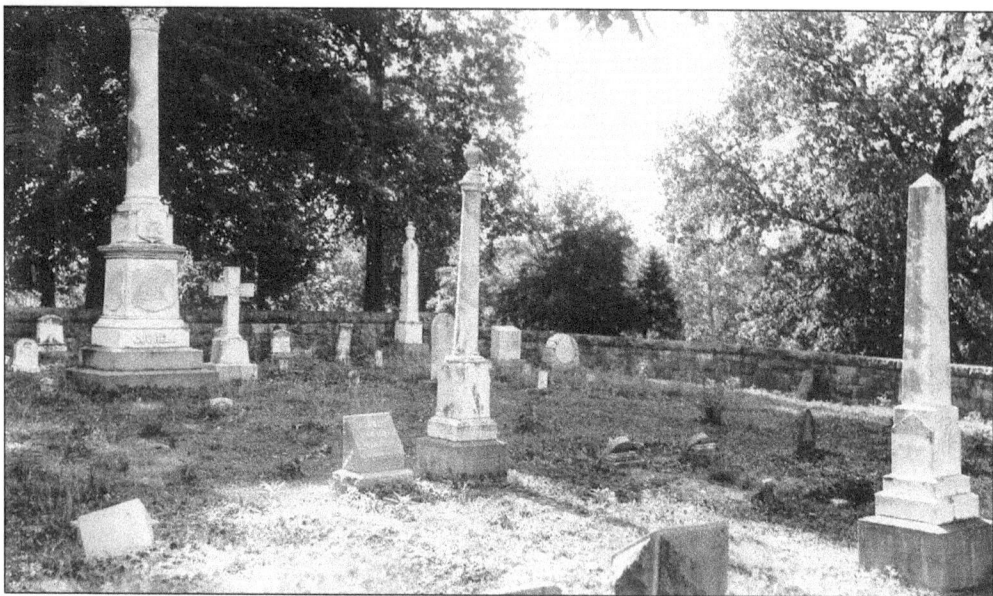

This 1930s photo shows the Helm Cemetery, located on West Dixie. Kentucky governor John L. Helm is buried here. Gen. Ben Hardin Helm's grave—the tombstone nearly covered by the earth—is buried in front Governor Helm. The Helm Cemetery is currently maintained by the Sons of Confederate Veterans and the Hardin County Historical Society. (Courtesy of the Brown-Pusey House.)

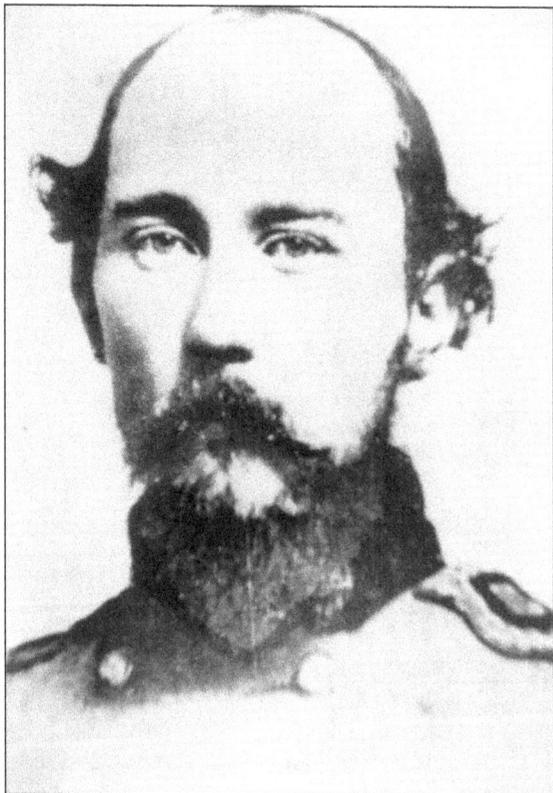

Brig. Gen. Benjamin Hardin Helm was born in Elizabethtown in 1831. He was a brother-in-law of President Lincoln, having married Emily Todd, a sister of Mary Todd Lincoln. Helm served as a Confederate general at the battle of Chickamauga, where he fell on September 20, 1863. He was so well loved by his soldiers that they adopted the name Orphan Brigade at his death. His wooden grave marker is located in the Brown-Pusey House. (Courtesy of the Brown-Pusey House.)

The Helm Mansion was restored in 1912. It was located in the community of Claysville, which was never incorporated into a town. The Civilian Conservation Corps was located in Claysville during the Great Depression. Slowly, Claysville became a part of Elizabethtown. Hardin Memorial Hospital is located in the old Claysville area. West Dixie Avenue becomes North Dixie Avenue at the intersection of St. John Road and Dixie Highway. (Courtesy of the Brown-Pusey House.)

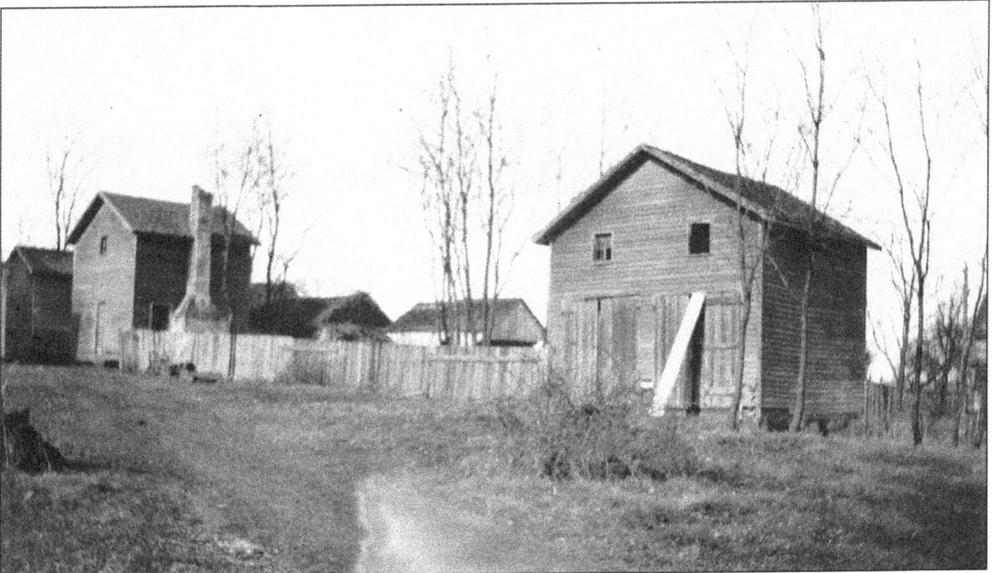

This photo shows the slave quarters at Helm Mansion. Emilie Todd Helm, half-sister of Mary Todd Lincoln, the wife of President Abraham Lincoln, visited the Helm Mansion. Emilie Todd Helm's husband was the Confederate general Ben Hardin Helm, the oldest son of Union supporter and Kentucky governor John C. Helm. The division of beliefs affected the Helm and Lincoln families tremendously. (Courtesy of the Brown-Pusey House.)

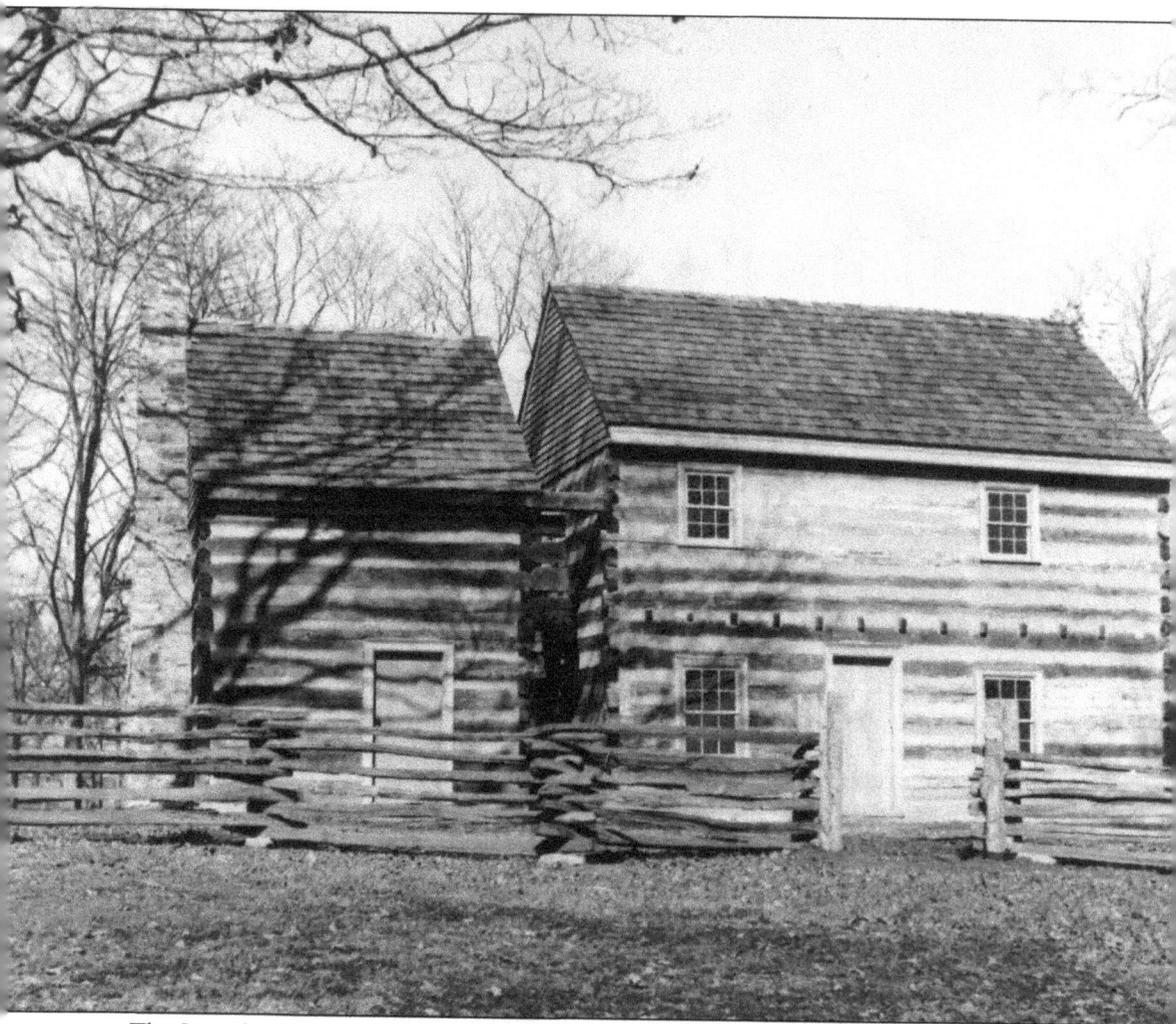

The Lincoln Heritage House is located in the Freeman Lake City Park. It was restored and opened to the public on June 24, 1973. The home of pioneer Hardin Thomas and his family was built between 1789 and 1805 by Thomas Lincoln, father of President Abraham Lincoln. Many creeks and lakes have been preserved and maintained by Greenspace over the past 30 years. Walking trails and park areas can be visited year-round. (Courtesy of the Brown-Pusey House.)

Four

BROWN-PUSEY HOUSE

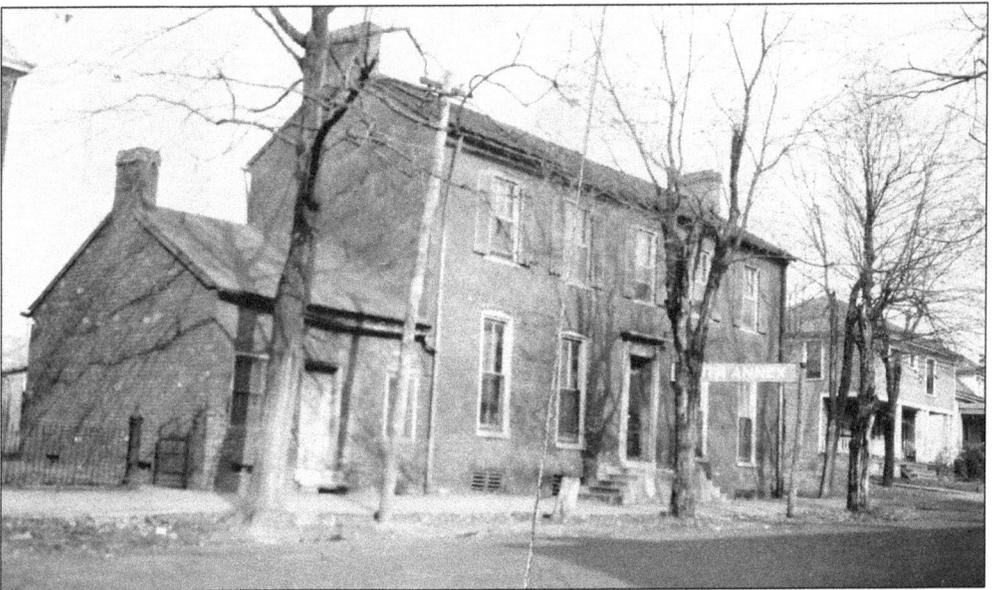

The Smith Hotel annex operated until 1922. This building was originally the Hill House, then the McCans House and the Smith Hotel annex, before becoming the Brown-Pusey House. The house on the right is the Jonathan Hills house, originally a log cabin. (Courtesy of the Brown-Pusey House.)

This 1923 photo of the Brown-Pusey House, center, shows Sallie Cunningham Pusey and two unidentified ladies. Adjacent to this building is 122 North Main Street, once a funeral home and the public library. At far left is the Hardin County Jail, today the Elizabethtown City Parking Lot. At right is the Embry Chapel (A.M.E.) Church. The Brown-Pusey House was originally the residence of John Y. Hill and Rebecca Davis Stone Hill. John Y. Hill was a tailor, a cattle herder, a bricklayer, and a hotelkeeper. Hill acquired 4,000 acres in Livingston County, Kentucky, for the Hardin Academy in the 1820s. He built the Severns Valley Baptist Church

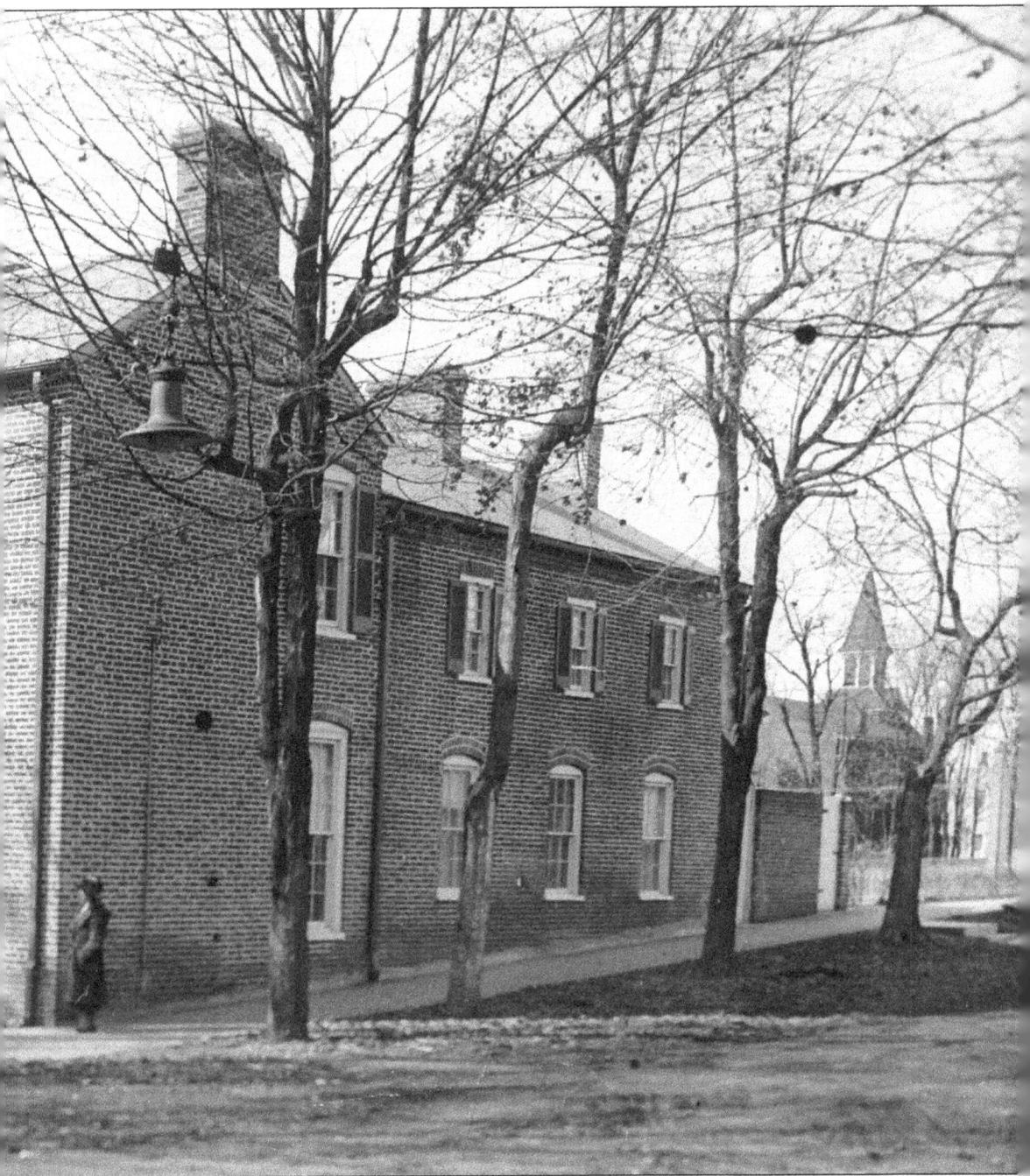

in 1834, as well as a quarter of the pre-1855 brick buildings in town. He turned his residence into a boarding house in the late 1840s. He died in 1855 and is buried in the Elizabethtown City Cemetery. "Aunt Beck" Hill continued to operate the Hill House until she died in 1882. The Hill House continued as a boarding house until the Pusey brothers bought it in 1922. Chicago architect Lincoln N. Hall restored the house. The building and the garden have hosted many weddings and receptions. In 1974, this historic house was placed on the National Register of Historic Places. (Courtesy of the Brown-Pusey House.)

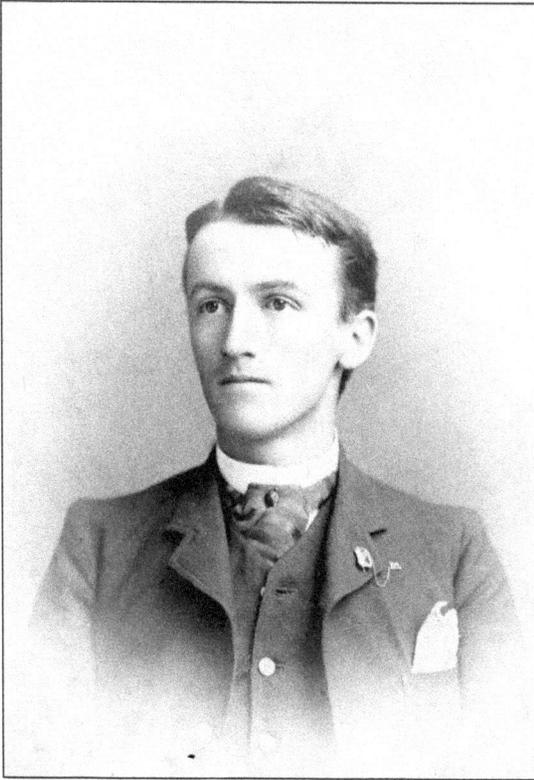

William Allen Pusey is pictured at the age of 19 while attending Vanderbilt University. (Courtesy of the Brown-Pusey House.)

The double doors to the Brown-Pusey House open on the Ball Room. Prior to 1922, this room had been a closed-in porch. The rear view of the Brown-Pusey House has a wooden pergola to the right and the watering well at the end of the garden. The pergola was later rebuilt with brick. The Hardin County clerk and circuit clerk's office is across the street. The building at right is the North Main Association. (Courtesy of the Brown-Pusey House.)

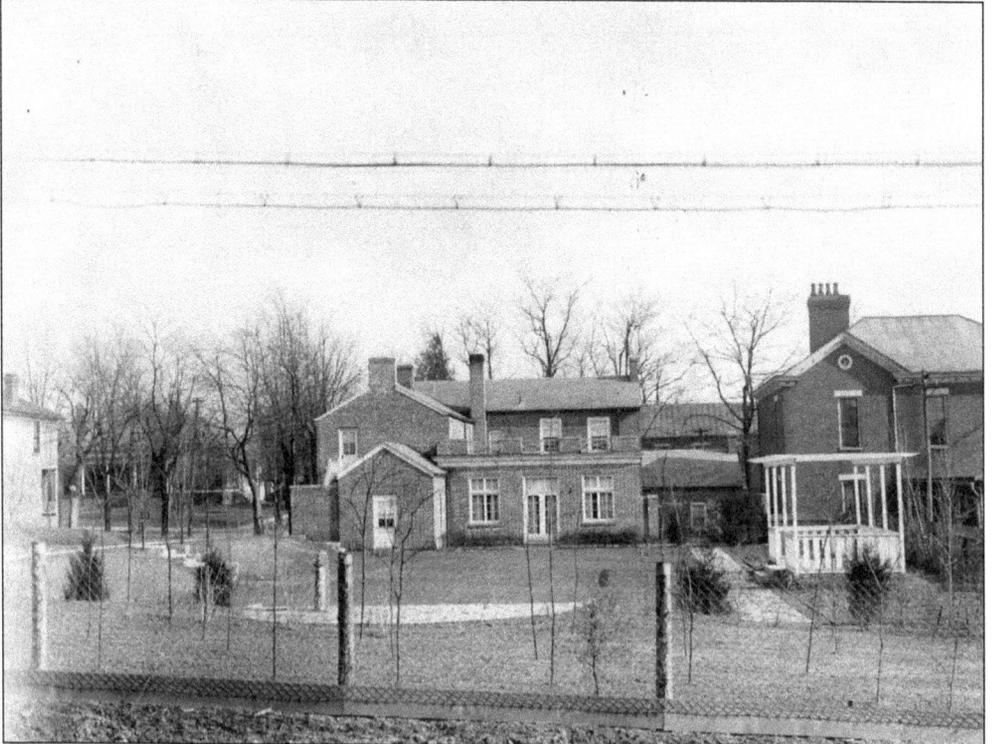

Dr. Alfred Brown Pusey, born in 1869 and died in 1953, was a surgeon in the military about 1896. He was an assistant surgeon in the United States Navy from 1893 to 1896. It has been said he made a fortune in Eversharp Pencils. (Courtesy of Brown-Pusey House.)

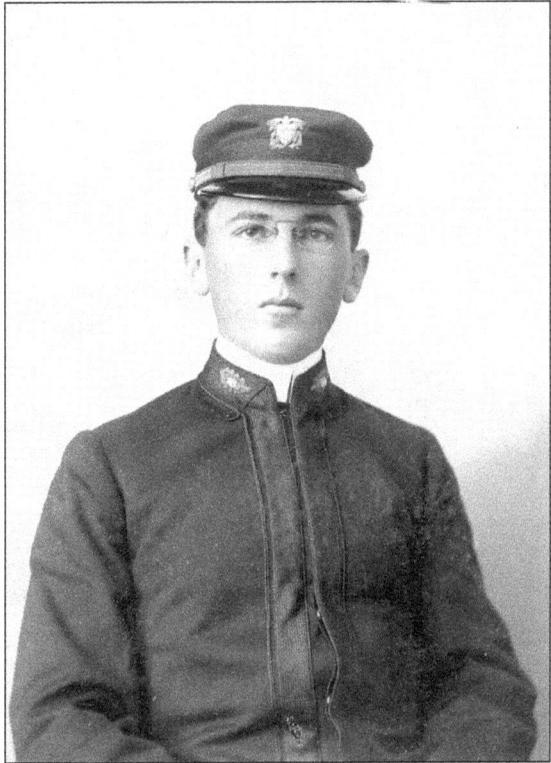

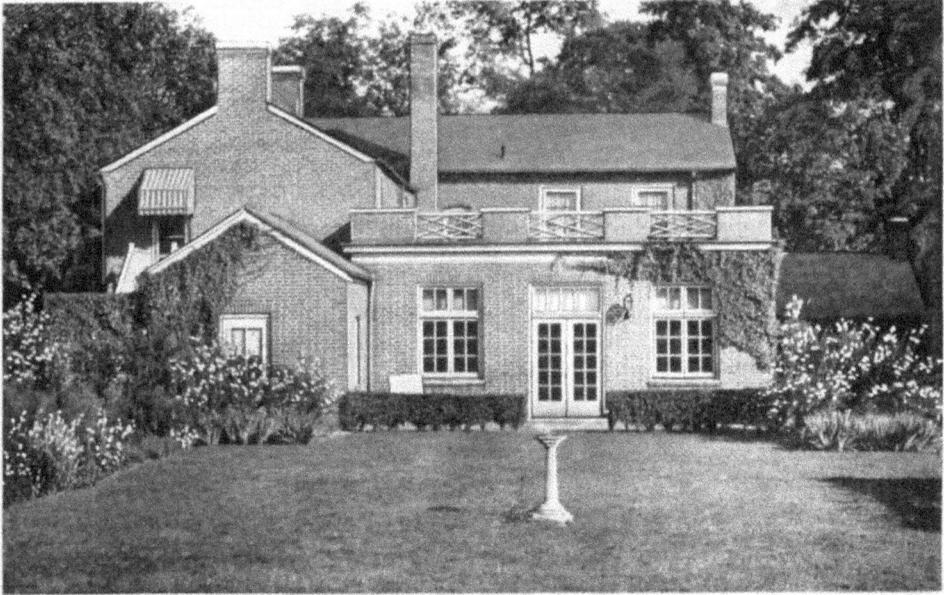

Garden and Rear View, Brown-Pusey Community House, Elizabethtown, Ky.

This postcard is of the Cunningham Garden and the rear view of the Brown-Pusey House, sometime between 1923 and 1930. The Cunningham Garden was landscaped by Chance Hill. This was probably the smallest project Chance Hill ever accomplished. (Courtesy of Meranda Caswell.)

Sallie C. Pusey is in front of the Brown-Pusey House about 1923. A city directory stated in 1922, "Kentucky Hospitality is exemplified at the Community Center. This House was established and is maintained for the entertainment of every guest who visits our city. Introduce yourself." This still holds true today. (Courtesy of the Brown-Pusey House.)

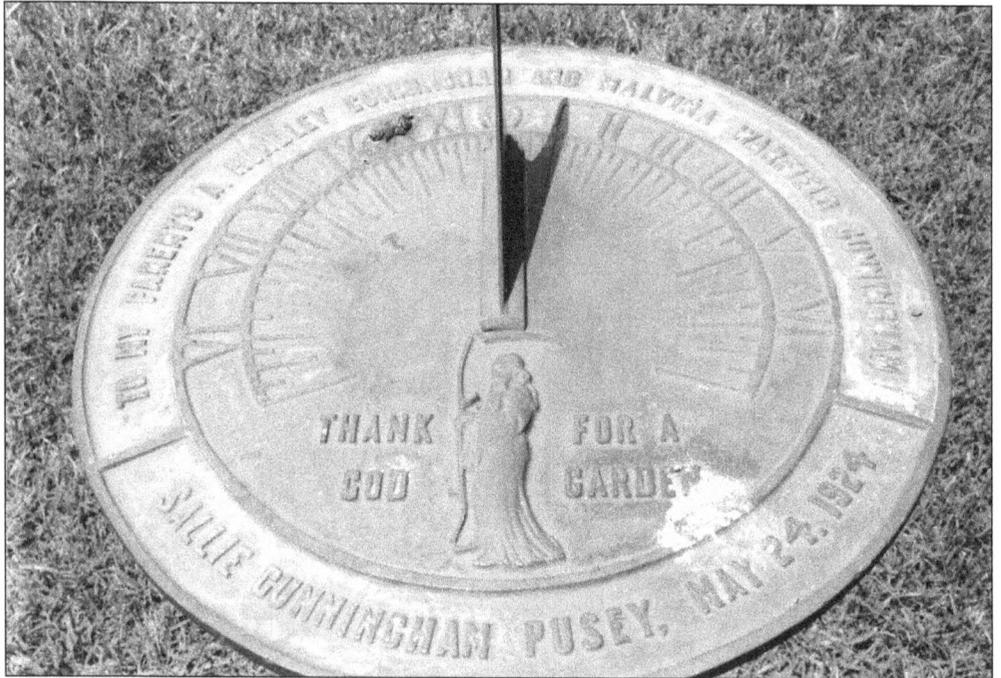

The sundial is located in the center of the Cunningham Garden of the Brown-Pusey House. The garden was dedicated "To my parents A. Hundley Cunningham and Malvina Warfield Cunningham. By Sallie Cunningham Pusey, May 24, 1924." This photo was taken at 1:00. (Courtesy of the Brown-Pusey House.)

Pictured in the Brown-Pusey House garden in the fall of 1941 are, from left to right, Lena Johnson, Richard Wathen, and Sallie C. Pusey. (Courtesy of the Brown-Pusey House.)

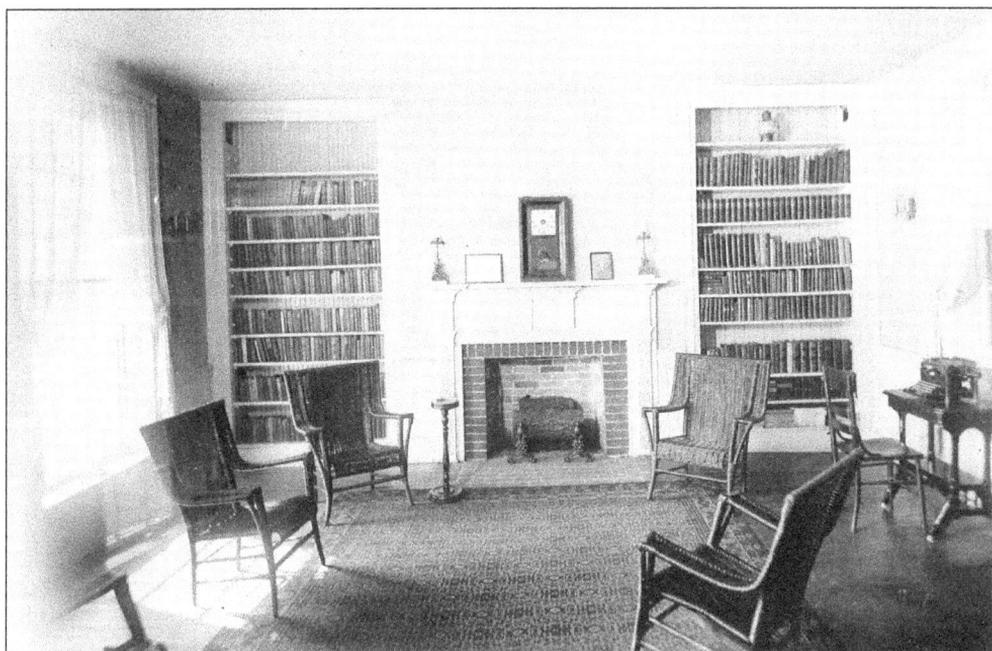

This photo is an interior view of the library at the Brown-Pusey House prior to 1936. The fireplace was removed in 1936. Today this room is the genealogy library. (Courtesy of the Brown-Pusey House.)

This is the rear of the Brown-Pusey House showing the Cunningham Garden. The garden was restored in 1992. During the 1800s, the stables of the Hill House were here. The Garden Club of Elizabethtown maintains the Cunningham Garden today. (Courtesy of the Brown-Pusey House.)

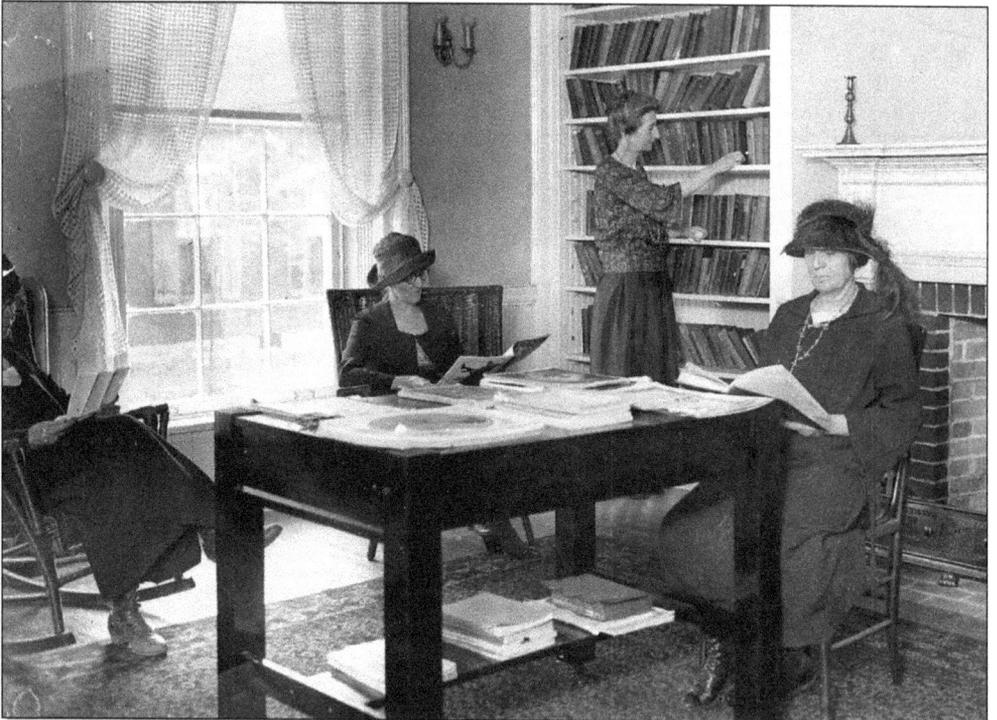

The first free public library was located at the Brown-Pusey House from 1923 to 1959. Standing is librarian Lena Johnson. Sitting in the rocker is Sallie C. Pusey. Lucy Robertson and Lillie C. Goldnamer are sitting at the table. The fireplace was removed in 1936, and a doorway was installed to enter the shop. The mantle and the chimney remain intact. The Hardin County clerk's office can be seen through the window. (Courtesy of the Brown-Pusey House.)

Rebecca Davis Stone Hill, also known as "Aunt Beck," was the sole proprietor of the Hill House from 1855 to 1882. Her husband, John Y. Hill, built the Hill House about 1825. Aunt Beck was born and reared in Nelson County, Kentucky, and married Hill about 1827. The Hills had no children together, but Aunt Beck reared her stepson, James Hill, after John Y. Hill's death. Aunt Beck's great-nephews, William A. Pusey and Alfred Brown Pusey, remembered eating and playing at the Hill House and Aunt Beck's character. (Courtesy of the Brown-Pusey House.)

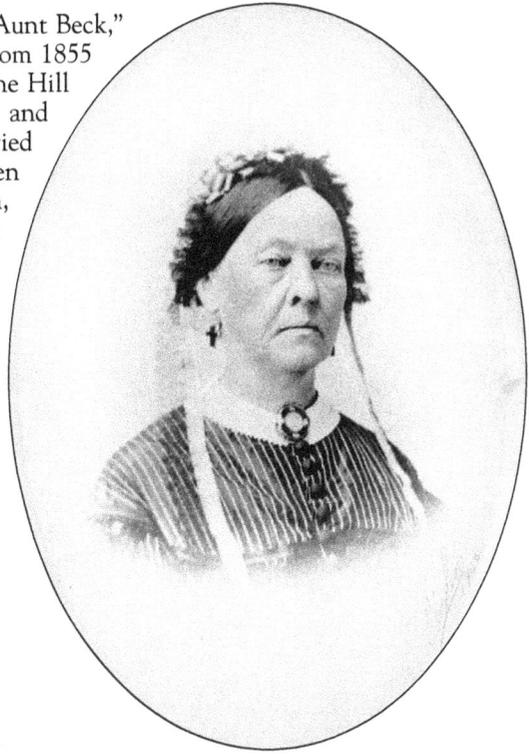

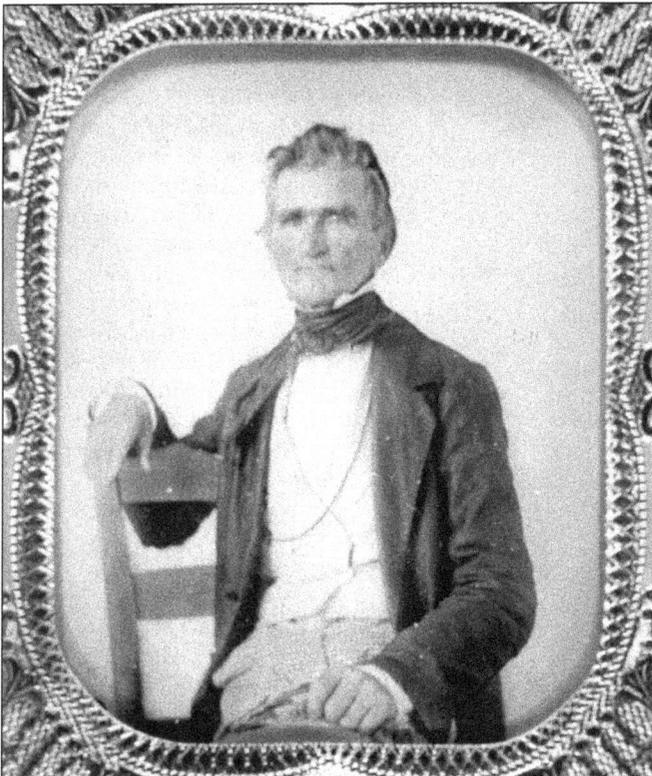

John Y. Hill arrived in Elizabethtown about 1818 with his wife, Eliza. Eliza Hill (born 1803) died in 1826 soon after the birth of her son, James Hill. Their daughter died in Ohio between 1820 and 1825. John Y. Hill had many occupations: he was a tailor from about 1818 to the 1830s, carried on a brick business from about 1825 to the late 1840s, and began a hotel in the 1840s. He was also on the House of Representatives of Kentucky. He built the Hill House about 1825 and married Rebecca Davis Stone after 1826. He died in 1859.

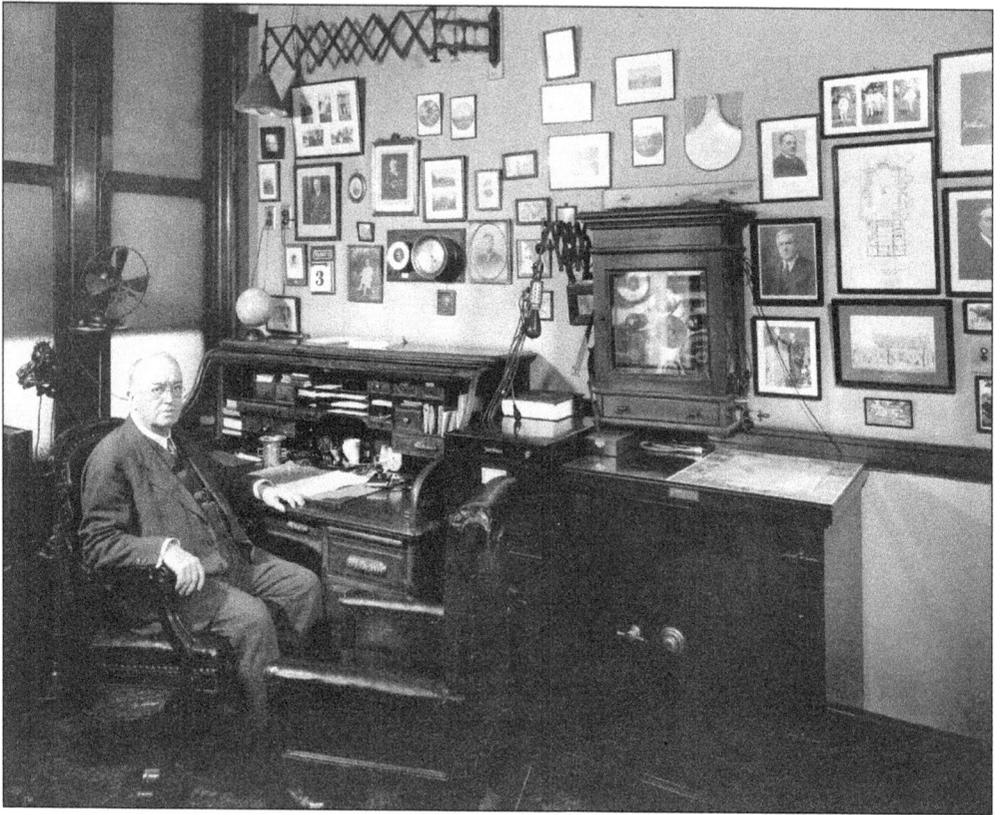

Dr. William Allen Pusey sits in his dermatology office in Chicago. The desk came from his father. This scene has been recreated in the Pusey Room Museum, the former shop of the Brown-Pusey House. The room has interior concrete walls, ceiling, and floors, fireproof glass windows, and metal doors. Pusey family memorabilia is located in this room, along with local Civil War artifacts, an original photograph of Gen. George Armstrong Custer, and local historical archives. (Courtesy of the Brown-Pusey House.)

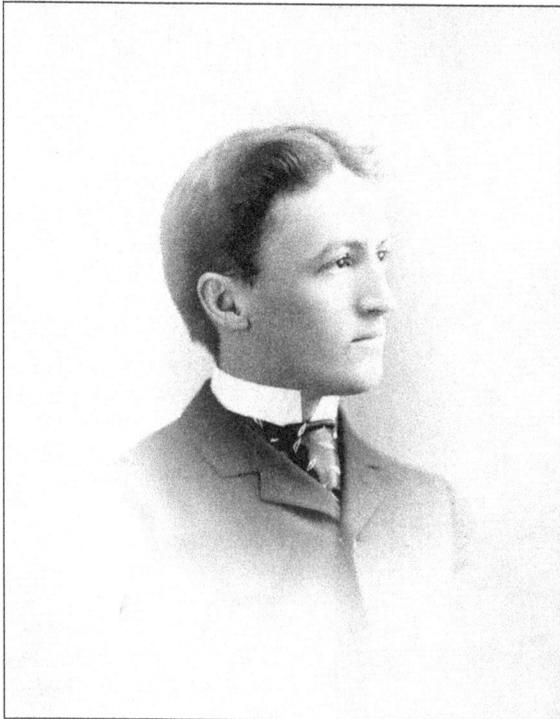

William Allen Pusey is pictured about 1888 or 1889. His father died in 1889, and William Allen Pusey served as a doctor in Elizabethtown for one year. (Courtesy of the Brown-Pusey House.)

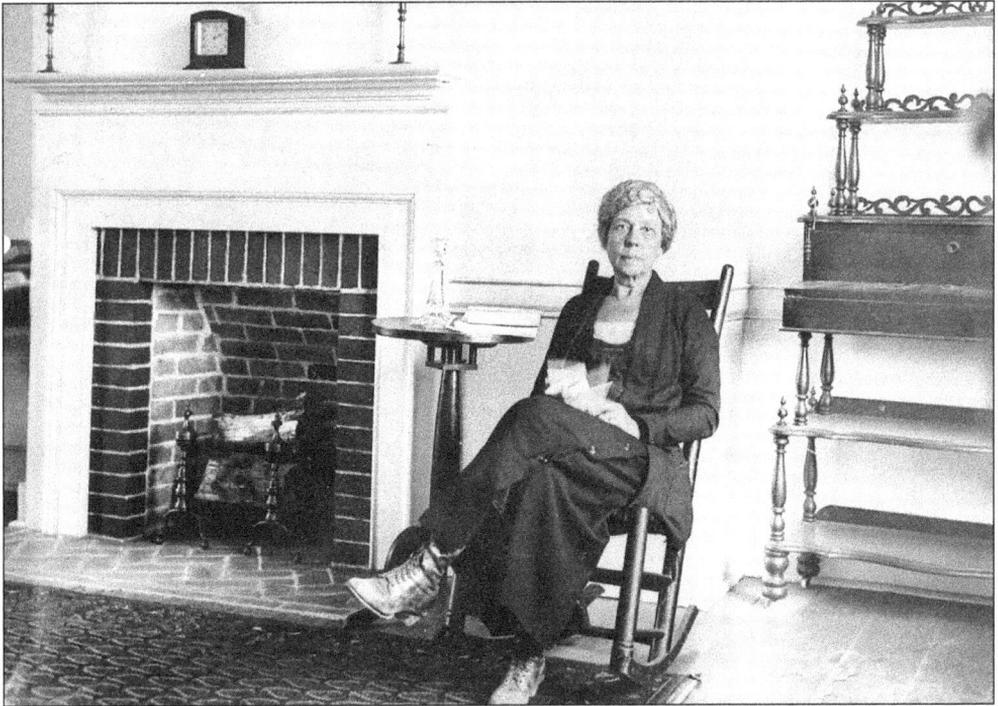

Sallie Cunningham Pusey is sitting in a rocker in 1923 in the Pusey Room Museum. This room of the Brown-Pusey House was renovated and turned into a museum in 1936. The candlestick table was original to the Hill House. The étagère belonged to the Pusey family in the 1800s. (Courtesy of the Brown-Pusey House.)

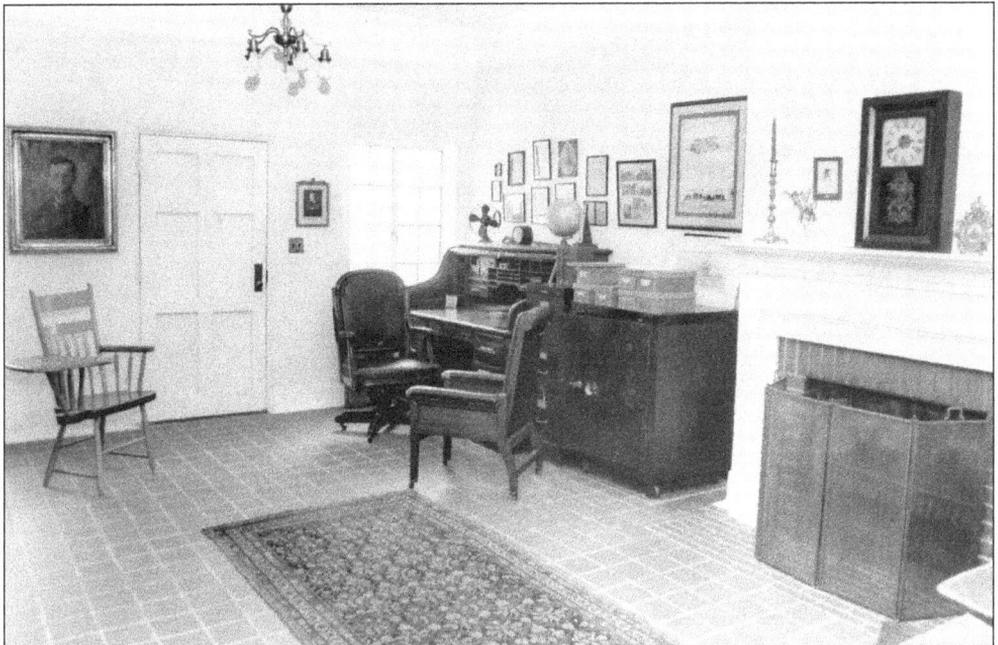

This photo is of the Pusey Room Museum of the Brown-Pusey House in the 1990s. This room has been opened to the public for free tours since 1999. (Courtesy of the Brown-Pusey House.)

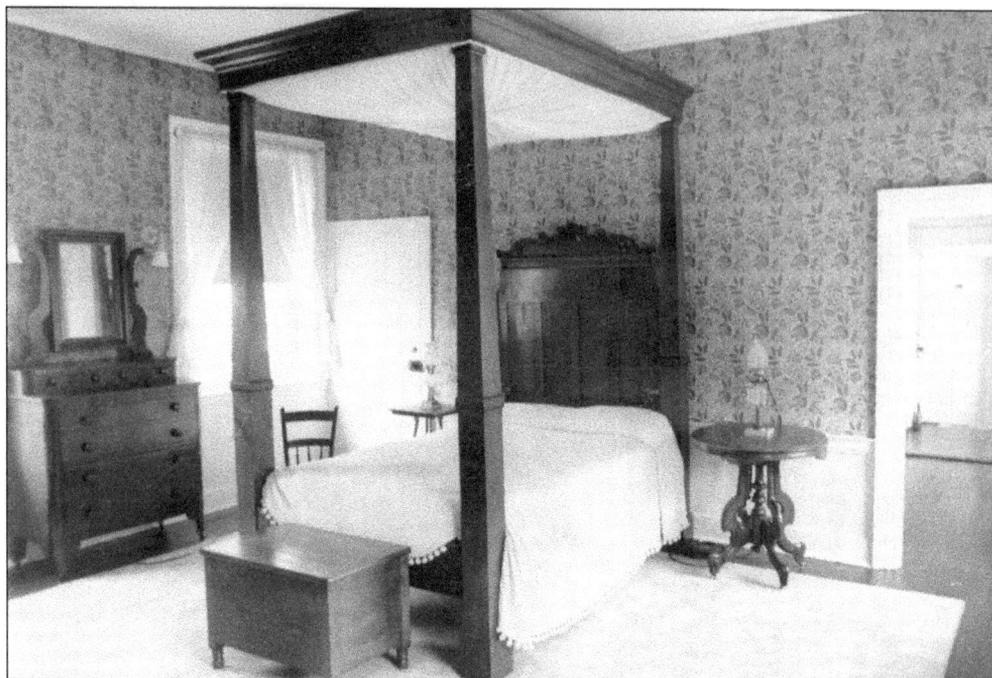

The Bride's Room is located upstairs in the Brown-Pusey House. Many weddings and receptions are held in the garden and the house. Usually, the bride and the bridesmaids dress in this dressing room. All of the furniture in the Brown-Pusey House is from the 1800s. (Courtesy of the Brown-Pusey House.)

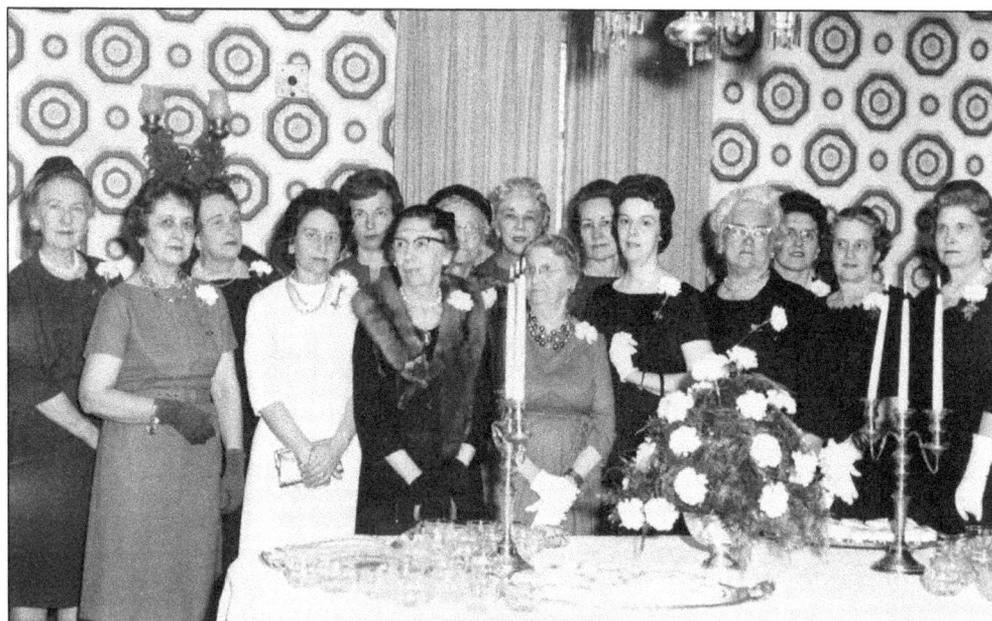

Elizabethtown Woman's Club organized about 1904. In 1923, the Brown-Pusey House offered the Elizabethtown Woman's Club a home. Today this organization still meets at the Brown-Pusey House. The ladies are standing in the dining room of the Brown-Pusey House in the 1950s. (Courtesy of Elizabethtown Woman's Club.)

64

Alfred Brown Pusey, pictured here in 1898, served in the navy. His sword is on display at the Brown-Pusey House. (Courtesy of the Brown-Pusey House.)

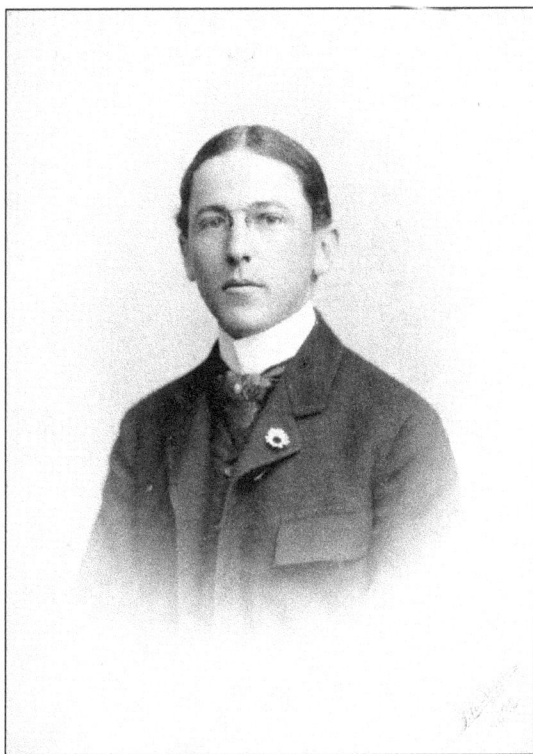

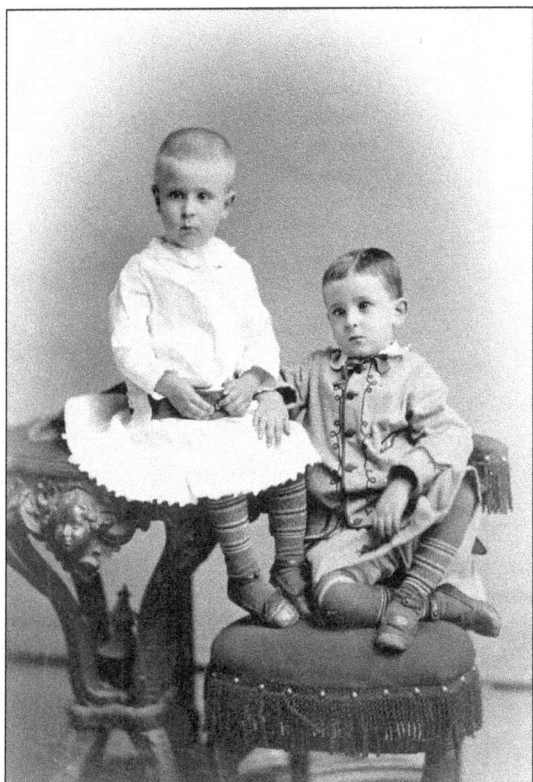

Pictured in July 1880 are Thomas Horace Hastings Jr., born July 15, 1876, and Alfred Brown Hastings, born October 5, 1877. Not pictured is Hill Hastings. Their mother, Edith Brown Hastings, died in 1877 at an early age, and their aunt Bell Brown Pusey became their foster mother. The three Hastings children were first cousins to William Allen Pusey and Alfred Brown Pusey. Their father was Thomas Horace Hastings, who died in 1914. (Courtesy of the Brown-Pusey House.)

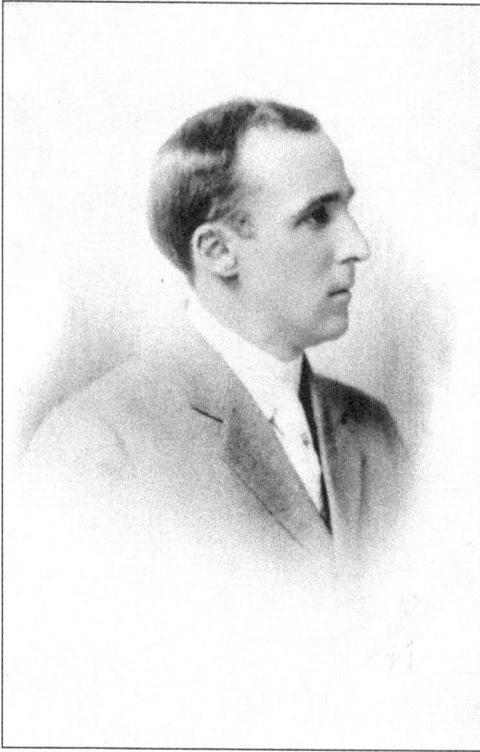

Dr. Hill Hastings was a contributor and supporter of the Brown-Pusey House. The Ball Room of the Brown-Pusey House was dedicated to his mother, Edith Brown Hastings, and his foster mother and aunt, Bell Brown Pusey, in 1923. (Courtesy of the Brown-Pusey House.)

Thomas Horace Hastings was a child of Edith Brown Hastings. Thomas Horace Hastings, Hill Hastings, and Alfred Brown Hastings were reared by their aunt, Bell Brown Pusey, and their uncle, Robert Burns Pusey, in the Pusey home on North Mulberry Street. (Courtesy of the Brown-Pusey House.)

This 1883 photo of Dr. Robert Burns Pusey inspired the chalk portrait hanging in the genealogy library of the Brown-Pusey House. Dr. Pusey was born in Meade County, Kentucky, one of 11 children of Joel Pusey and Ann Roup. He earned his degree in 1860 and served as a physician during the Civil War. He continued his career in Elizabethtown. In 1876, he and Dr. Frank Strickler built an office that still stands across from the Hardin County Justice Center. Dr. Pusey died in 1889. (Courtesy of the Brown-Pusey House.)

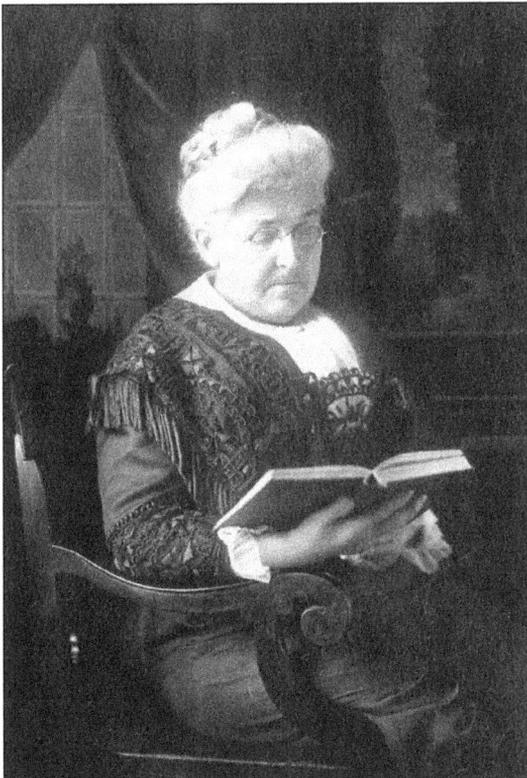

This portrait of Bell Brown Pusey, age 70, hangs in the Brown-Pusey House parlor room. She died in 1922, and her sons, Dr. William Allen Pusey and Dr. Alfred Brown Pusey, restored the Hill House as a memorial to her and the Pusey heritage. They named the building the Brown-Pusey House in honor of their parents, Bell Brown Pusey and Robert Burns Pusey. Bell Brown Pusey was also the foster mother to Alfred and Hill Hastings. Her sister, Edith Brown Hastings, died at an early age. (Courtesy of Brown-Pusey House.)

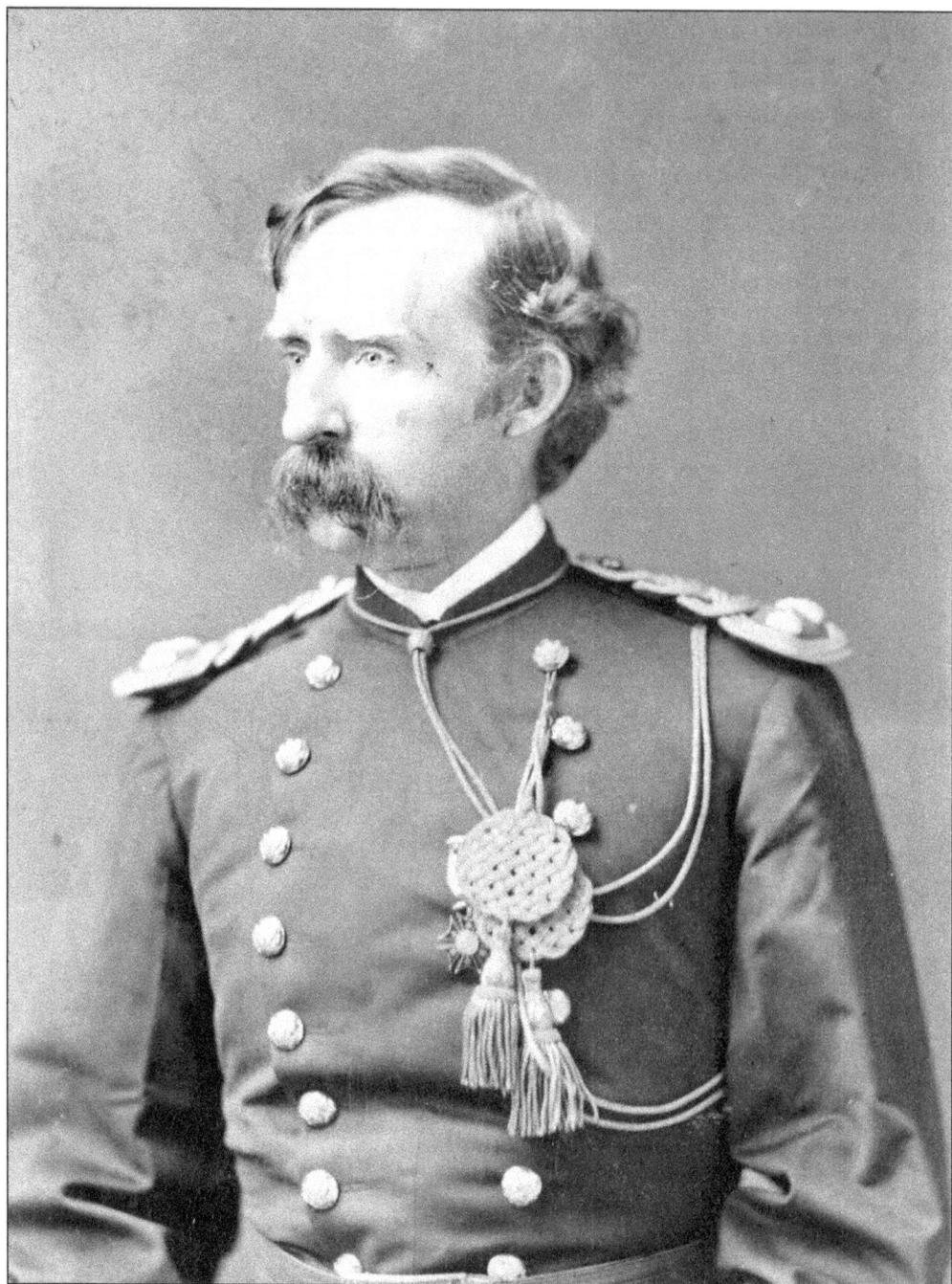

Gen. George Armstrong Custer was stationed with the 7th U.S. Cavalry in Elizabethtown from 1871 to 1873 to disband the Ku Klux Klan, the moonshiners, and the carpetbaggers. He and Elizabeth Custer, his wife, resided at the Hill House. While in Elizabethtown, General Custer wrote his autobiography and was entertained by the local people. General Custer showed his horses and hound dogs to the Russian Grand Duke Alexis in 1872, and they hunted and toured the West together. Elizabeth Custer autographed and mailed this photograph of General Custer to Aunt Beck Hill in October 1882. (Courtesy of the Brown-Pusey House.)

This is the site of an old stable used as a corral by General Custer during the stay of the 7th U.S. Cavalry. The stable, located on South Main Street, burned in April 1929. General Custer had many horses and hounds in Elizabethtown. In 1872, General Custer was a tour guide for the Russian Grand Duke Alexis. They traveled to Louisiana during the Mardi Gras season. The colors of Mardi Gras—purple, green, and gold—date from the grand duke's visit. (Courtesy of the Brown-Pusey House.)

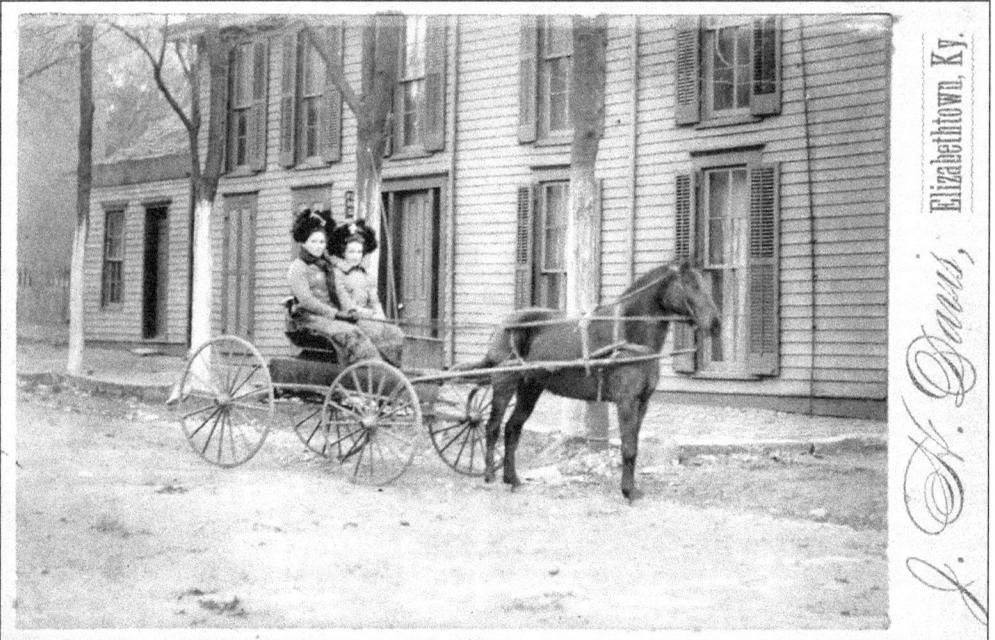

Thomas Lincoln and Sarah Bush Johnston married in the Samuel Patton house. This building was once the Marion Garage Building. Today, Bean Publishing Company occupies this lot. The ladies are unidentified. Two bricks from this building are on display at the Brown-Pusey House. Notice the photographer: J.H. Davis of Elizabethtown, Kentucky. (Courtesy of Mary Jo Jones.)

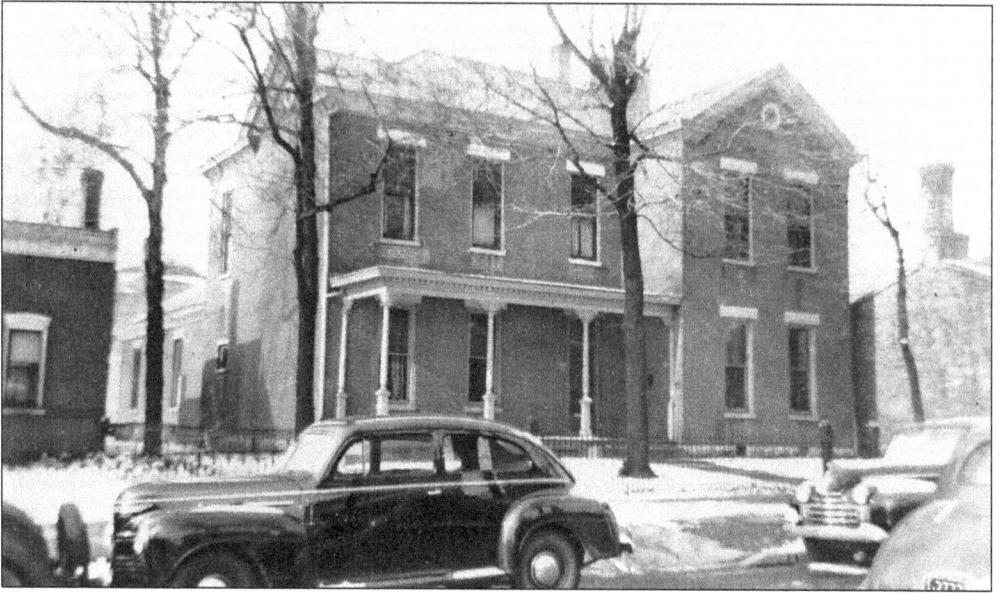

This photo shows 122 North Main Street. On the left is the Hardin County Jail. On the right is the Brown-Pusey House. The building at 122 North Main Street was built between 1896 and 1901. In 1896, Alex McCans bought the building. Alex McCans removed the "ell" from the Hill House and constructed the building presently located at 122 North Main Street. (Courtesy of the Brown-Pusey House.)

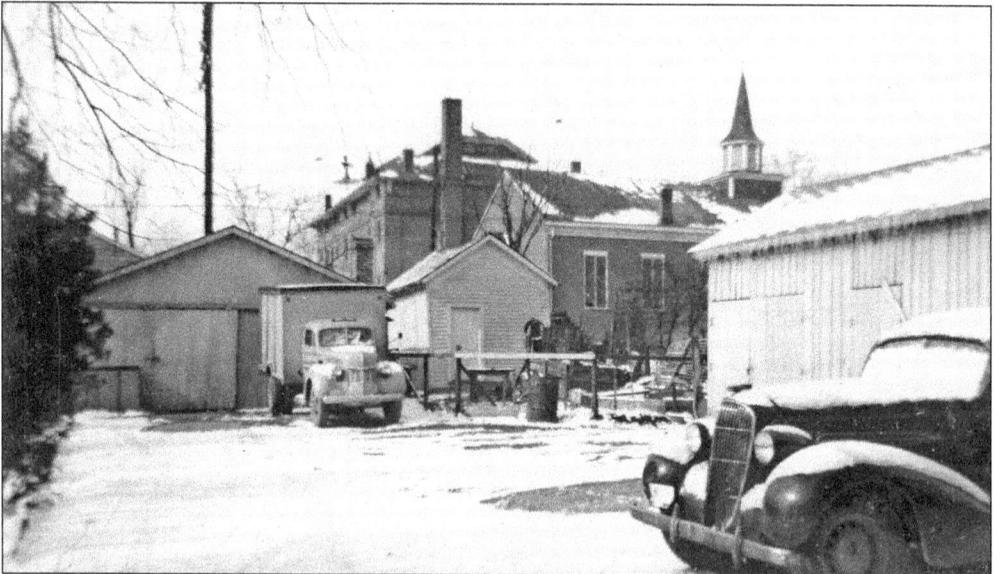

This photo shows the rear of 122 North Main Street. Today, most of this area is the City Parking Lot. Severns Valley Baptist Church and the Masonic Temple, seen in the rear of the photo, are still there. (Courtesy of the Brown-Pusey House.).

The Spriggs Residence was later turned into the office of the Hardin County clerk and Hardin circuit clerk. Dr. Robert Burns Pusey's office was in this building from 1860 to the late 1870s. The building was torn down in 1963. Today, this area is the parking lot of Bean Publishing Company. (Courtesy of the Brown-Pusey House.)

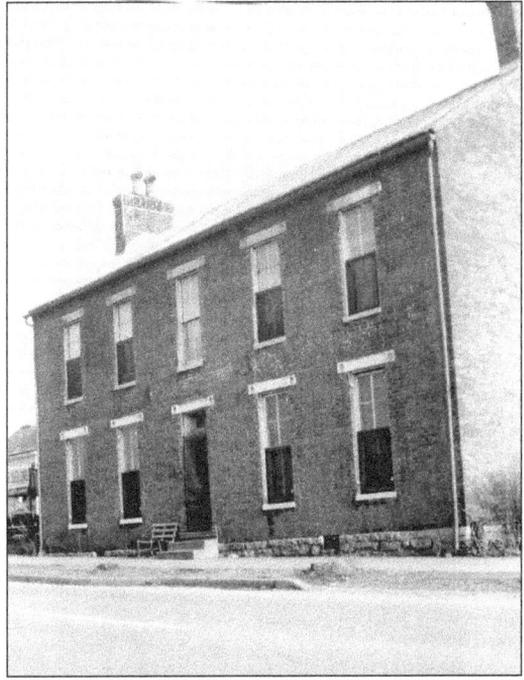

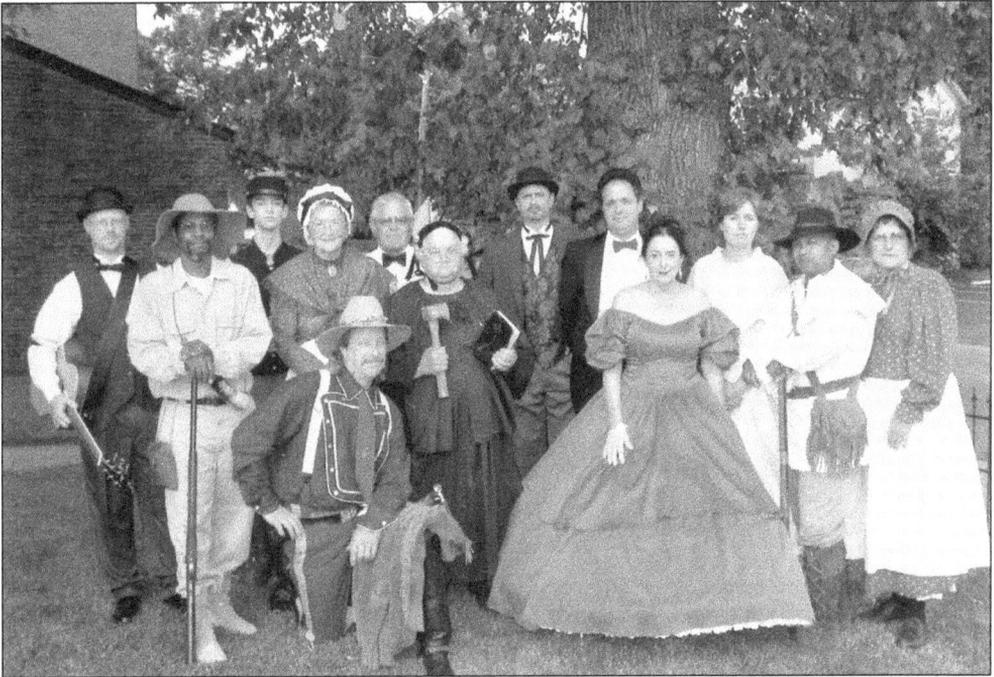

The Elizabethtown Historic Downtown Walking Tour has performed for almost two decades. The tour begins on the Public Square. General Custer is performed by Charles Skees; General Braddock is performed by Tony Bishop; Aunt Beck is performed by Julia Richardson; Carrie A. Nation is performed by Velma Sarver; Samuel Haycraft Jr. is performed by Tim Asher; P.T. Barnum is performed by Chris Shaw; and Sarah Bush Johnston Lincoln is performed by Deborah Shaw. (Courtesy of Edith Dupin.)

71

This Orphan Brigade Souvenir Program is dated September 24, 1914. The meetings of the Orphan Brigade began in 1882 at Blue Lick Springs. Prior to 1914, the brigade had met in Elizabethtown one other time in 1884. (Courtesy of the Brown-Pusey House.)

Shown here are the first two pages of the Orphan Brigade Souvenir Program from September 24, 1914. (Courtesy of the Brown-Pusey House.)

In March 1887, Mary Bell Stone Brown had this photo taken. She was the half-sister to Rebecca Davis Stone Hill. Mary Bell Stone Brown was born in 1820 and died in 1900. Two of her four children—Fannie and Willie Davis—died during the scarlet fever epidemic in 1859. (Courtesy of the Brown-Pusey House.)

In March 1887, Alfred Mackenzie Brown had his photo taken. Brown was born in 1811 and died in 1903. He worked in the retail business until 1857, when he was elected circuit clerk until 1862. His Southern sympathies during the Civil War landed him in a Federal prison in Louisville. He became one of the most successful lawyers in Elizabethtown. (Courtesy of the Brown-Pusey House.)

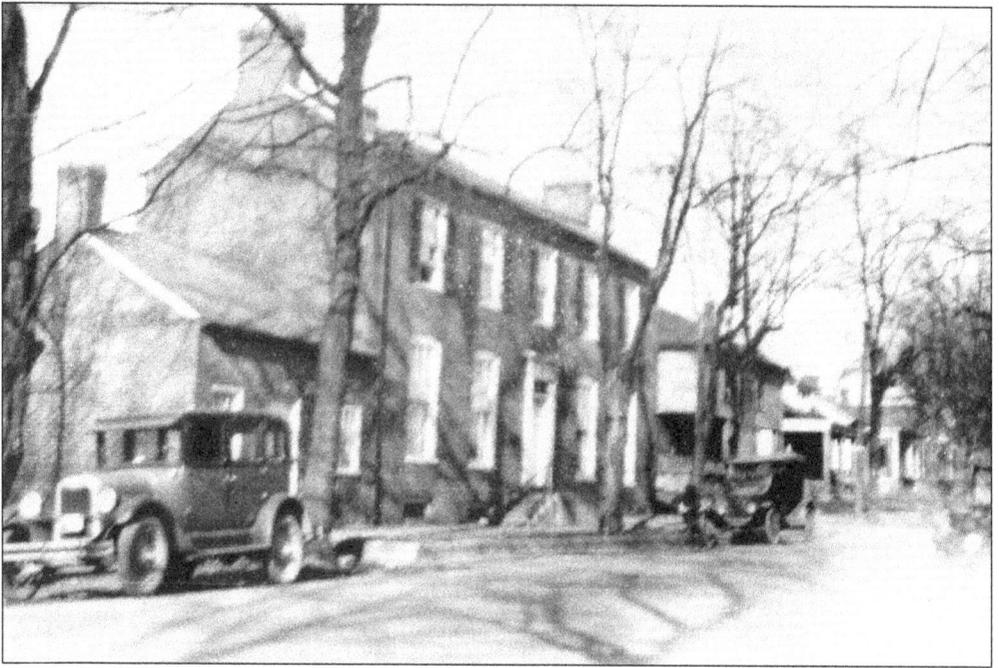

This is a view of some of the buildings on North Main Street. (Courtesy of the Brown-Pusey House.)

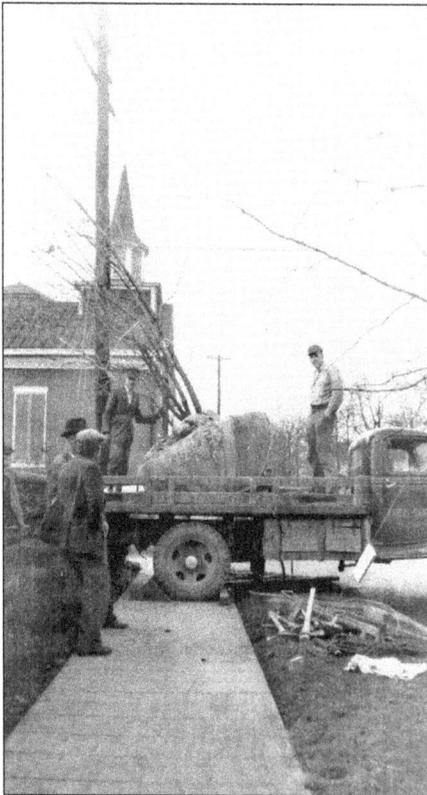

Here trees are planted in the 1920s and 1930s on Poplar Street for the Brown-Pusey House. President Franklin D. Roosevelt began the New Deal program during the Great Depression in the 1930s. The creation of the Civilian Conservation Corps was to protect and conserve the forests and natural resources. Sallie Pusey had created the Cunningham Garden in the 1920s. Then she bought dogwood trees in the 1930s to plant in and around the perimeter of the garden as well as along the streets of the Brown-Pusey House. (Courtesy of the Brown-Pusey House.)

Shown is a dogwood tree being planted in the garden of the Brown-Pusey House. One of the functions of the CCC was to plant trees. Sallie Pusey bought trees in the 1930s to commemorate forestry and the CCC. (Courtesy of the Brown-Pusey House.)

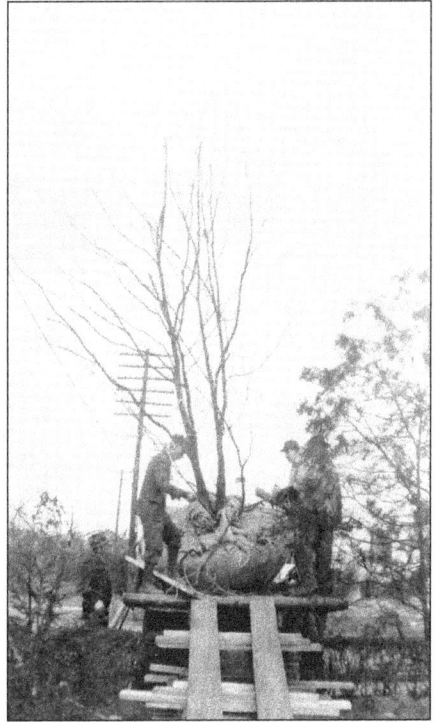

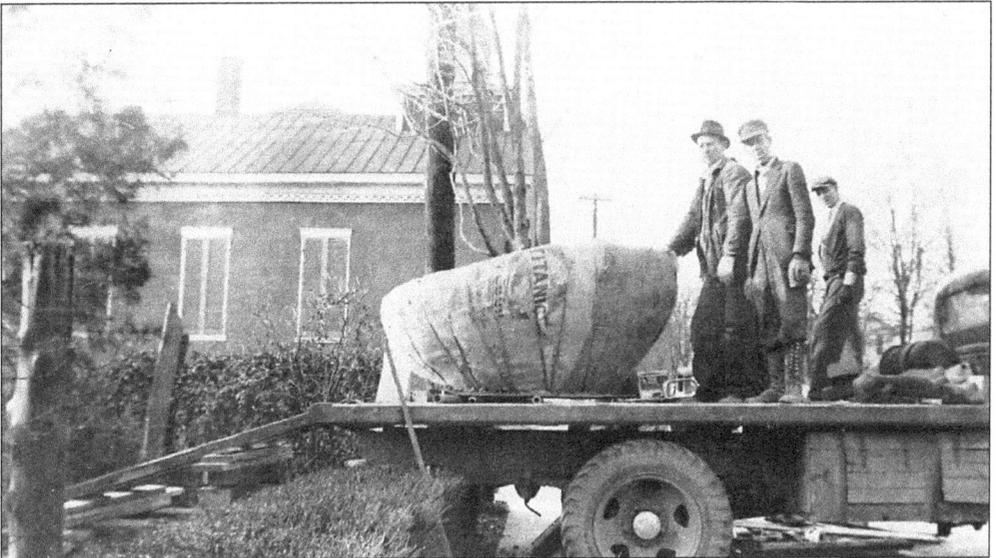

Trees are planted in the 1920s and 1930s on Poplar Street for the Brown-Pusey House. (Courtesy of the Brown-Pusey House.)

The rear of the Brown-Pusey House and the building at 122 North Main Street are seen here in 1926. The Puseys bought the Brown-Pusey House in 1922 and the adjacent building in 1929. The Hill House originally was U-shaped and encompassed both buildings. (Courtesy of the Brown-Pusey House.)

This view shows Severns Valley Baptist Church (built in 1834), the house at 204 North Mulberry (built c. 1878), and a house on Poplar Street. The house on the right was built c. 1830 by Jacob Warren Larue and was later known as the Horace Hays house. (Courtesy of the Brown-Pusey House.)

Five

MORE PLACES IN ELIZABETHTOWN

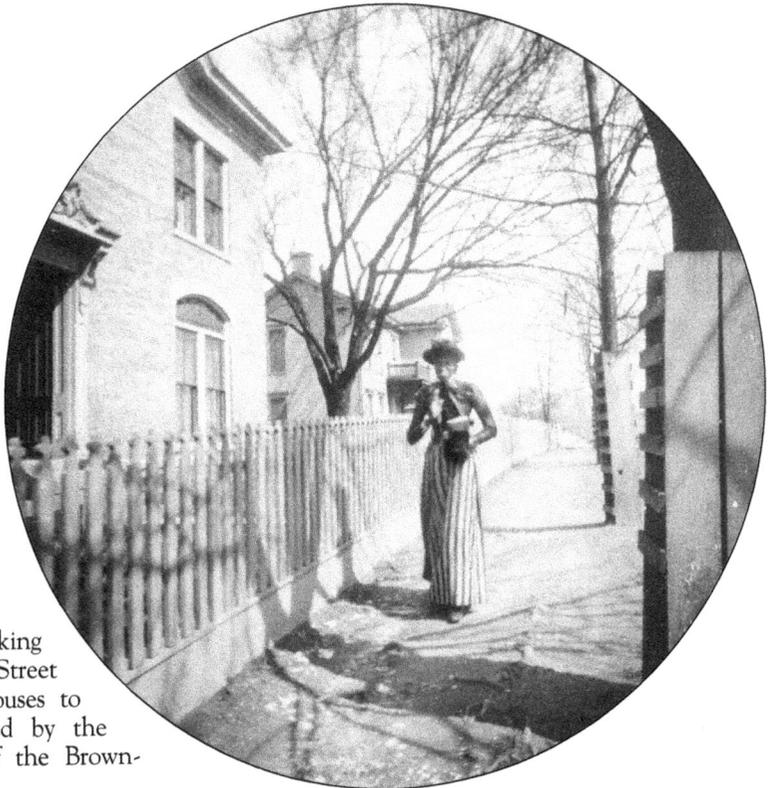

Notice the lady walking on North Mulberry Street about 1900. The houses to the left were owned by the Puseys. (Courtesy of the Brown-Pusey House.)

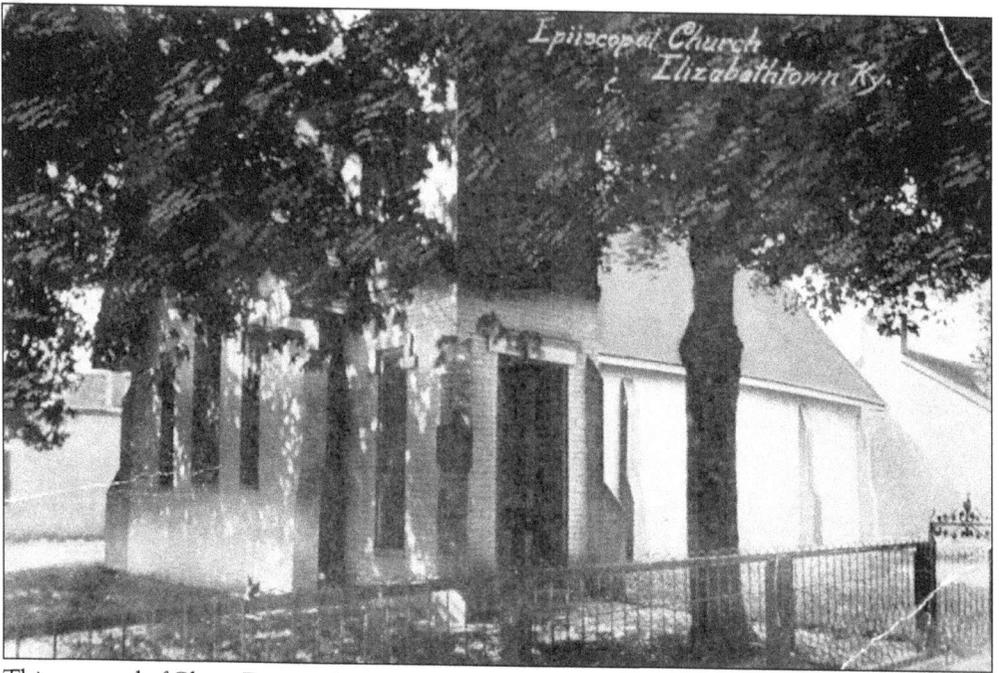

This postcard of Christ Episcopal Church is postmarked 1919. The land and most of the building costs were donated by Judge Armistead Henry Churchill about 1840. He owned a farm, which is the site of the world-famous Churchill Downs race course, the home of the Kentucky Derby. (Courtesy of Meranda Caswell.)

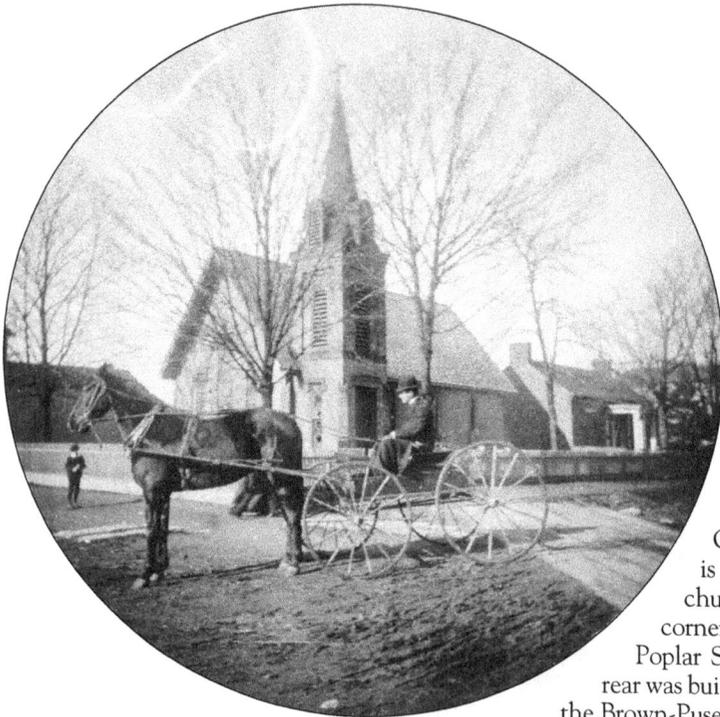

Christ Episcopal Church is shown about 1890. The church is located on the corner of North Mulberry and Poplar Streets. The rectory in the rear was built about 1890. (Courtesy of the Brown-Pusey House.)

This is the front of Christ Episcopal Church. The tower, with bell, was added about 1876. Bishop Smith was the first pastor in 1840. Confederate captain W.F. Bell was a member of this church until his death in 1887. (Courtesy of the Brown-Pusey House.)

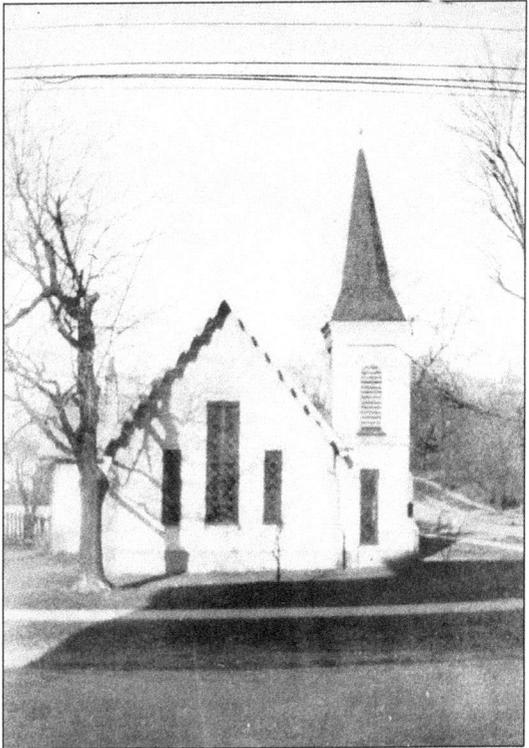

Certificate of Baptism.

IN THE NAME
OF THE FATHER
AND
OF THE SON
AND
OF THE HOLY GHOST.

Sally W.

BAPTIZED

Into the Church of Christ

December 29th In the year of our Redemption— 1867

PARENTS { Huntley Cunningham
Malvina P. do

SPONSORS { Julia Spurrier,
A.H. Churchill

Elizabethtown. Christ Church.

Diocese of Kentucky

Rev. John C. Tennent Rector.

Sallie W. Cunningham was born on December 29, 1867, and baptized at the Christ Episcopal Church of Elizabethtown. This baptismal record is the only actual baptismal record housed at the Brown-Pusey House. (Courtesy of the Brown-Pusey House.)

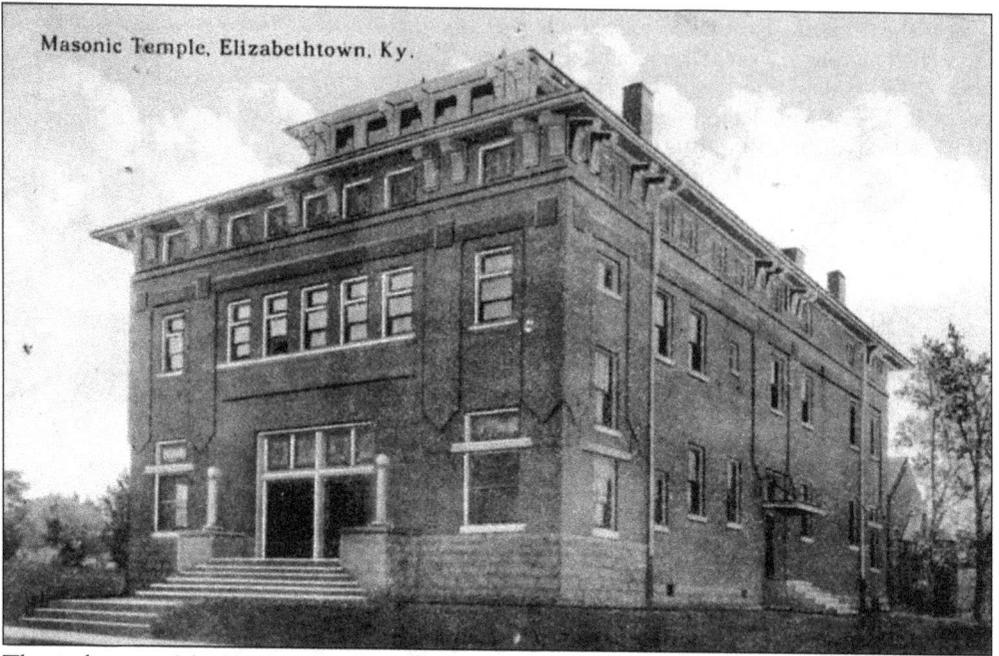

Masonic Temple, Elizabethtown, Ky.

This is the site of the Hardin Academy. The Hardin Academy was built by John Y. Hill in 1844, and it burnt about 1911. The Masonic Temple located on this site was built in 1913 for less than $15,000. (Courtesy of Meranda Caswell.)

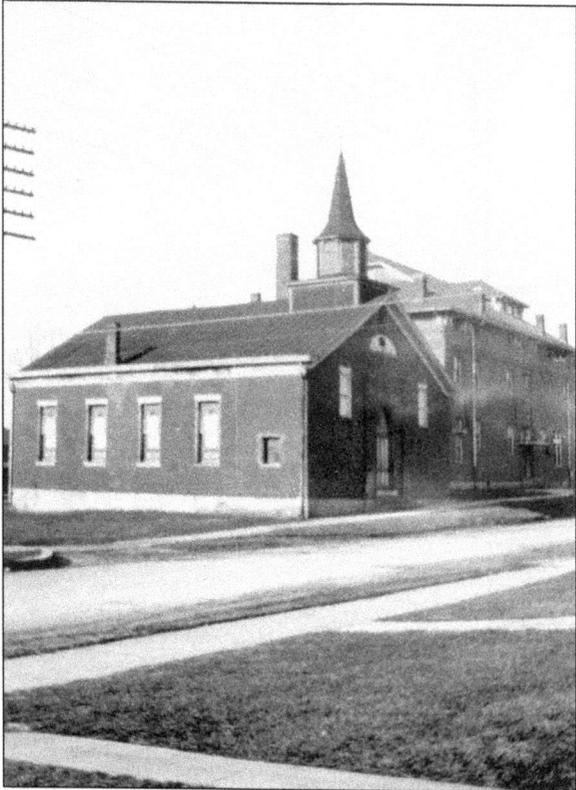

Severns Valley Baptist Church was first organized under a tree in Elizabethtown in the 1780s, close to Hynes Fort. The first brick Severns Valley Baptist Church was built by John Y. Hill in 1834 on Poplar Street. John Y. Hill built the Hardin Academy about 1844. The Masons used the upstairs for many years. Hardin Academy burnt about 1911 and was replaced by the Masons as the Masonic Temple in 1913. (Courtesy of the Brown-Pusey House.)

The Cunningham home, later Dr. Strickler's house, was on East Poplar Street. It was razed for Vertrees Court, a subdivision. (Courtesy of the Brown-Pusey House.)

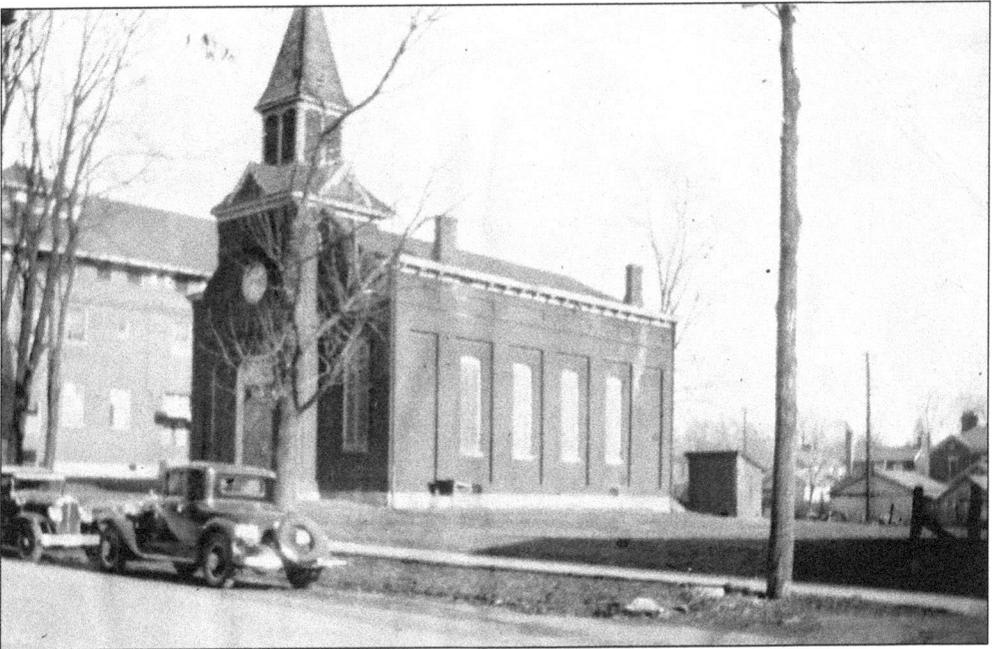

The Masonic Temple was adjacent to the Presbyterian Church. The Presbyterian Church was built in 1868. Aunt Beck Hill heavily contributed funds to have this building constructed for African Americans. From 1883, it was the Embry Chapel (A.M.E.) Church, located on Mulberry Street. (Courtesy of the Brown-Pusey House.)

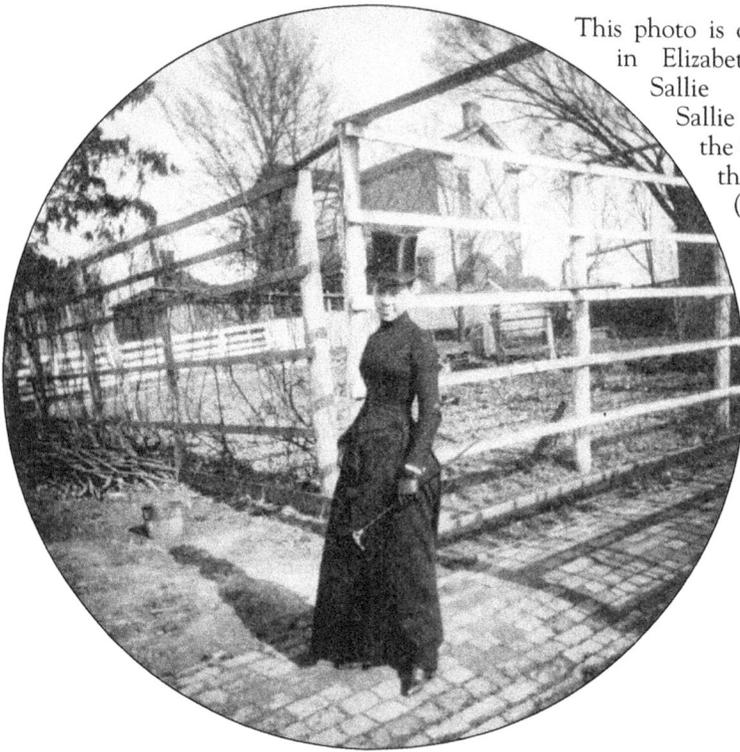

This photo is one of the Pusey farms in Elizabethtown. The lady is Sallie Cunningham Pusey. Sallie was responsible for the Cunningham Garden at the Brown-Pusey House. (Courtesy of the Brown-Pusey House.)

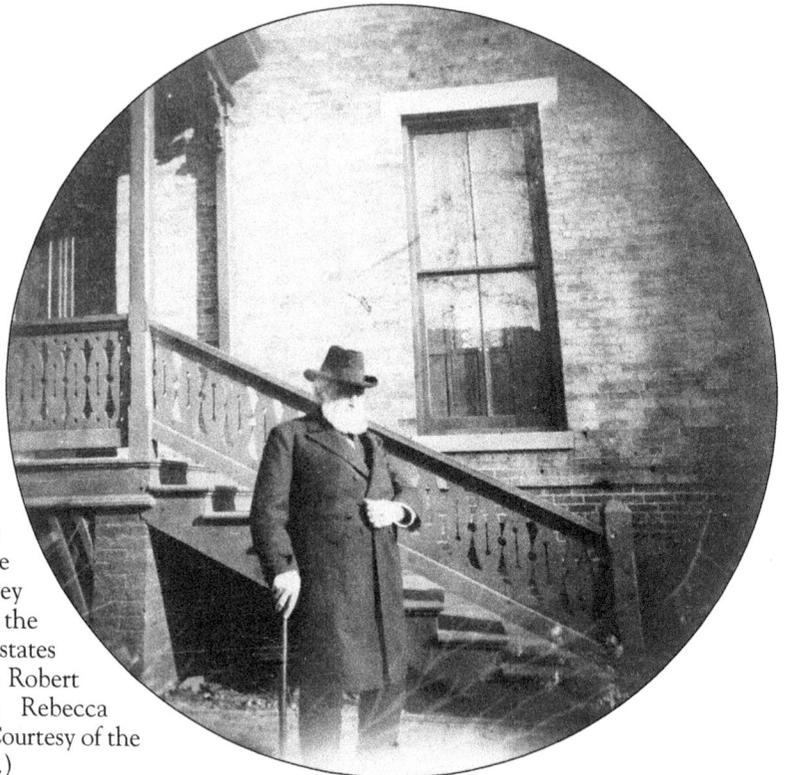

Attorney Alfred Mackenzie Brown is standing at the home of Bell Brown Pusey in 1901. Brown was the administrator of the estates of John Y. Hill, Dr. Robert Burns Pusey, and Rebecca Davis Stone Hill. (Courtesy of the Brown-Pusey House.)

Dr. Robert Burns Pusey built this house on North Mulberry Street. The Pusey brothers rented this building, and they used the income to support the Brown-Pusey House. This building is used as an attorney's office today. (Courtesy of the Brown-Pusey House.)

This building, the same one as pictured above, is still located at 204 North Mulberry Street. It was built about 1878 by Dr. Robert Burns Pusey, a local country doctor who died in 1889. (Courtesy of the Brown-Pusey House.)

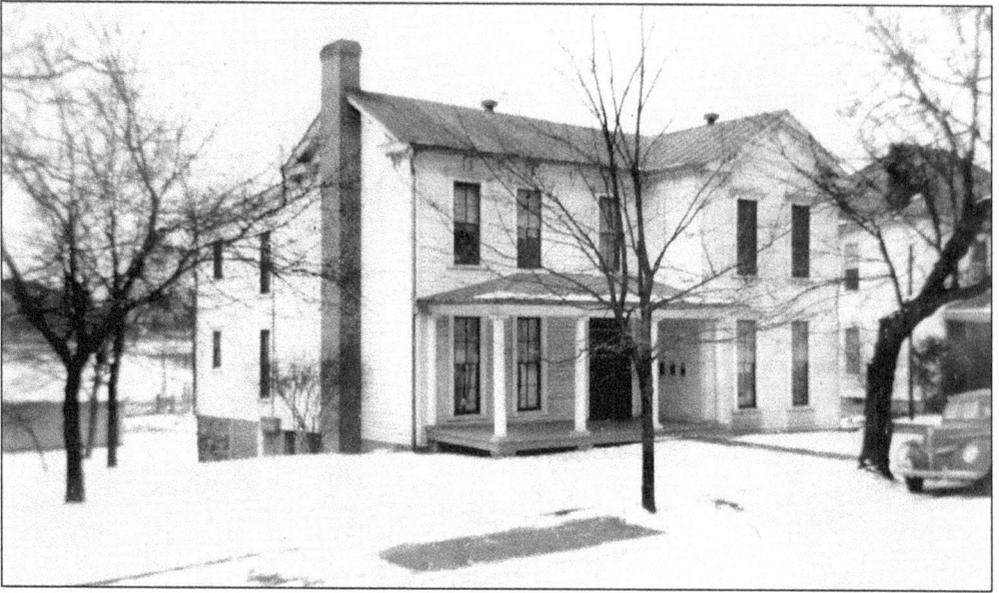

This building is still located at 208 North Mulberry Street. It was built about 1898. Mary Bell Stone and Alfred Mackenzie Brown lived in this house. A.M. Brown's father was one of the first pioneers of Kentucky. (Courtesy of the Brown-Pusey House.)

This is the rear of 208 North Mulberry Street, showing its private garage. The Pusey and Hastings children played in this area in the 1870s and 1880s. (Courtesy of the Brown-Pusey House.)

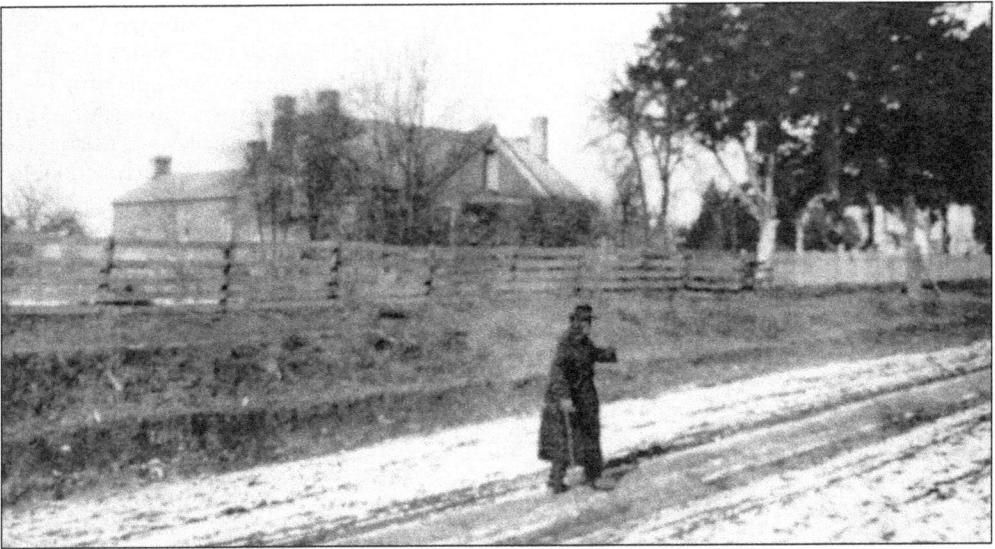

Confederate soldier John Augustus Warfield, the son of Roderick Warfield, drowned in action in the Ohio River in 1863. The actual Civil War road pass used by J.A. Warfield is housed at the Brown-Pusey House. Shown here is the Roderick Warfield House, once located at 420 North Mulberry Street. (Courtesy of the Brown-Pusey House.)

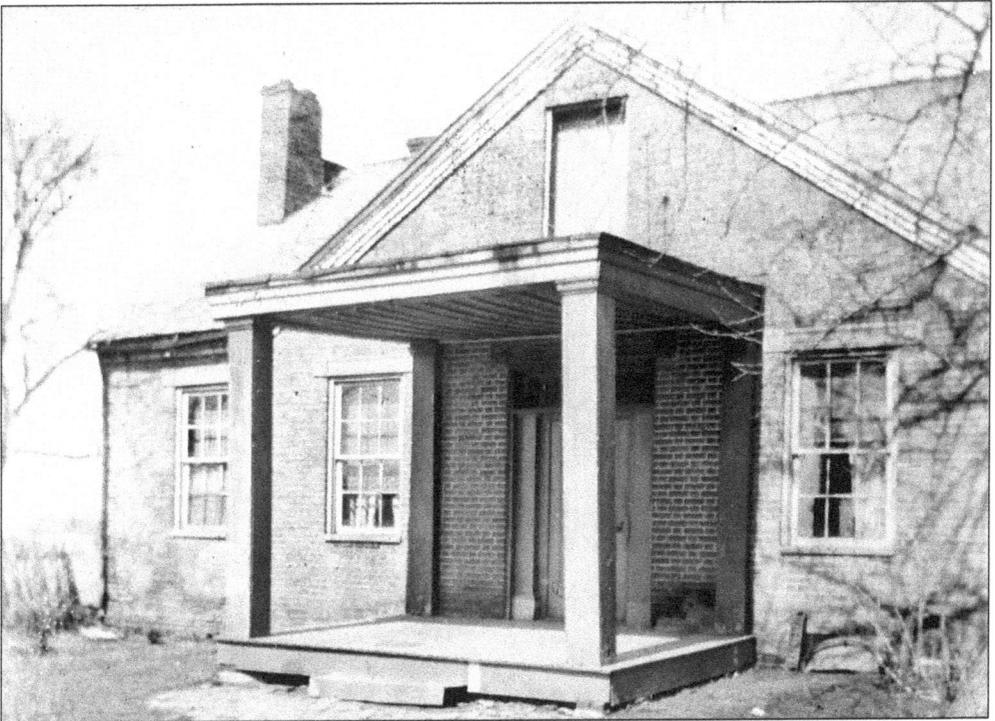

This is the Roderick Warfield House on North Mulberry Street. Roderick D. Warfield was the father of Malvina Warfield Cunningham and the grandfather of Sallie Cunningham Pusey. Malvina Warfield and Anthony Hundley Cunningham were married at this home on July 10, 1866, by Methodist reverend John W. Cunningham, Anthony's brother. (Courtesy of the Brown-Pusey House.)

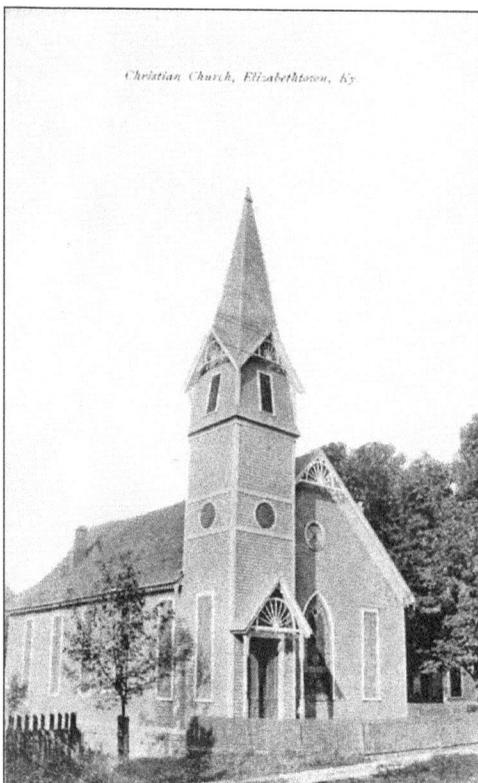

Christian Church, Elizabethtown, Ky

This postcard of the First Christian Church is postmarked 1910. In 1922, pastor Henry W. Schwan presided over a membership of 140. The Christian Church was organized in 1878. Rev. George F. Trinsley was pastor and a coach of the Elizabethtown High School in the early 1900s. This church was located on Main Cross Street near the intersection of Miles Street. (Courtesy of Meranda Caswell.)

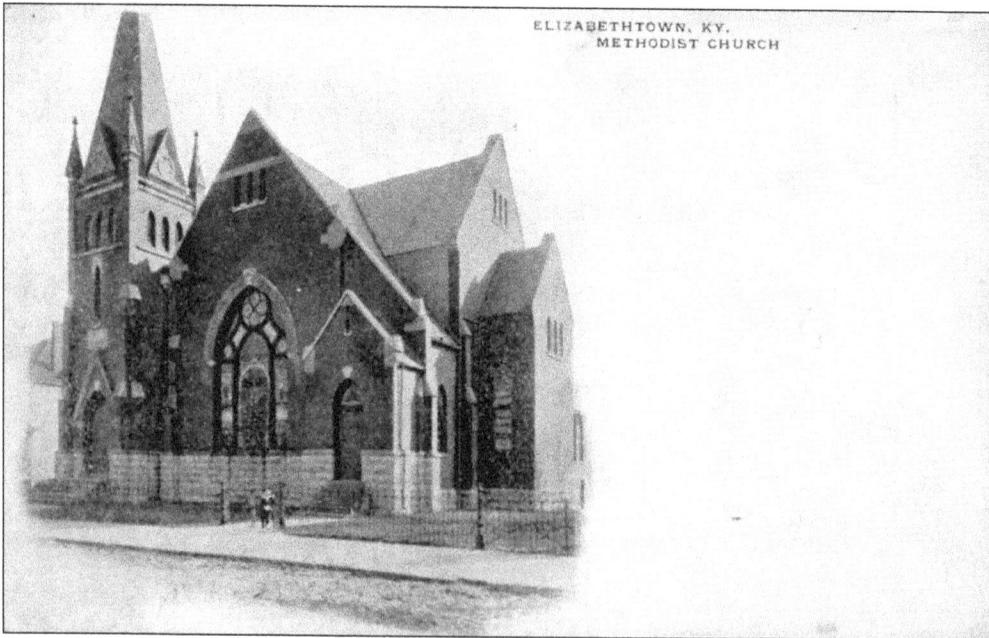

ELIZABETHTOWN, KY.
METHODIST CHURCH

This postcard shows the Lucinda B. Helm Memorial Methodist Church, used by the congregation until 1957 and torn down soon afterwards. It was located on West Dixie Avenue. The pastor in 1922 was W.C. Frank, and the church had 486 members. (Courtesy of Meranda Caswell.)

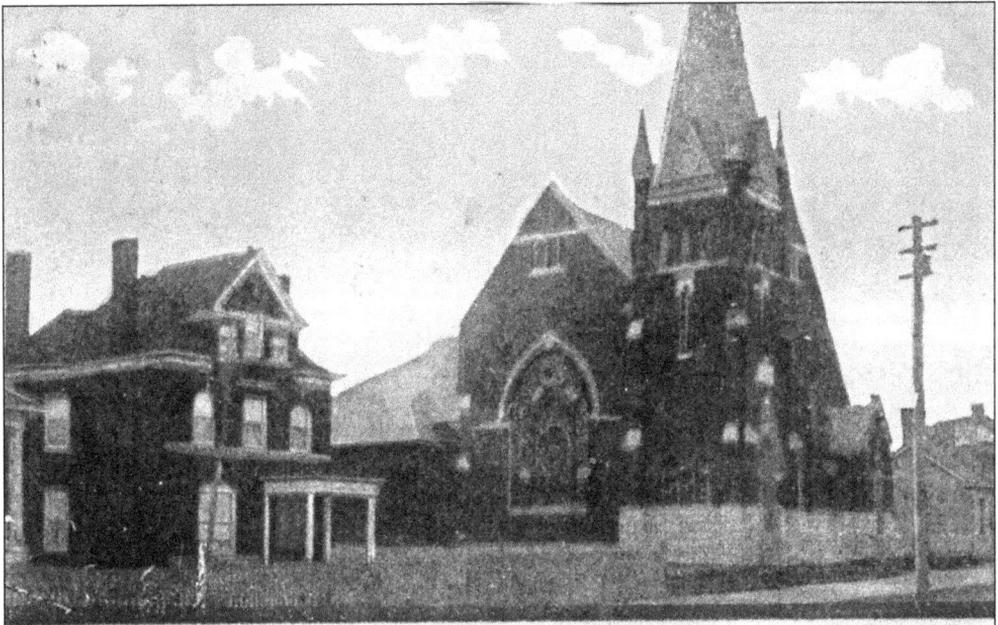

M. E. Church & Parsonage, Elizabethtown, Ky.

This postcard of the Methodist church and parsonage is postmarked 1914. The Lucinda B. Helm Memorial Methodist Church was dedicated in May 1901. (Courtesy of Meranda Caswell.)

The Old Methodist Church on South Mulberry was torn down in the 1950s and later used as Modern Woodman Hall. In 1832, Maj. Benjamin Helm built the First Methodist Church, the first brick church erected in town. (Courtesy of the Brown-Pusey House.)

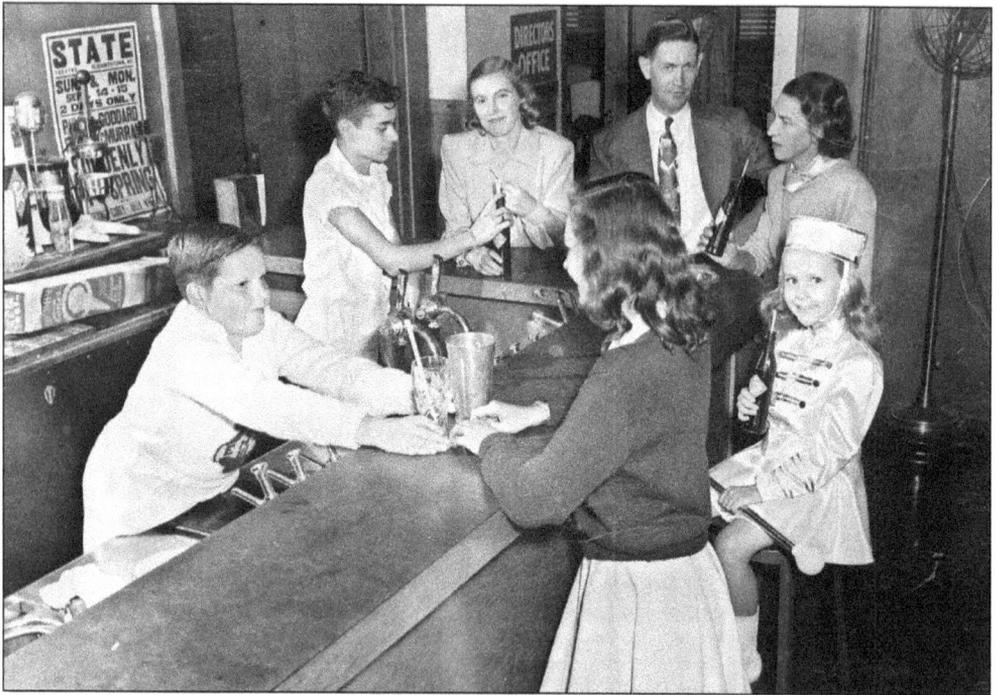

Pictured at the Memorial Recreation Center (MRC) on South Mulberry Street in the 1940s are ? Richerson, Lib Faurest, Frank Lanz, and four unidentified children. (Courtesy of Mary Jo Jones.)

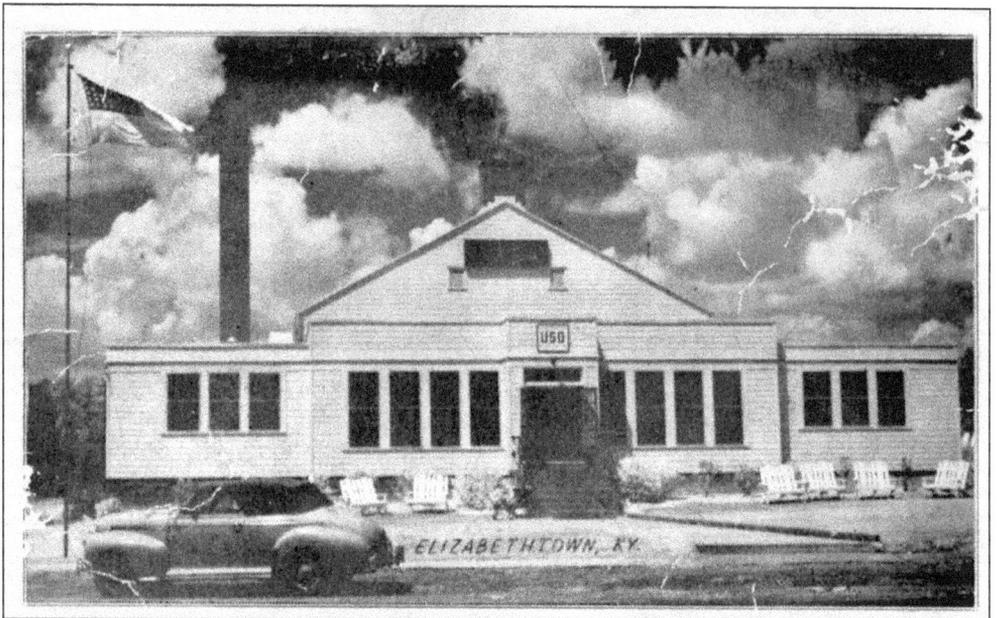

Memorial Recreation Center was built in 1941 and used for the entertainment of service people in World War II. After the war, young people used the MRC building, on South Mulberry Street, for dances and other recreational activities. (Courtesy of Mary Jo Jones.)

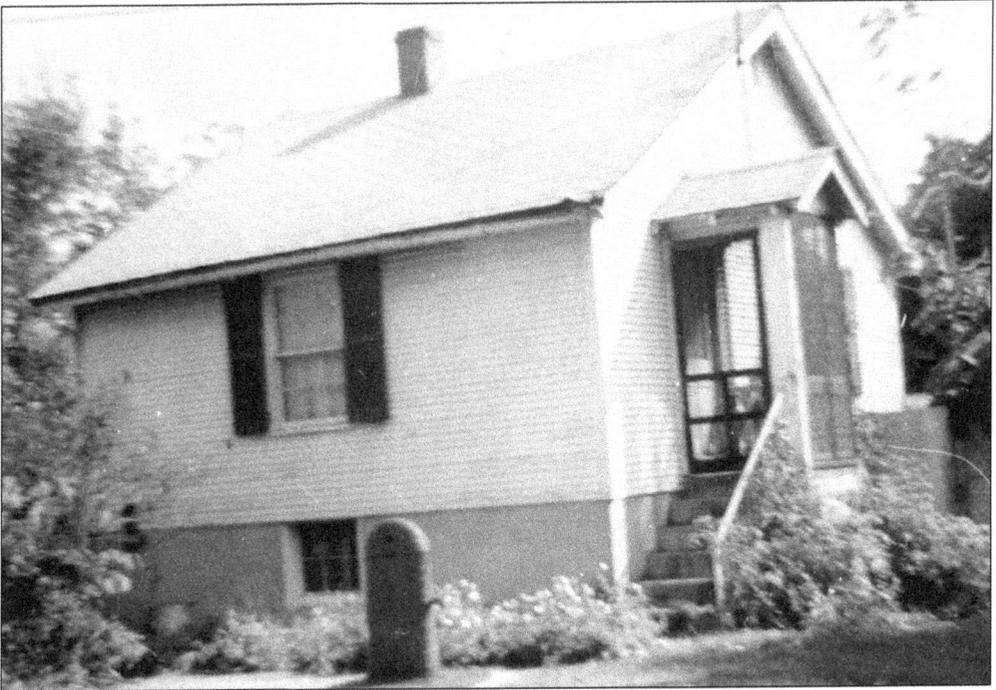

Pictured is the home of Spiro Agnew while he lived in Elizabethtown. Spiro Agnew was the vice-president under Richard Nixon. Mrs. L.B. Hoke rented the house out. (Courtesy of the Brown-Pusey House.)

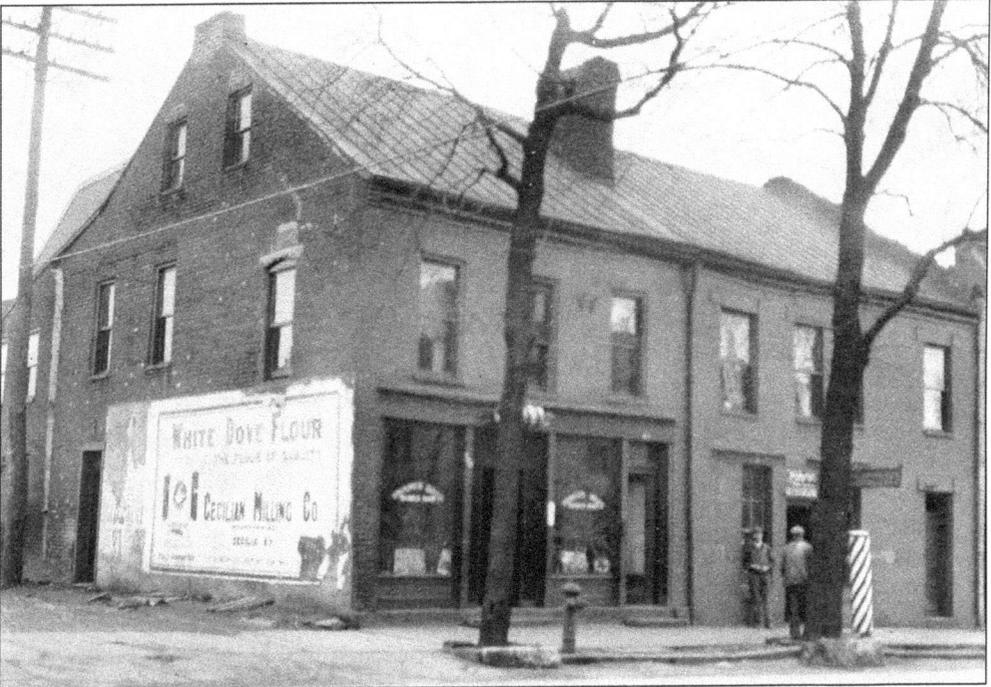

Prior to the 1930s, White Dove Flour, made by the Cecilian Milling Company, painted this advertisement on the side of a building in Elizabethtown. (Courtesy of the Brown-Pusey House.)

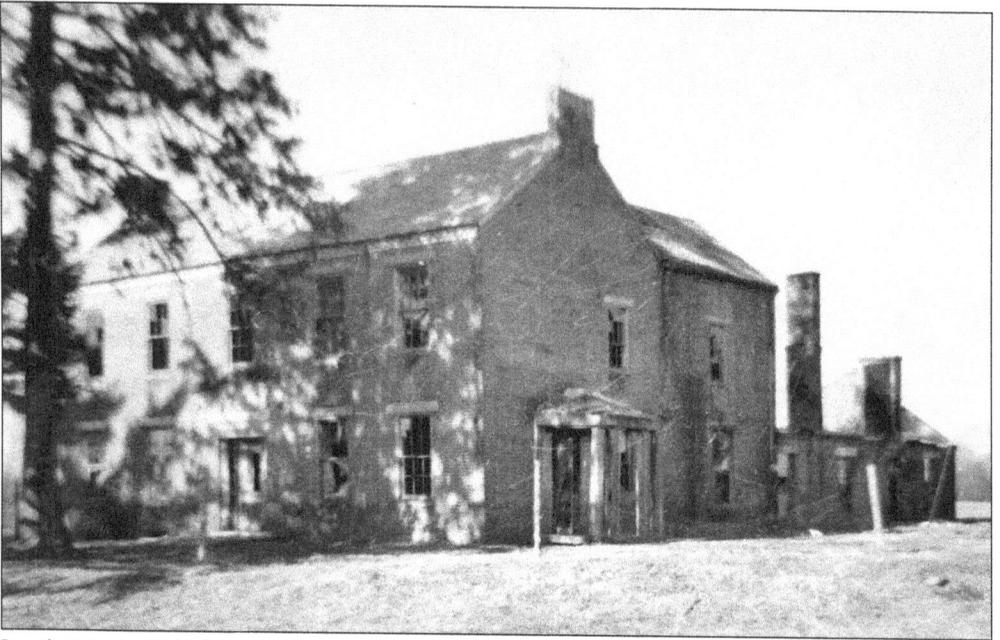

Jacob Vanmeter's house was razed prior to 1976. This building was on the outskirts of Elizabethtown, where Manakee Funeral Home is today. Jacob Vanmeter was one of the first settlers. The Jacob Vanmeter Chapter of the Daughters of the American Revolution meets at the Brown-Pusey House. (Courtesy of the Brown-Pusey House.)

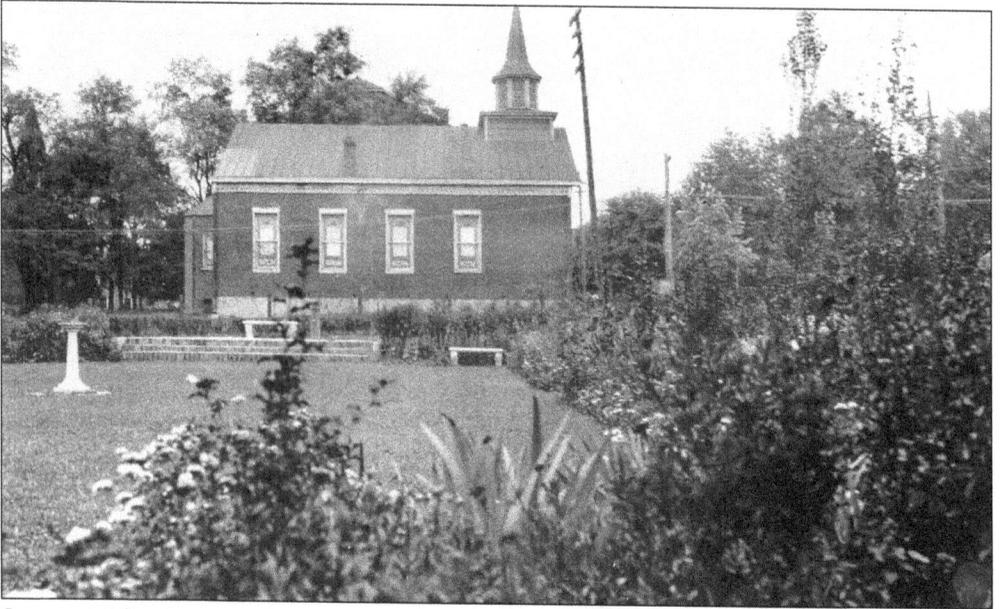

Severns Valley Baptist Church is the oldest Protestant church in the Mississippi Valley. John Barnett organized it on June 11, 1791, with 37 members. John Gerrard was the church's first pastor. In 1922, J.B. Trotter was the pastor of a congregation of 800. The first brick church building for Severns Valley Baptist Church was built in 1834 by John Y. Hill. Pictured is a side view of the church from the garden of the Brown-Pusey House. (Courtesy of the Brown-Pusey House.)

Six

EDUCATION

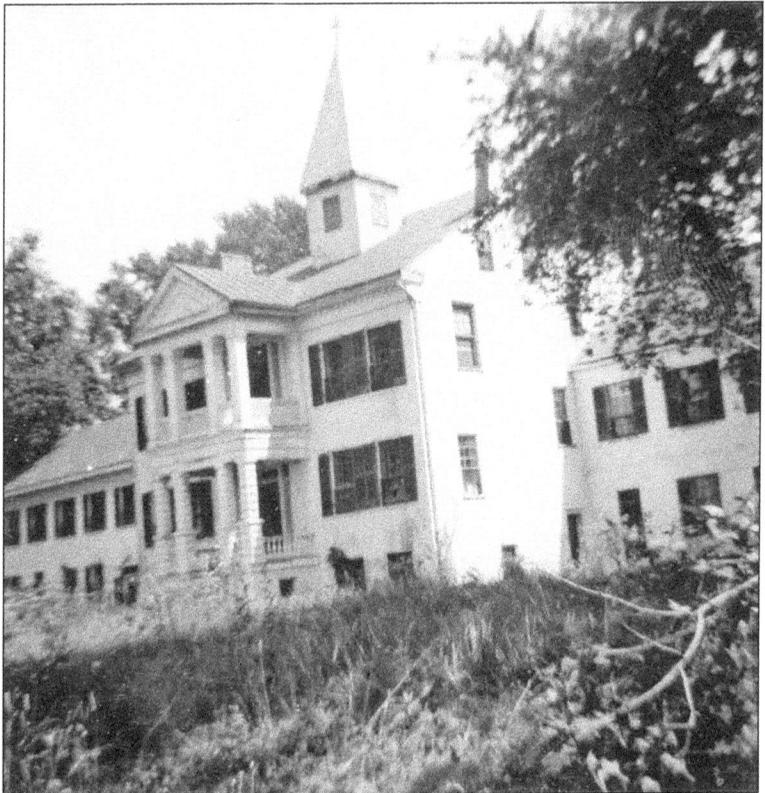

Bethlehem Academy, located on St. John Road, was one of the oldest Kentucky girls' Catholic boarding schools, established about 1830 or 1831. The first reverend was Charles T. Cecil. Bethlehem was once a self-supporting academy, but it closed in 1959. (Courtesy of the Brown-Pusey House.)

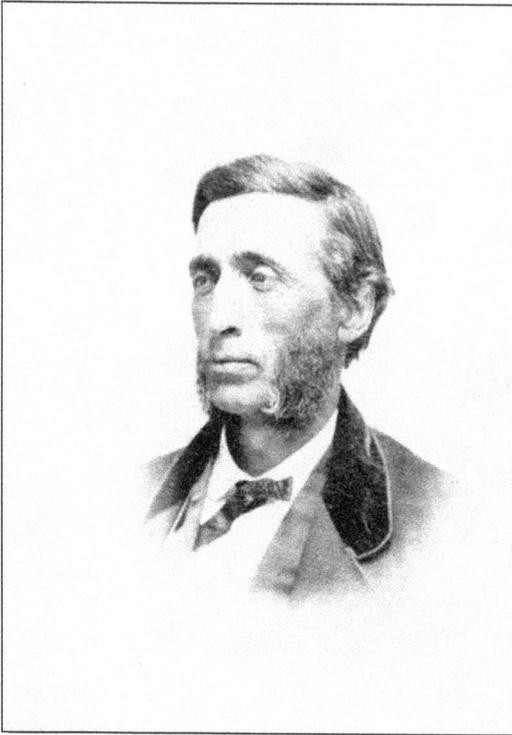

Alfred Mackenzie Brown, seen here in the 1840s, was the first public school commissioner for Elizabethtown and Hardin County, Kentucky. Later, he was on the board of the Hardin Academy, which was located at the corner of North Mulberry and Poplar Streets. (Courtesy of the Brown-Pusey House.)

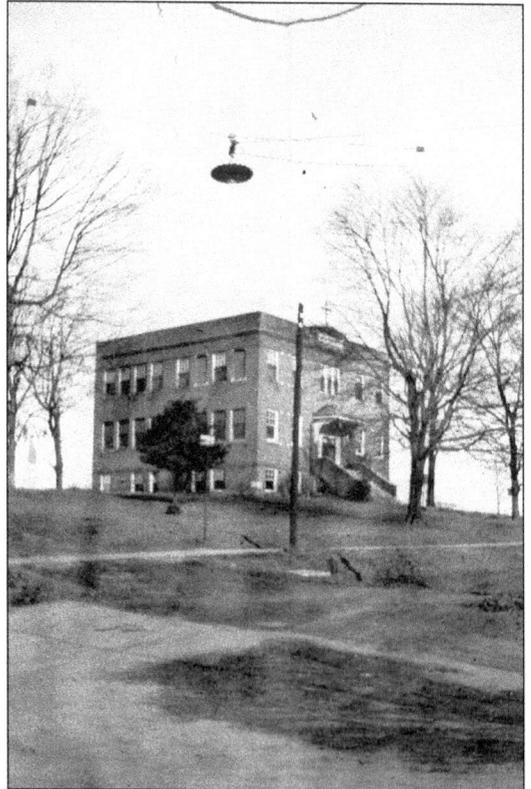

St. James Parochial School began about 1869. Rev. T.J. Disney was the first pastor for this school. (Courtesy of the Brown-Pusey House.)

This postcard depicts the Hardin Collegiate Institute in 1909. The co-educational Hardin Collegiate Institute, established in 1892, was originally called Elizabethtown Preparatory School for the Central University of Richmond, Kentucky. The H.C.I. had been transferred to the control of the Presbyterian Synod of Kentucky in 1907. This building was sold to Hardin County for a high school in 1911 and later became the Knights of Columbus Hall. (Courtesy of the Brown-Pusey House.)

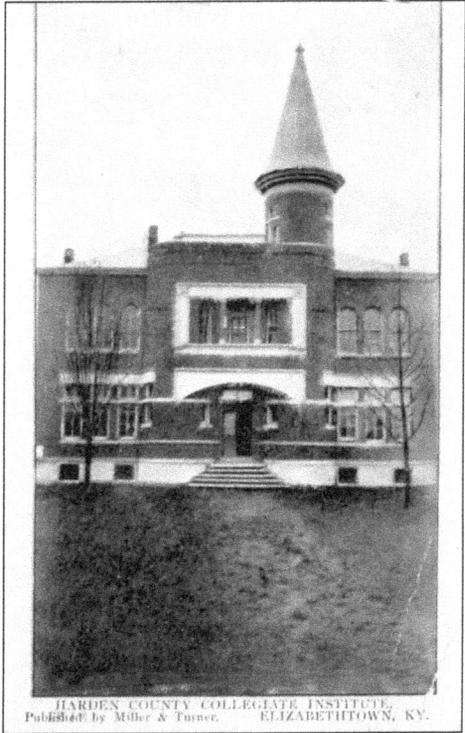

HARDIN COUNTY COLLEGIATE INSTITUTE,
Published by Miller & Turner. ELIZABETHTOWN, KY.

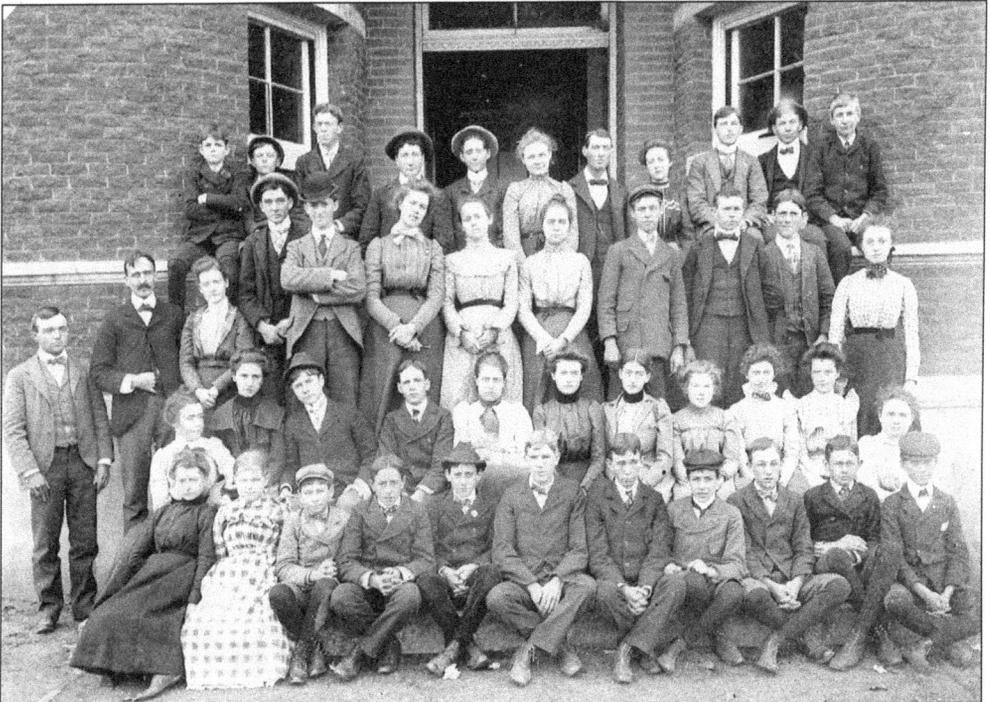

This is the Hardin Collegiate Institute faculty and students *c.* 1914; they are unfortunately unidentified. Robert T. McMurtry, Nellie Bridwell, Robert Bridwell, and Frank Bridwell attended the H.C.I. in the 1899–1900 school year. (Courtesy of the Brown-Pusey House.)

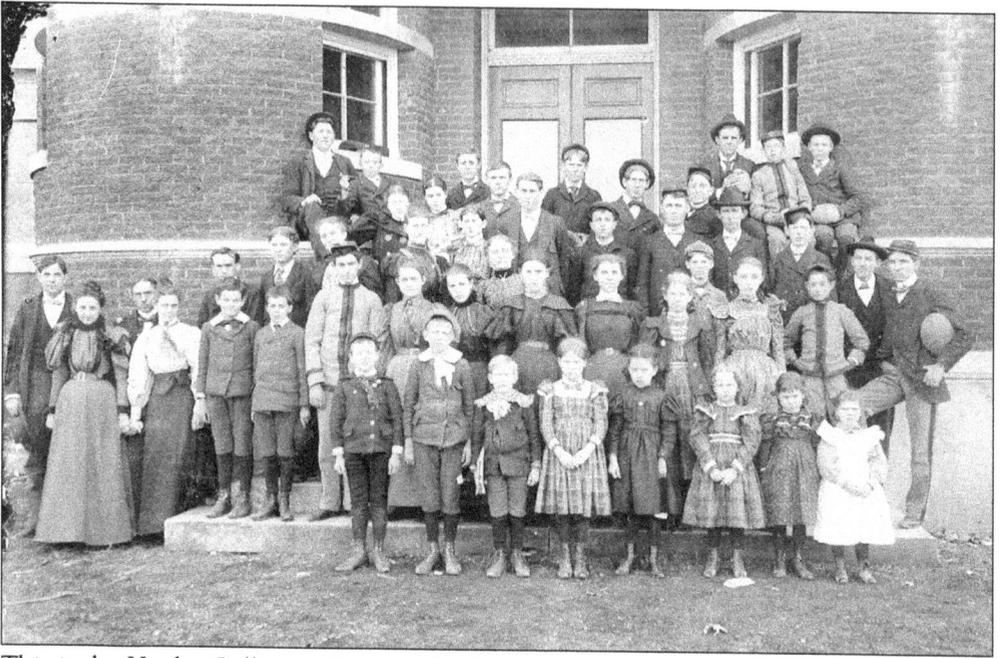

This is the Hardin Collegiate Institute faculty and students c. 1914. They are unidentified. Elizabethtown Community College opened in the 1960s in this area. (Courtesy of the Brown-Pusey House.)

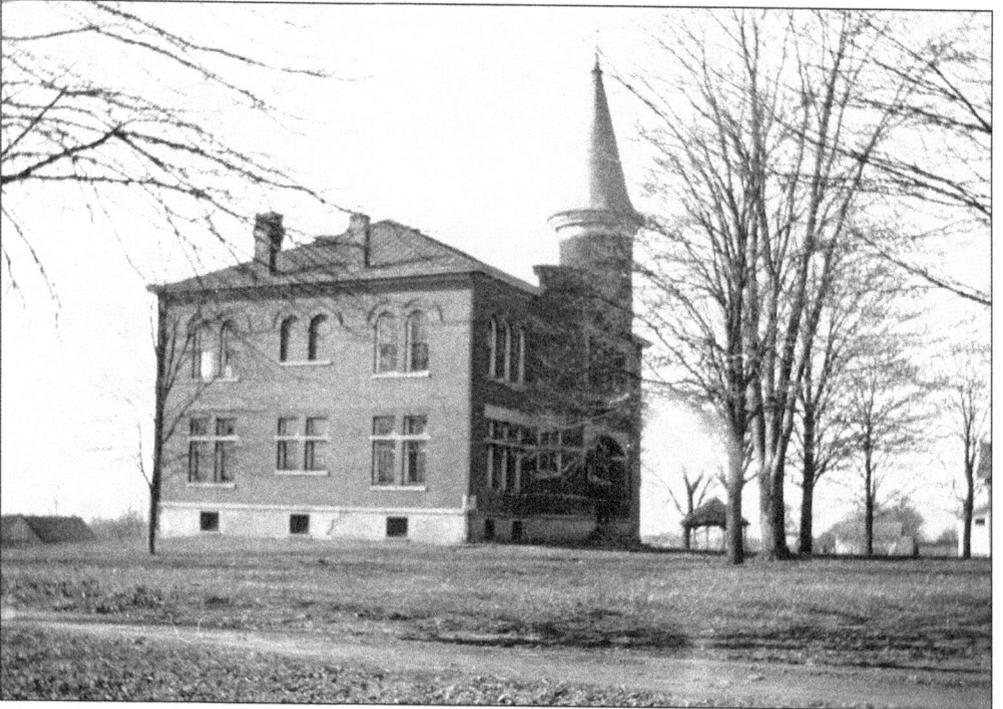

This side view shows Hardin Collegiate Institute about 1930, shortly before being destroyed. The building was erected about 1892 on five acres of land. After it was destroyed, the Audubon Court subdivision replaced it. (Courtesy of the Brown-Pusey House.)

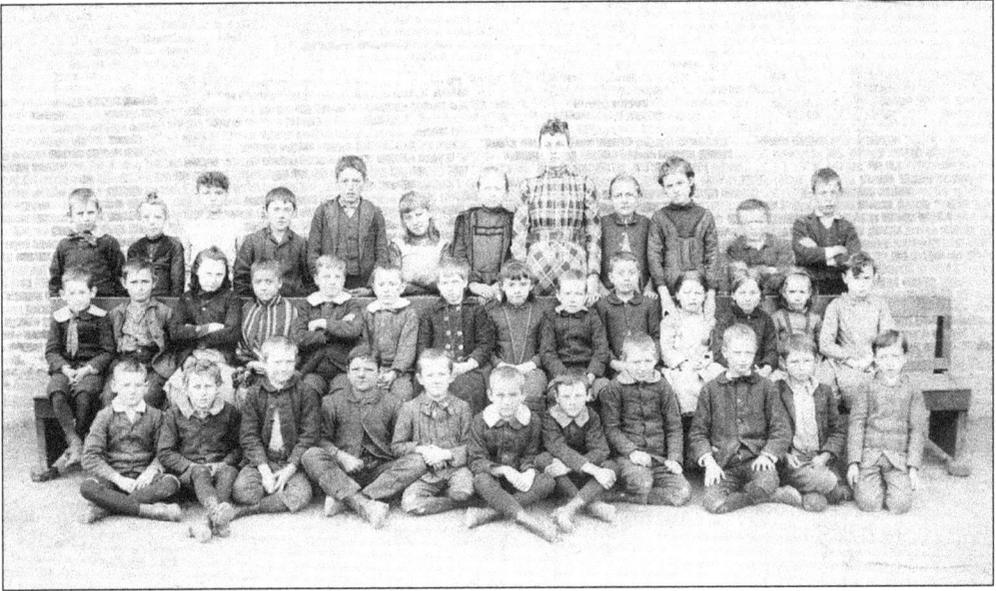

This is the Elizabethtown Public School prior to 1914. The teacher was Katie Cates. Identified here are (front row, second from left) Willie Shawon; (middle row) Paul Quiggins (far left), Sam Bush (fifth from left), Tom Robertson (sixth from left), Bob Holdsworth (tenth from left), and Mary Terry (second from right). (Courtesy of the Brown-Pusey House.)

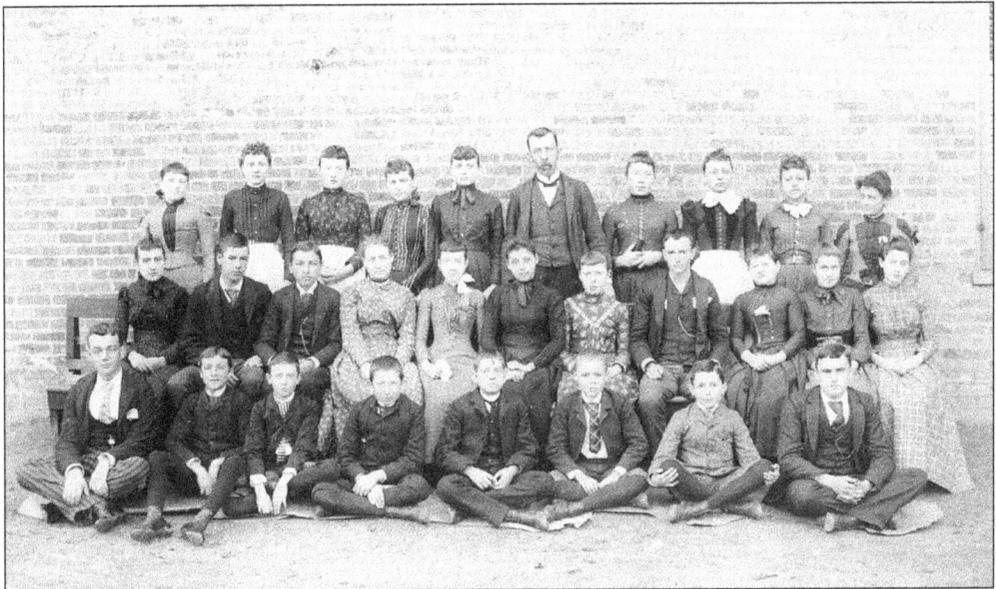

At Elizabethtown Public School prior to 1914 and pictured here from left to right are (front row) Leslie Watkins, Hill Hastings, Lawrence Poston, Wayne Joplin, Horace Johnson, Noel Bushfield, Walter Wintersmith, and Joe Cresap; (middle row) Bertie Cordrey, Wilson Cook, Milton Holbert, Alice Hotopp Johnston, Effie Poston, Bell Brown, Dollie Burkholder, Rodman Selby, Minnie Hesse, Maggie Sweets Faurest, and Lucy Lasley Pate; (back row) Minnie Sweets Selby, Lucy Robertson, Ella Montgomery, Lena Kennedy Nye, Mary Bush Mann, Prof. R.E. Woods, Bertha Birkholder, Mary Robertson Wintersmith, Annie Perceful Wathen, and Ella Simmons. (Courtesy of the Brown-Pusey House.)

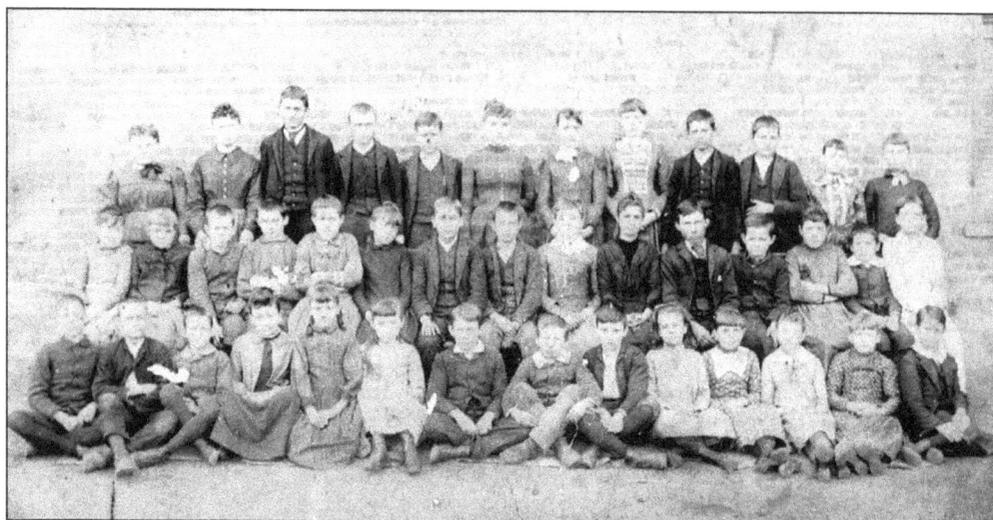

This photo is of the Elizabethtown Public School about 1889. Lizzie Sweets Atcher was a teacher. Some names are known, but their order is not; included here are ? McClure, ? Sweets, Mayme McCans, Frank Ansley, Dixon Branch, Nora Sandidge, Anna Miller, Lillie Dyer, Maggie Bell, Kelly Robertson, Alfred Vernon, ? Holston, ? Phillips, Willie Eggeman, Charlie Middleton, Emma Moore, Millie Sweets, Albert Linton, Claude Ansley, Annie Pope, John Martin, Lula Barnes, Claude Hawkins, Loy Duncan, Emma Hesse, Eugema Robertson, Lena Mudd, Richard Wilson, Jimmie Linton, Rodney Hansbro, Mande Hawkins, Minnie Kirkpatrick, Mayme Irwin, and Willie Redman. (Courtesy of the Brown-Pusey House.)

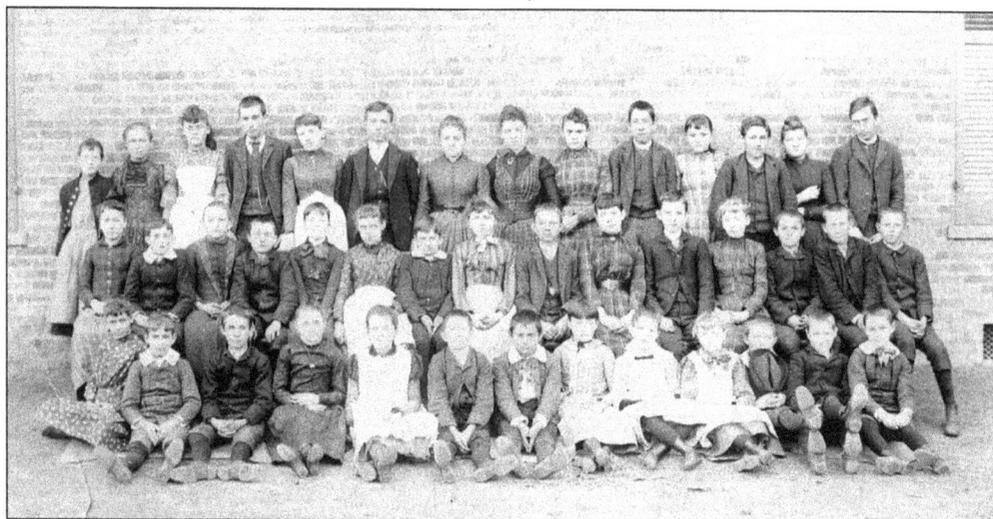

This is a photo of the Elizabethtown Public School prior to 1900. From left to right are (front row) Anna Kennedy, two unidentified, Clarence Kennedy, Margie Martin, Mary ?, Paul Joplin, unidentified, Annie English, Linda Payne, Bettie Matthis, Jim Martin, Will Bush, and Brooks Montgomery; (middle row) Russie Dillard, Tom Hastings, Sophie Ehret, Warren Proctor English, Louise Larue Porter, Maggie Kennedy McKay, unidentified, Ada McGinnis Daugherty, unidentified, Ruth Warfield, Elisha Matthis, Mary Lizzie Robertson, unidentified, and W. Hawkins; (back row) Lena Johnson, Minnie Crow, unidentified, Earl Sanders, ? Redman, H. Middleton, ? Anderson, unidentified, Stella Moore, George Wood, Sudie Schuller Nourse, John Myers, Etta Branch, and Will Park. (Courtesy of the Brown-Pusey House.)

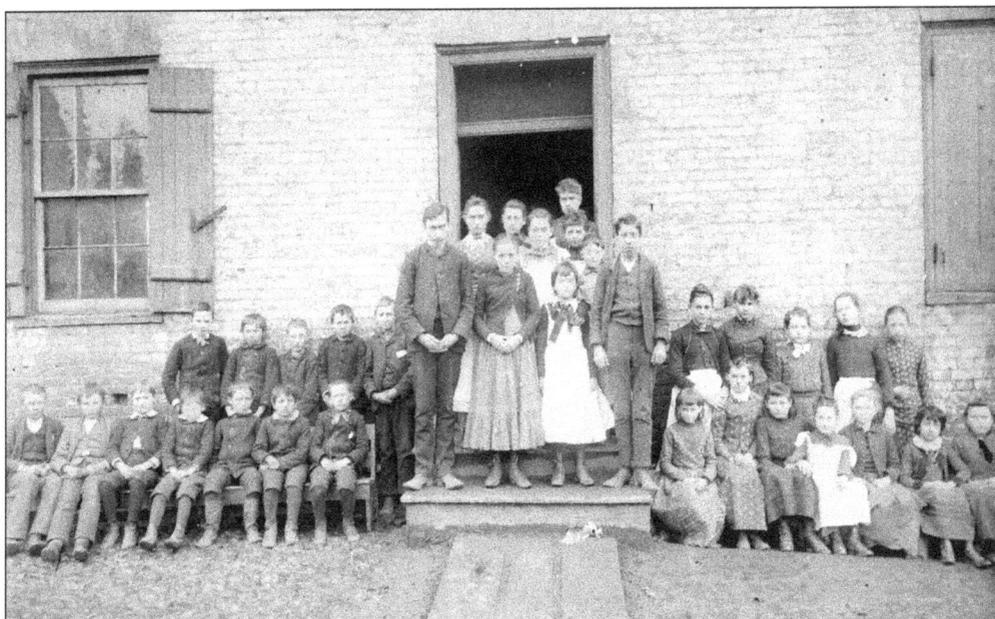

This is the Elizabethtown third-grade class in 1887. On the steps is the teacher, Lizzie Sweets. Included in this picture are Hattie Bunch, Ada McGinnis, Mary Eyre Wintersmith, Will Park, Louise Larue, George Wood, Will Bush, Paul Joplin, Stella Moore, Ruth Warfield, Lizzie Kennedy, Maud Combs, Emma Moore, Etta Branch, Lena Johnson, Mary Lizzie R?, and Mary W. Payne. (Courtesy of the Brown-Pusey House.)

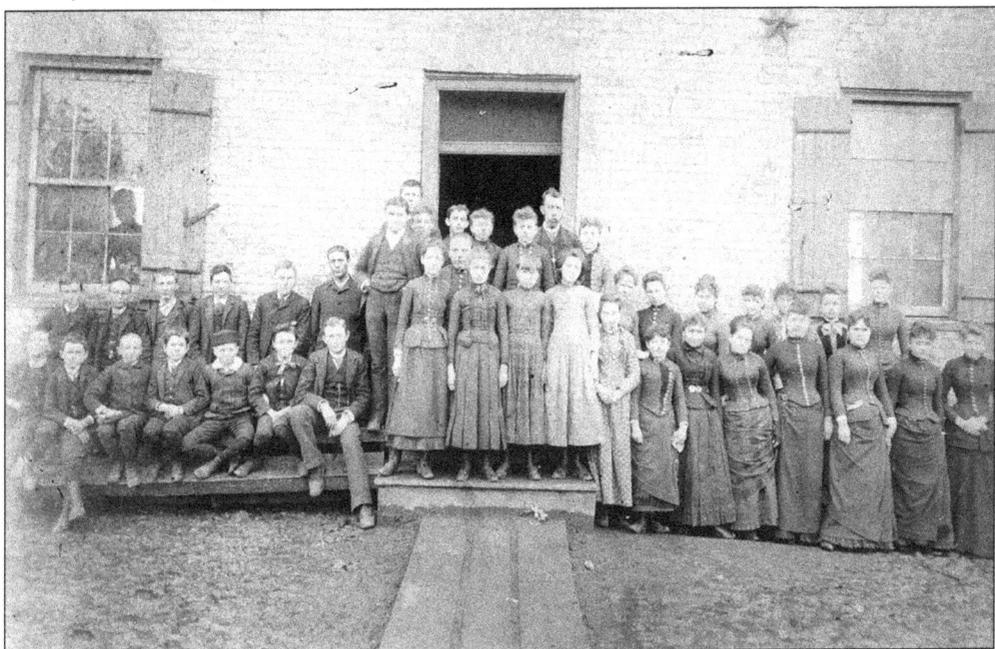

This is the Elizabethtown first-grade class of 1887. R.E. Woods is the teacher. This picture includes students L. Poston, H. Johnson, N. Bushfield, C. Goldnamer, Effie Poston, ? Sweets, M. Hesse, B. Cordury, Minnie Sweets, K. Hotopp, ? Montgomery, Joe Cresap, and Lizzie Beeler. (Courtesy of the Brown-Pusey House.)

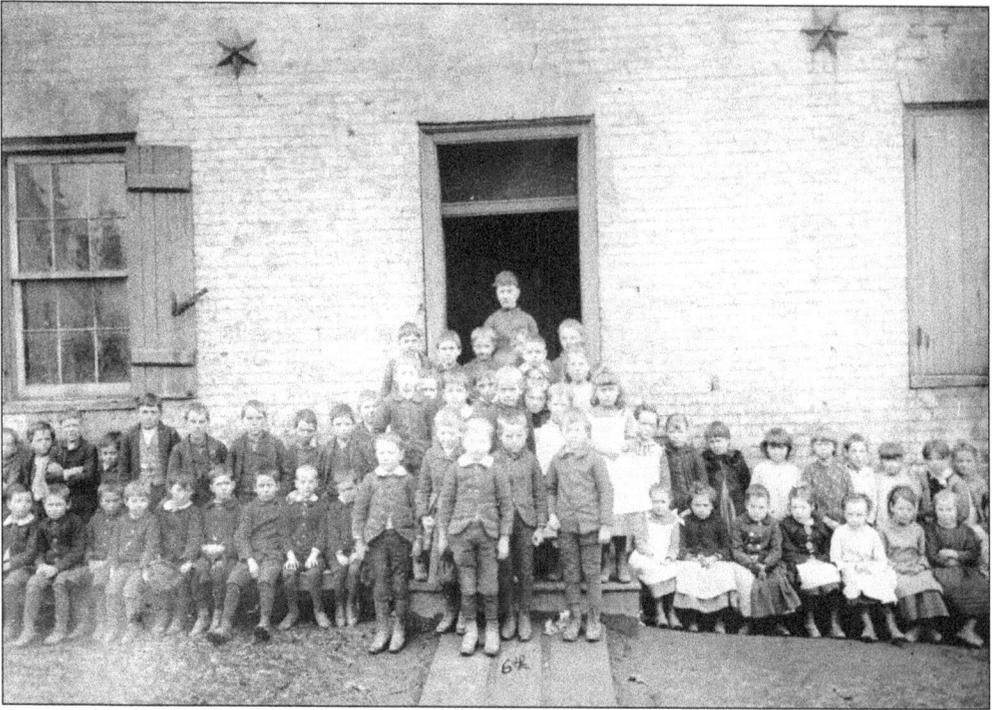

This is the Elizabethtown sixth-grade class of 1887. The teacher is Mrs. Isabelle Shacklette. None of the students are identified. (Courtesy of the Brown-Pusey House.)

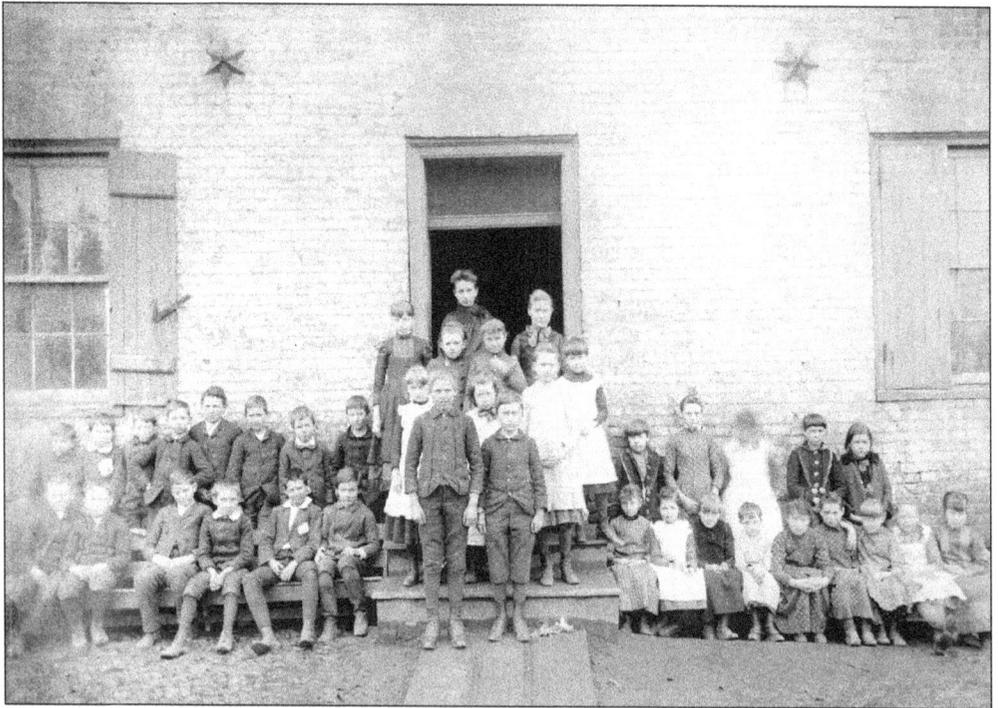

This is the Elizabethtown fourth-grade class of 1887. None of the students in the picture are identified. (Courtesy of the Brown-Pusey House.)

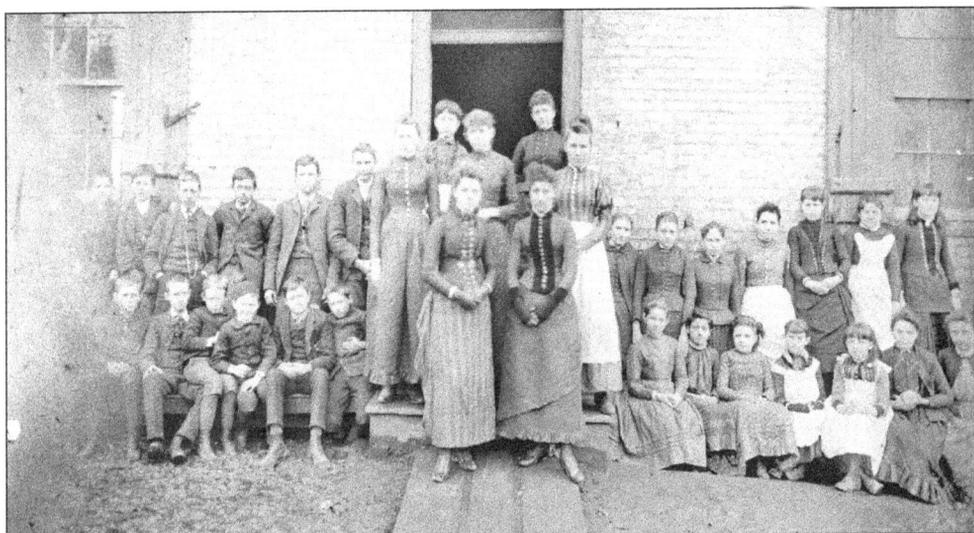

This is the Elizabethtown second-grade class of 1887. Standing in the center are Maud Eggeman, teacher Albe Anderson, Minnie Branch, unidentified, Minnie Read, Floss Maffett, and Lena Kennedy; students included in the photo are Rosa Payne, Mary Lizzie Fraize, Minnie Quiggins, Julia Payne, H. Ehret, Anna Redman, Syde Payne, Stanley Cresap, and Lille Goldnamer. (Courtesy of the Brown-Pusey House.)

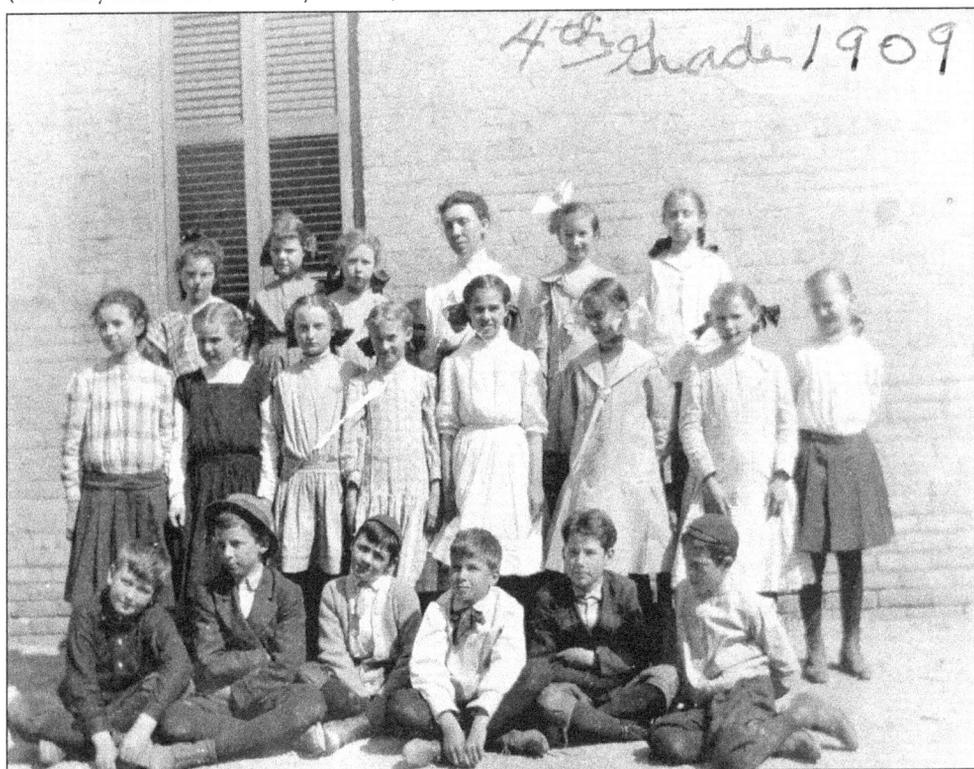

Mary Elliott taught the Elizabethtown fourth grade in 1909. None of the students are identified. The Elizabethtown Graded School building shown here was built about 1816 and razed about 1914. (Courtesy of Mary Jo Jones.)

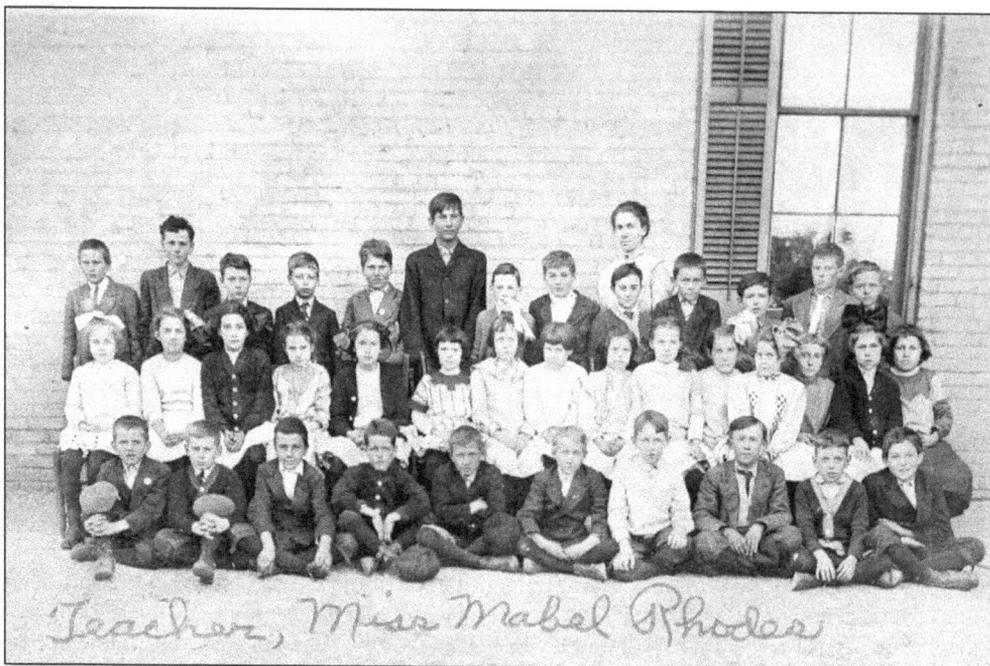

The teacher here is identified as Mabel Rhodes. The Kentucky Legislature in 1878 passed an act to establish a public school in the Elizabethtown Common School. Hence, the Elizabethtown Graded School, located on West Dixie Avenue, became a public school in 1890. (Courtesy of Mary Jo Jones.)

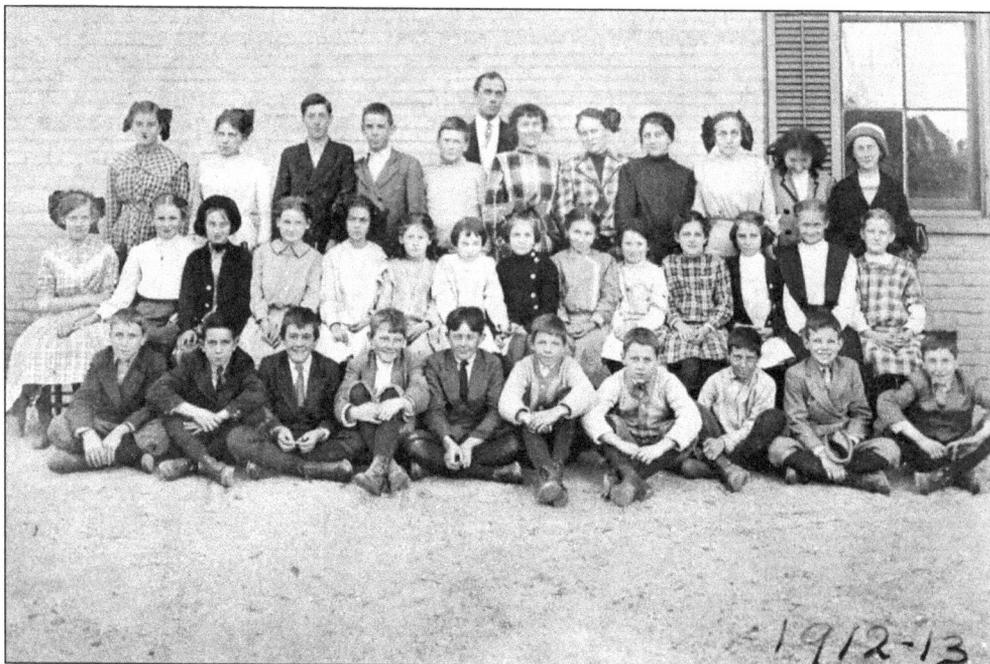

The Elizabethtown graduating class of 1912–1913 is pictured here. None of the students are identified. The building shown was built in 1816 and razed about 1914. (Courtesy of Mary Jo Jones.)

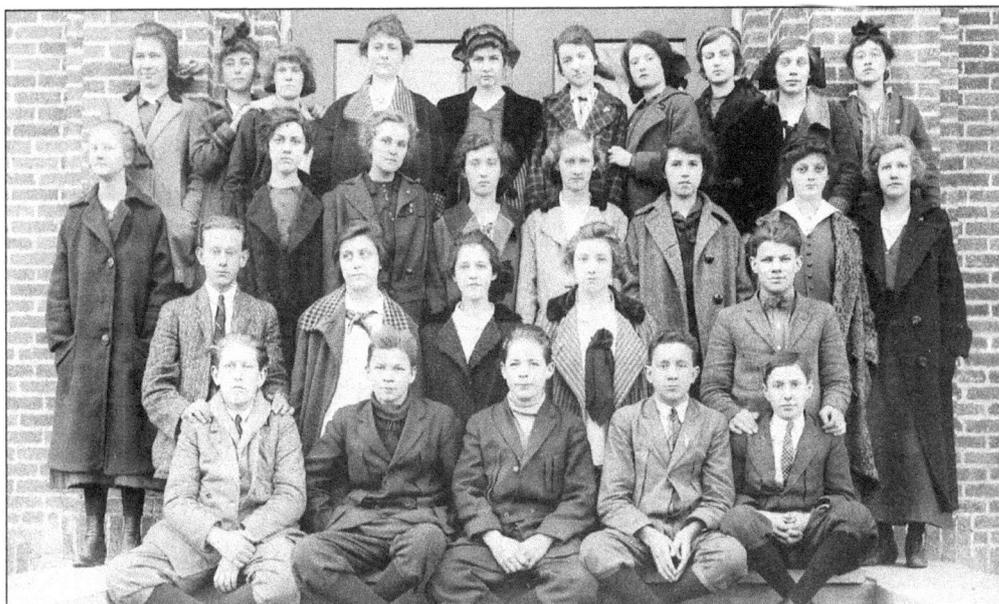

The Elizabethtown freshman class of 1914–1915 is, from left to right, (first row) Brown Rider, Joseph Sweets, Edmund Richerson, Ikey Morrison, and Hagan Jenkins; (second row) James Dean, Nellie Scott, Winnie Riordan, Lena Morrison, and Clinton Igleheart; (third row) Nell Riordan, unidentified, Mrs. Will Bond's sister, unidentified, Pauline Berry, Ina Drain, Thelma Boyd, and Eva Purcell; (fourth row) Anna Rhodes, two unidentified, ? Vimont, Fannie Gross, Clara Bond, Margaret Settle, Mary Ellen Moore, Abbie Berry, and Nell Ashlock. (Courtesy of Mary Jo Jones.)

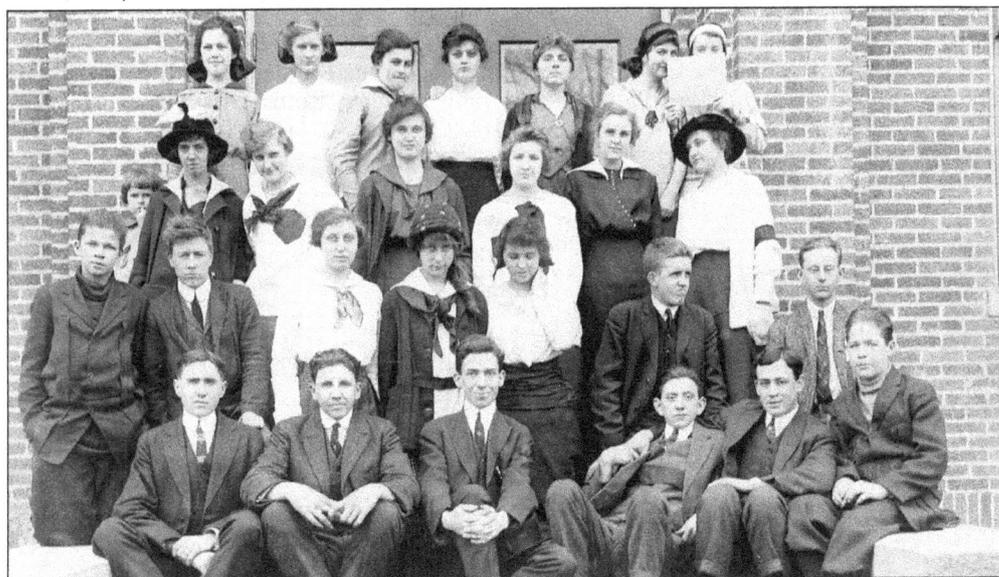

Shown sometime between 1914 and 1922, the students of Elizabethtown High School are, from left to right, (first row) Heady Jenkins, Henry Brown, Allen Ament, Lawrence Morrison, unidentified, and Edmund Richerson; (second row) Joseph Sweets, ? Hull, Margaret Mantle, Ina Cates, unidentified, James Dean; (third row) Myrtle Irwin, unidentified, Mildred Boyd, Lena Morrison, unidentified, and Della Crume; (fourth row) Winnie Riordan, Pauline Berry, Lucile Crawford, Thelma Boyd, unidentified, Fan Gross, and Clara Bond. (Courtesy of Mary Jo Jones.)

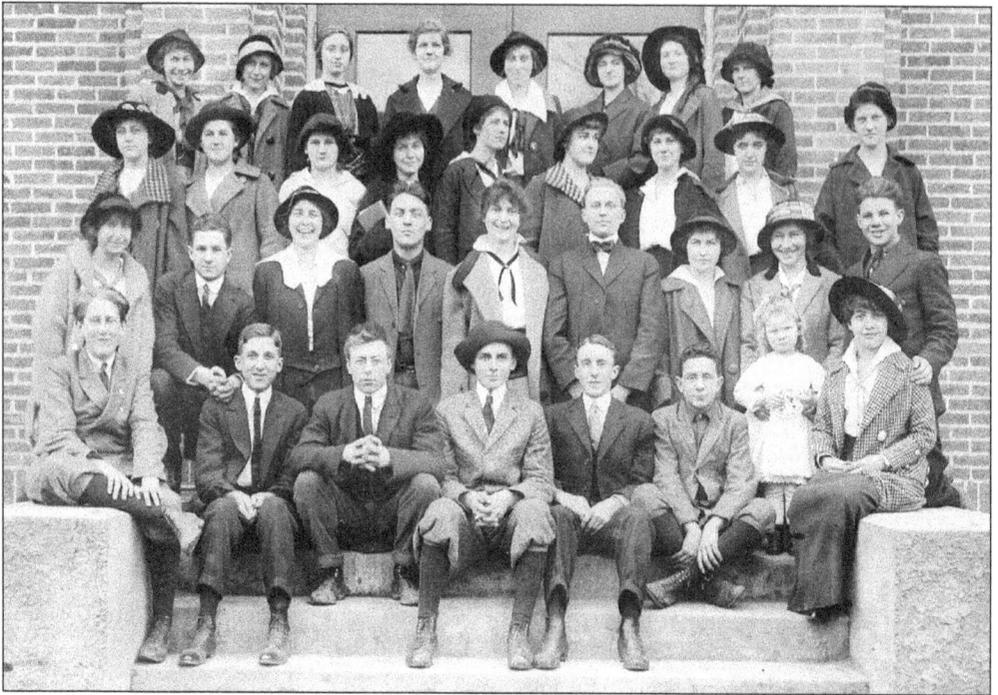

Shown sometime between 1914 and 1922, the student class of Elizabethtown High School is, from left to right, (first row) Brown Rider, Stewart Fischer, Herbert Hull, Sam Fischer, Pusey Jenkins, Raymond Morrison, and Daisy Albert; (second row) Elizabeth Rhodes, Katherine Spink, Nell Ashlock, Eva Purcell, Ollie Berry, Mary Ellen Moore, Margaret Settle, and Lula Osborne; (third row) Nellie Scott, Tommy Morgan, Lila Jenkins, Ellen Kaye, Virginia Nall, Hannah Crawford, Katherine Cash, Mary Smith, and Winnie Riordan; (fourth row) Virginia Cresap, Raymond Jenkins, Virginia Marriott, Charles Nourse, Ruth Lewis, Colonel English, unidentified, Anna Rhodes, and Clinton Igleheart. (Courtesy of Mary Jo Jones.)

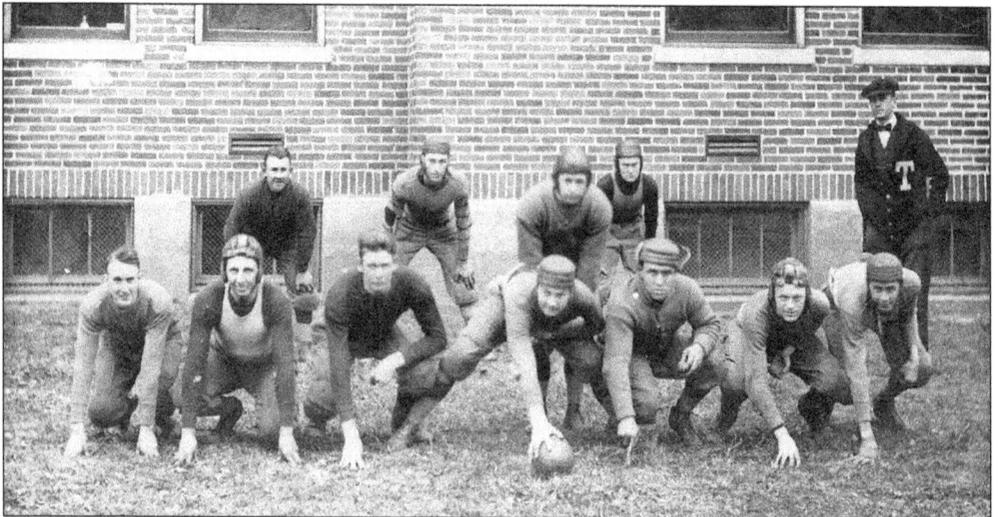

The Elizabethtown football team of 1917 included Pusey Jenkins, Henry Brown, Tom Hagan, Silas Hart, and Hobart Gordon Collier. The coach, Rev. George F. Tinsley, is standing at far right. (Courtesy of Mary Jo Jones.)

102

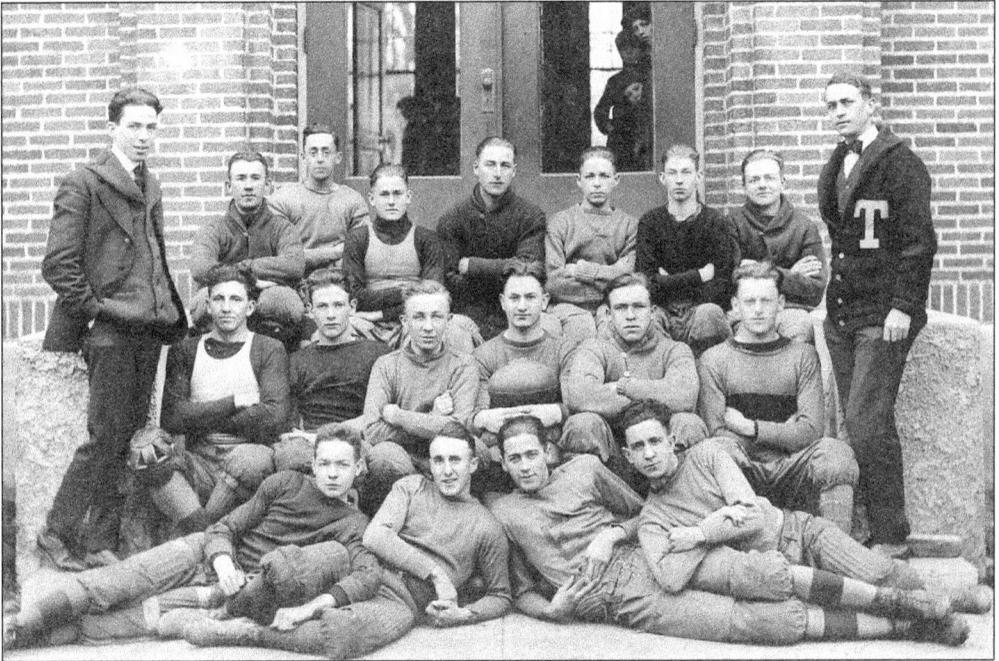

The Elizabethtown football team in 1917 is, from left to right, (front row) Nevin Neighbors, right tackle; Pusey Jenkins, right end; Tom Hagan, left end; and Raymond Morrison, substitute; (middle row) Allen Ament, referee; Henry Brown, substitute; William Bedford, left tackle; Shirley Bassett, right guard; Arthur Jenkins, center; Silas Hart, left guard; Lisle McAfee, right-half; and Rev. George F. Tinsley, coach; (back row) Hobart Gordon Collier, substitute; James Dean, substitute; Ben Gray, left half; Rudolph Rogers, fullback; Edmund Richerson, quarterback; Eugene Matthis, substitute; and Louis Faurest, substitute. The coach was a pastor of the Christian Church. (Courtesy of Mary Jo Jones.)

These students are in a home economics class in the early 1900s. From left to right are Margaret Settle (Richerson), Jackie James, unidentified, and Jean Ricket. (Courtesy of Mary Jo Jones.)

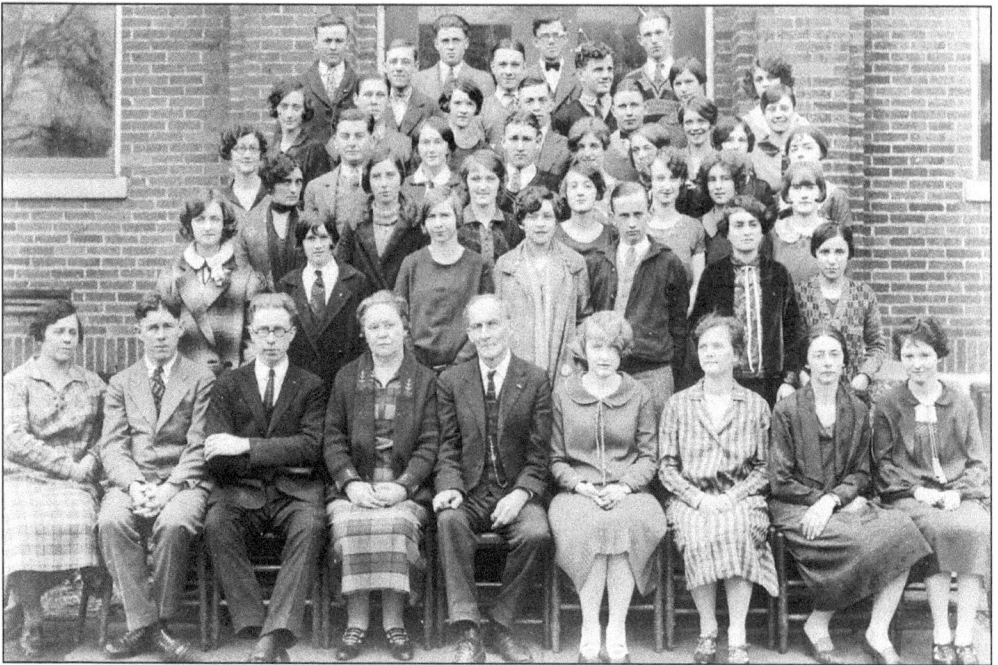

The Elizabethtown class and faculty of 1927 are, from left to right, (first row) Virginia Morgan Willett, Oakley Brown, Emerson Wortham, Mattie Elliott, Superintendent John C. Pirtle, Katherine Wharton Keith, Lelia Kennedy, Virginia Beeler, and Margaret Settle Richerson; (second row) Alma Rogers Redman, Louise Hill Taylor, Vivian Nett Ash, Edith Cecil Gentry, Glenny Terrill, Zelma Viers Atcher, and Lucille Morrison; (third row) Ida Mae Horn Bruce, Lorraine Dutschke, Katie Mobley Searcy, Florence Rose Samuels, LaVerne Linton Wallace, Nannie Maffet Lee, and Virginia Buckles Thomas; (fourth row) Evelyn Wise Rider, Herbert Cooper, Bernice Strickler Payne, Clifford Jaggers, Mary R. Vertrees Goodman, Margaret Faurest Black, Margaret Lewis Hodge, and Louise Jones Hargan; (fifth row) Lucille Bond, James Nall, Edith Bond Yellig, Holly Sidmore, Stanley Cooper, Lottie Sinclair Keiffer, and Florence Alsop Brown; (sixth row) Wilbur Sutzer, Charles Faught, Frankie Brown, Jack Baird, James Brown, Cary Allen Sikes, Lewis Wallace, Mona Crawford, and Mary T. Watkins. (Courtesy of Mary Jo Jones.)

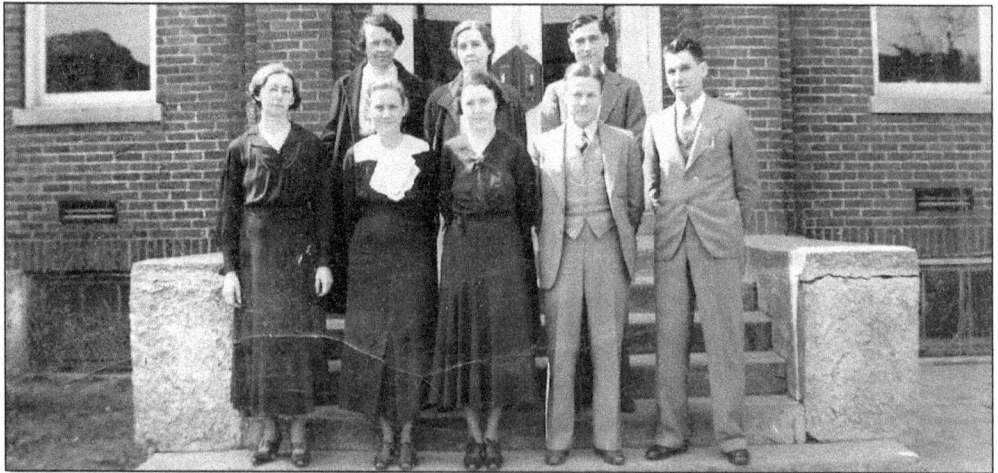

The Elizabethtown faculty of 1937 is unidentified. (Courtesy of Mary Jo Jones.)

104

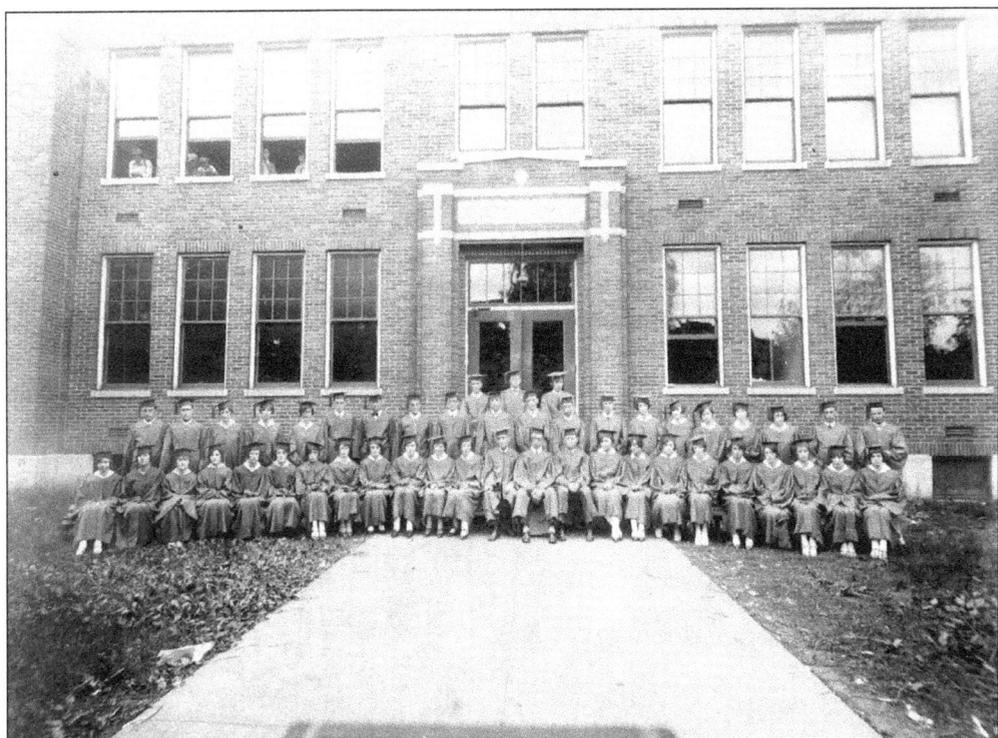

This photo shows an unidentified class at Elizabethtown school in the 1930s. (Courtesy of Mary Jo Jones.)

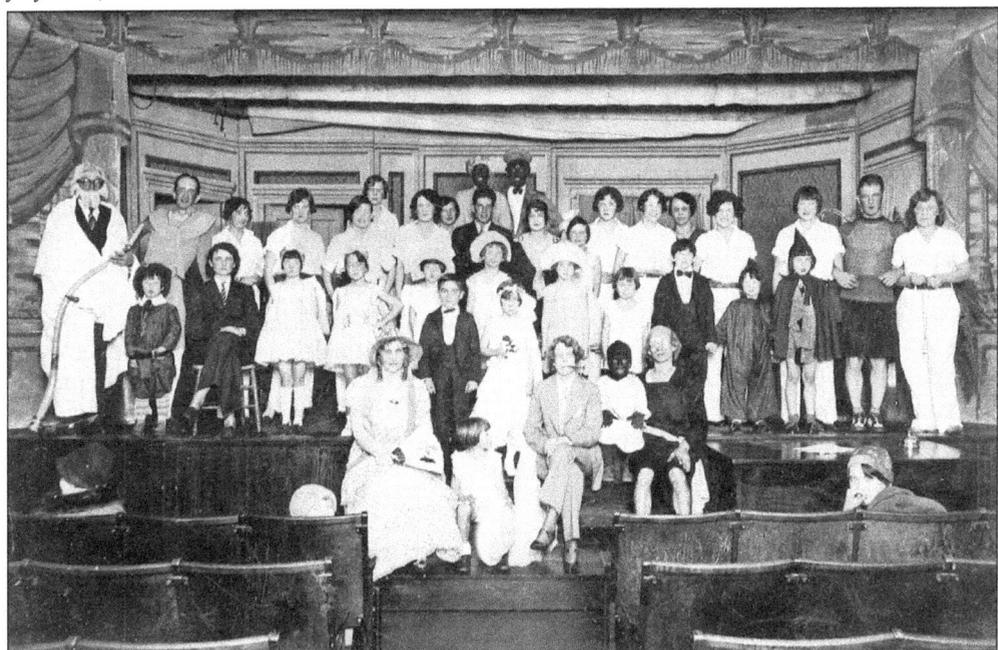

The play *Minstrel* was given for the benefit of the Mary Helm Society. The actors in blackface are Edmund and Margaret Richerson and their daughter, Mary Josephine Richerson. (Courtesy of Mary Jo Jones.)

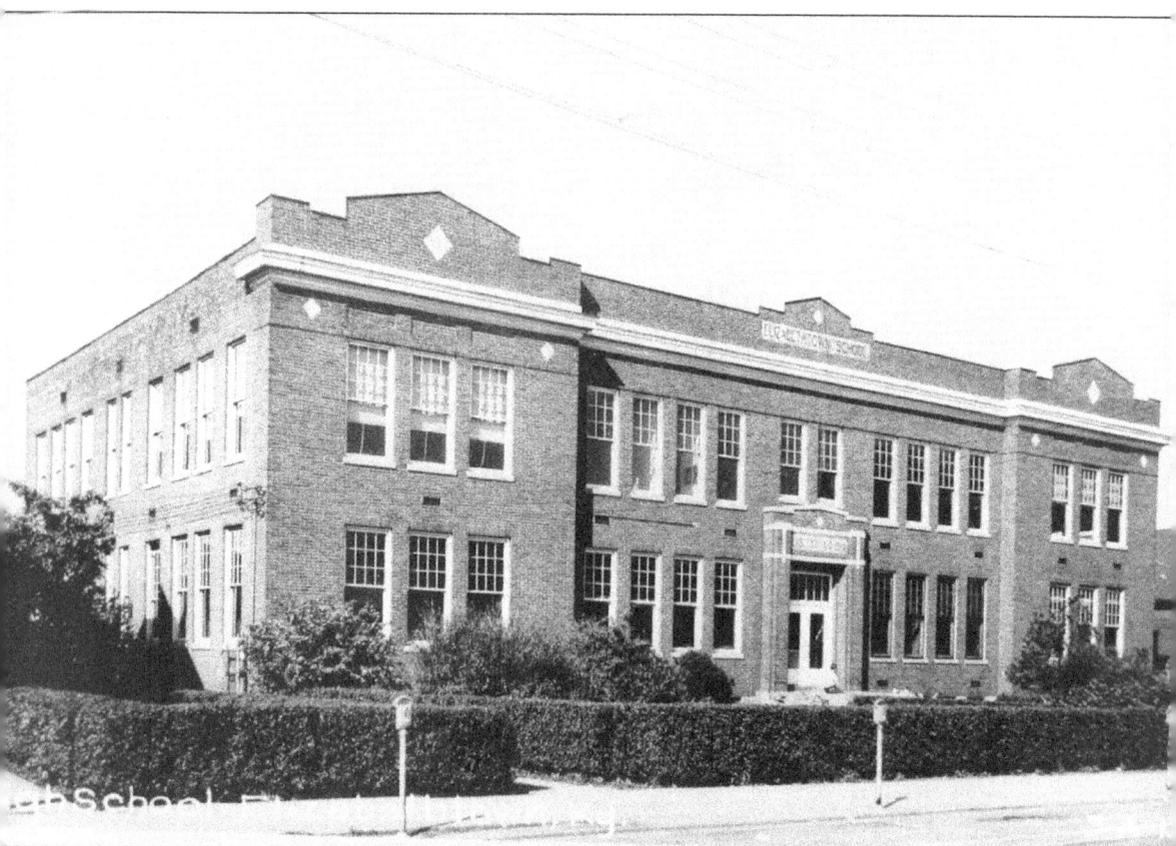

Elizabethtown High School was built in 1914 and was actively supported by women. The public was divided about the proposition of a new school building. This school opened in 1915 and was destroyed by a boiler explosion in 1955. Superintendents of Elizabethtown High School were R.Y. Maxie, J.C. Pirtle, C.E. Martin, and H.C. Taylor. The state's history of education begins in 1798. The State of Kentucky gave 6,000 acres of land to each county for establishing a seminary of learning. The first school in Elizabethtown was Hardin Academy in 1799. A log building, constructed in 1806, was the first building for Hardin Academy. In August of 1812, Duff Green was a teacher for the academy. He had achieved national prominence as a member of President Andrew Jackson's Kitchen Cabinet. The first brick schoolhouse, for a subscription school, was built in 1816. John Y. Hill claimed 4,000 acres of school land in Livingston County, Kentucky, in 1825. The first brick building for the Hardin Academy female seminary was built in 1844 by Hill on the corner of North Mulberry and Poplar Streets. The Masons rented a room in the academy until the building burnt in 1911. In 1877, the graded school was opened in the 1816 building. None of these buildings exist today. The Bond-Washington Colored School, built in 1923, still exists today as Hardin Florist Wholesale located on Springfield Road. (Courtesy of Mary Jo Jones.)

Seven

PEOPLE

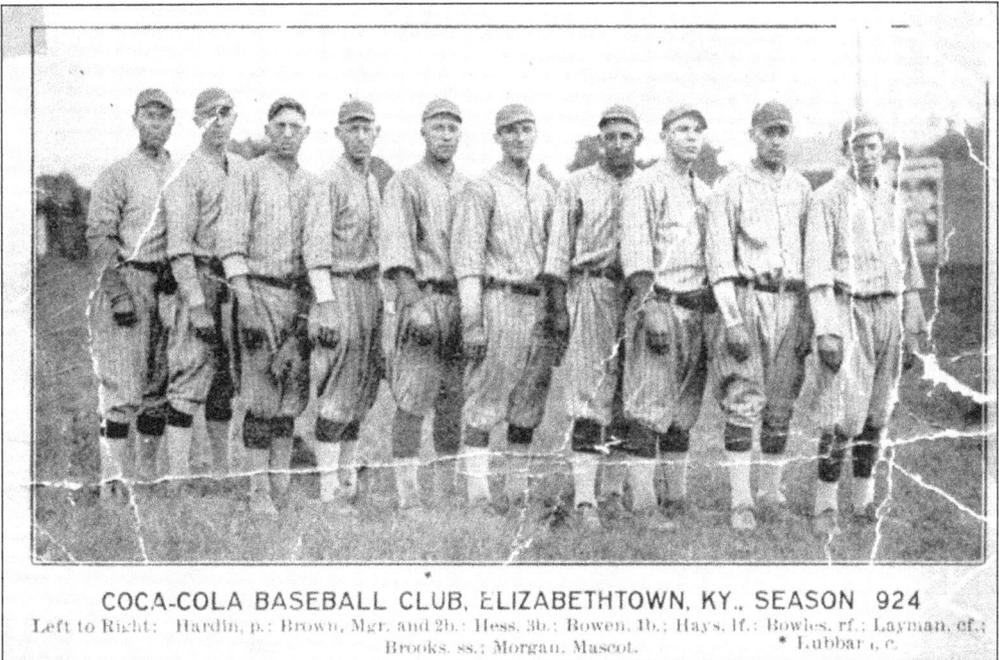

COCA-COLA BASEBALL CLUB, ELIZABETHTOWN, KY., SEASON 924
Left to Right: Hardin, p.; Brown, Mgr. and 2b.; Hess, 3b.; Bowen, 1b.; Hays, lf.; Bowles, rf.; Layman, cf.; Brooks, ss.; Morgan, Mascot. * Lubbar, c.

This 1924 postcard depicts an amateur baseball club in Elizabethtown. They were called the Coca-Cola Baseball Club because Luke Schmidt, owner and operator of the local Coca-Cola Bottling Works since 1920, donated the uniforms. This club was formed in 1921 and continued up to 1927 or later. (Courtesy of Mary Jo Jones.)

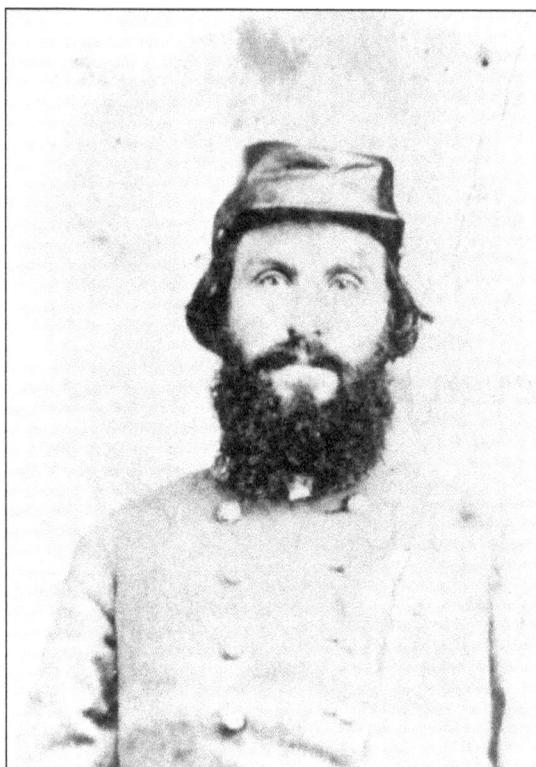

Col. Martin Hardin Cofer was part of the Orphan Brigade during the Civil War. He was a lawyer and later a judge. After the 14th Amendment to the U.S. Constitution was ratified, Colonel Cofer, a Hardin County circuit court judge in the 1870s, allowed the testimony of an African-American man in the case of a black person versus a white man in Meade County. His papers are located in the Pusey Room Museum of the Brown-Pusey House. (Courtesy of the Brown-Pusey House.)

Pusey Jenkins is dressed in a World War I uniform in 1917. (Courtesy of Mary Jo Jones.)

Philip Arnold moved to the West in the early 1860s. He and John Slack salted mines with precious gems in the 1870s and stored some of their "findings" in banks. Word leaked out that they had discovered diamond mines, and people began to invest in their venture. Civil suits were filed against Arnold and Slack but were settled out of court. Philip Arnold was shot by H.N. Holdsworth in 1878. He died in 1879 from pneumonia. (Courtesy of Mary Jo Jones.)

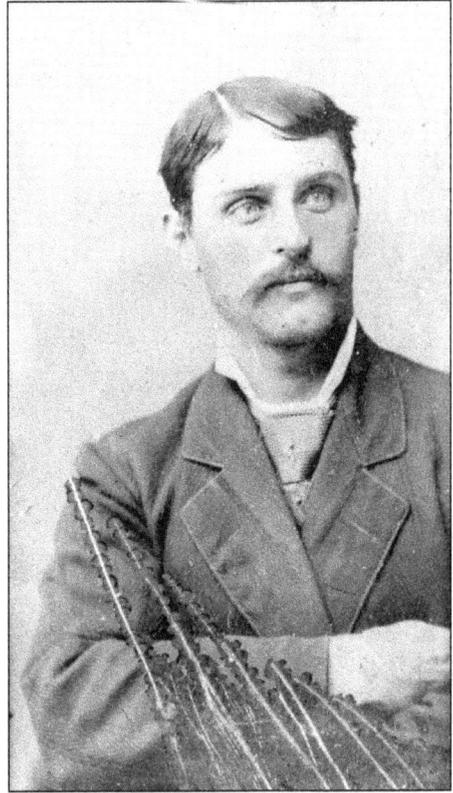

Attorney William Wilson built this house in 1869. Philip Arnold bought the house in 1872 along with 34 acres of land and some livestock; the full payment of $17,875 was paid in cash. J.S. McMurtry extensively restored the house in 1912. The house still stands today. (Courtesy of Mary Jo Jones.)

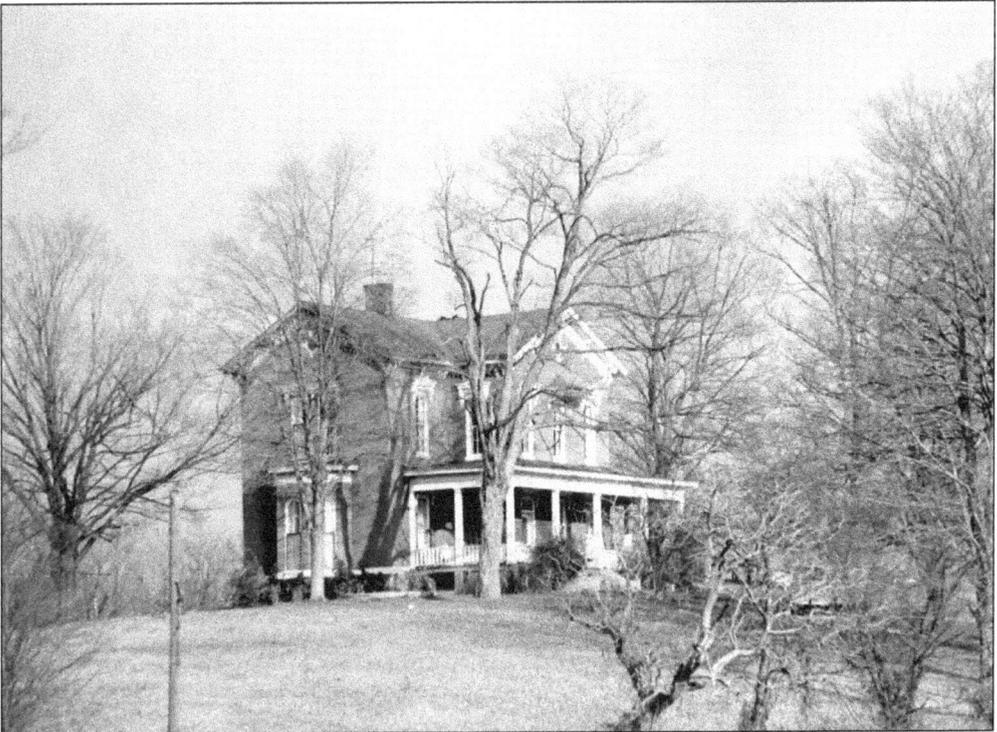

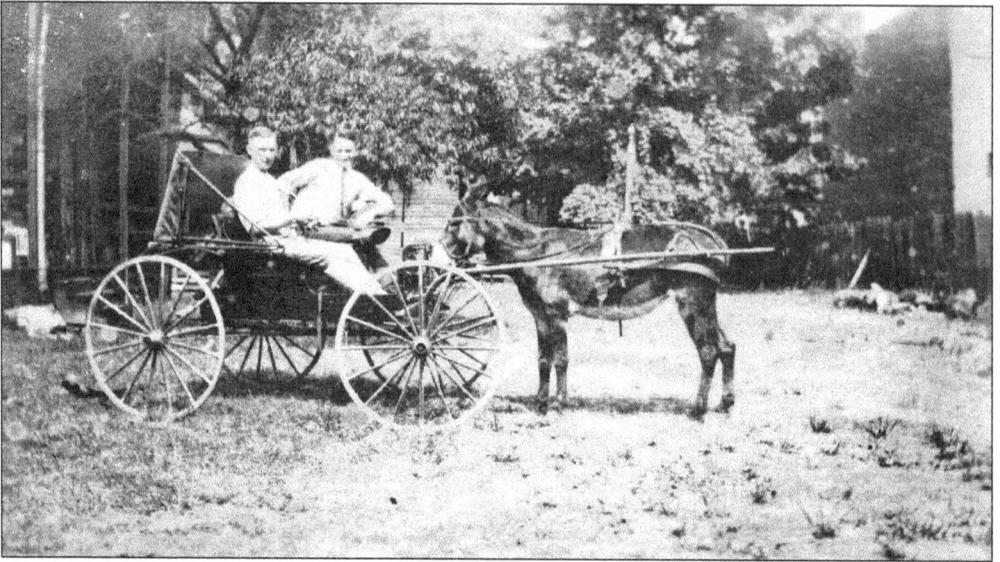

Weed Chelf turned his mule backwards for this photograph. In the early 1900s, Elizabethtown was leading in the mule market. Other countries bought mules from Elizabethtown to be used during World War I. (Courtesy of Mike Sisk.)

This little girl is toting her wagon with a doll in Elizabethtown. This woman and both children are from the Chelf family. They lived on East Dixie Avenue in the late 1800s and early 1900s. (Courtesy of Mike Sisk.)

This is possibly a member of the Berry family. The Berry family had been in local and county politics since 1886. The photographer is from Evans Art Company of Bardstown and Elizabethtown, Kentucky. (Courtesy of Mary Jo Jones.)

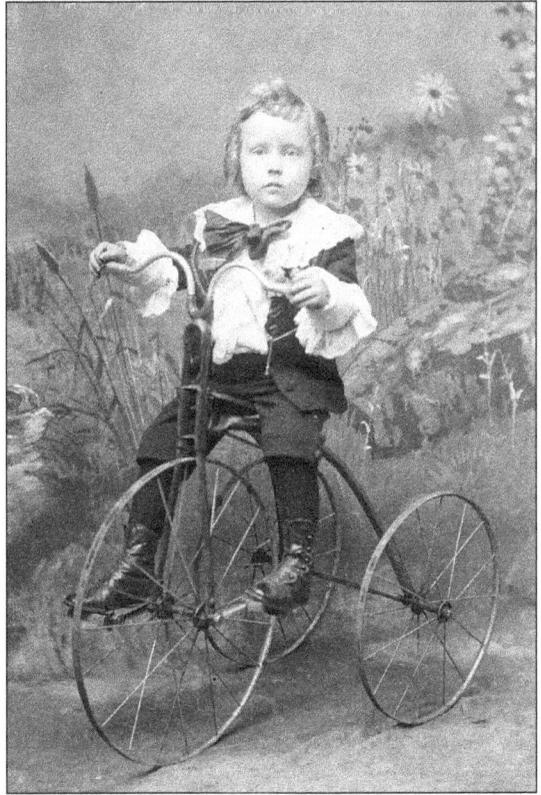

These ladies are in their bathing suits about 1920. Margaret Mantle is wearing a cap. (Courtesy of Mary Jo Jones.)

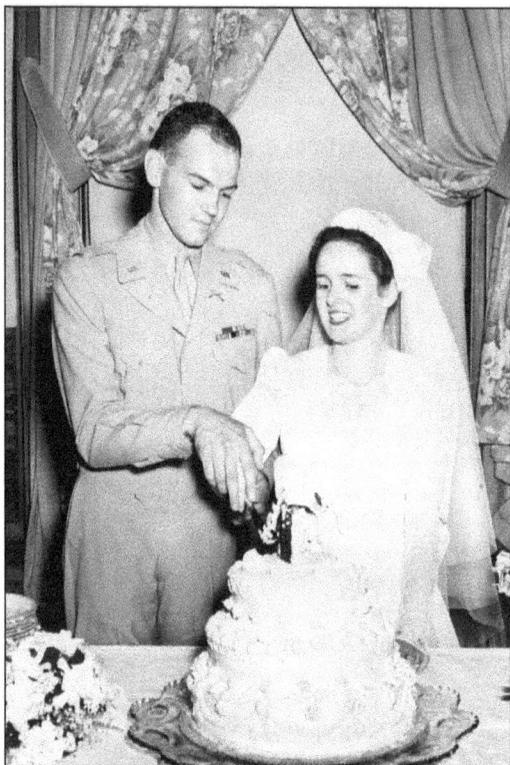

James Jones and Mary Jo Richerson Jones married at Fort Knox. James and Mary Jo compiled tombstone inscriptions of Hardin County in a series of books. Mary Jo Jones has been an active member and editor of the Hardin County Historical Society for many years. (Courtesy of Mary Jo Jones.)

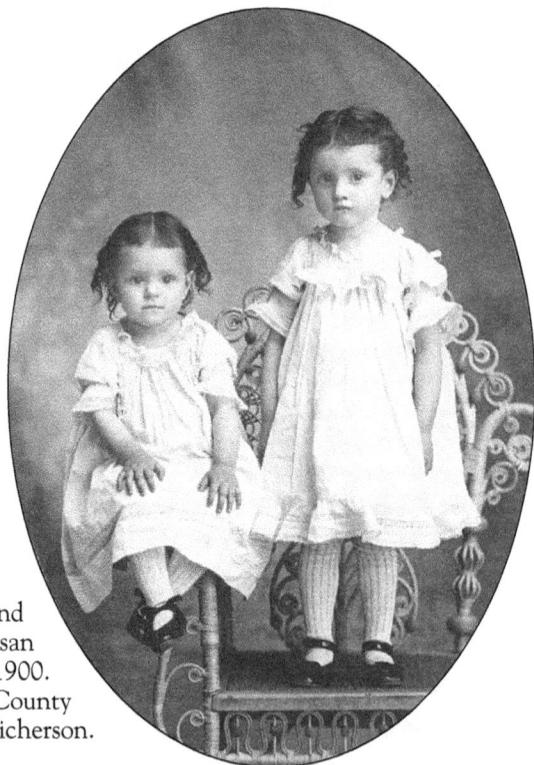

Elizabeth Holbert Settle (1902–1917) and Susan Margaret Settle are pictured here. Susan Margaret was born in Elizabethtown in 1900. She was an active member of the Hardin County Historical Society and married Edmund Richerson. (Courtesy of Mary Jo Jones.)

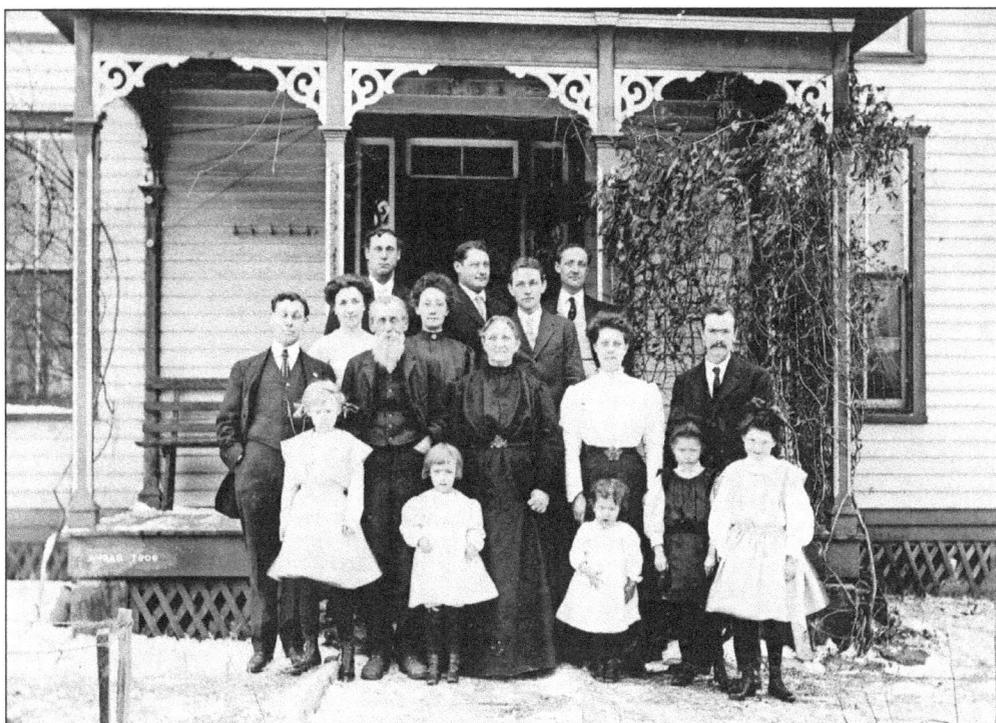

The Holbert family gathers in Vertrees for Christmas 1909. Most of the family lived in Elizabethtown. George King Holbert, born in 1876 and died in 1954, came from Vertrees to Elizabethtown to practice law with John Sprigg. In 1927, he won the nomination for circuit judge of the Ninth Judicial District and held the office for over 25 years. (Courtesy of Mary Jo Jones.)

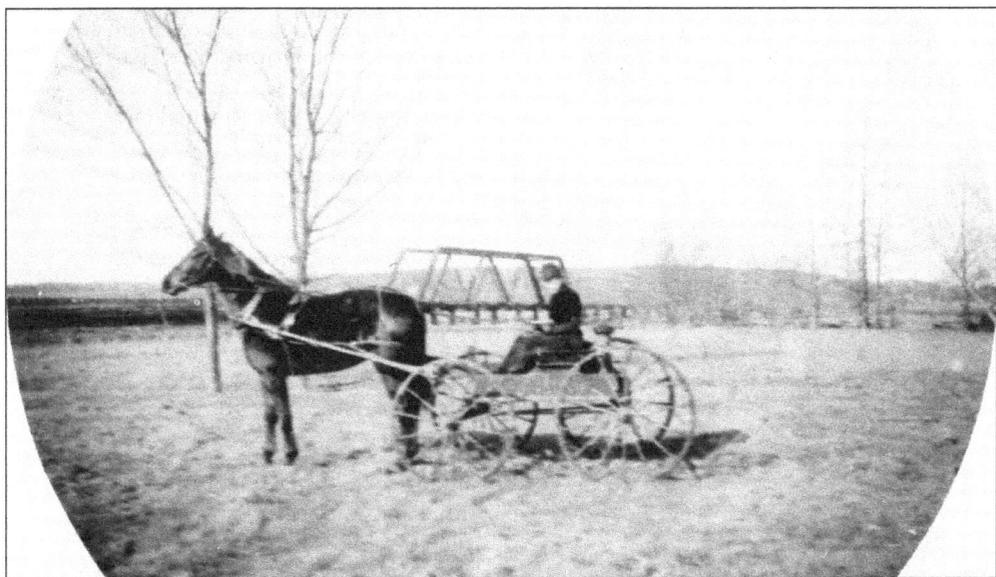

Sallie C. Pusey is in the horse and cart at the Pusey farm in Elizabethtown. One of the Hastings boys is in the back in this photograph, taken prior to 1930. The Hastings are the first cousins and step-brothers of William A. and Alfred Brown Pusey. Their combined effort restored the Hill House in 1922. (Courtesy of the Brown-Pusey House.)

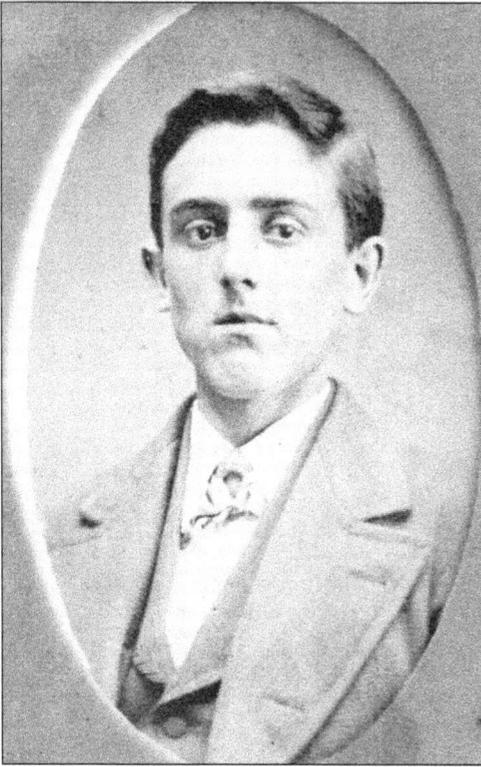

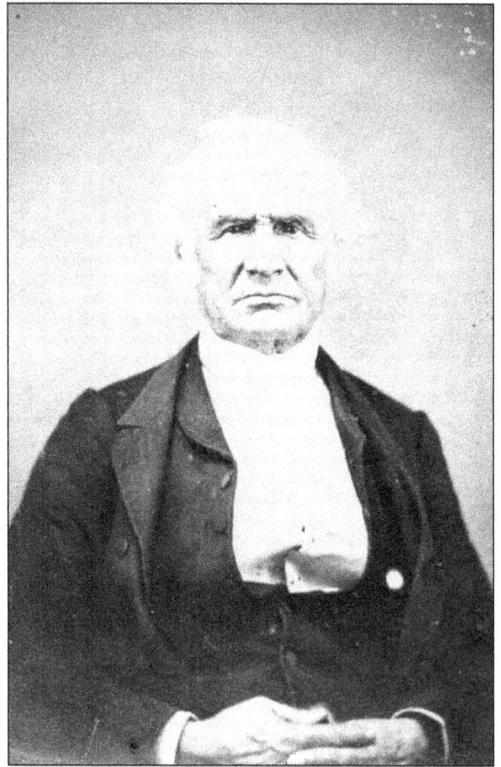

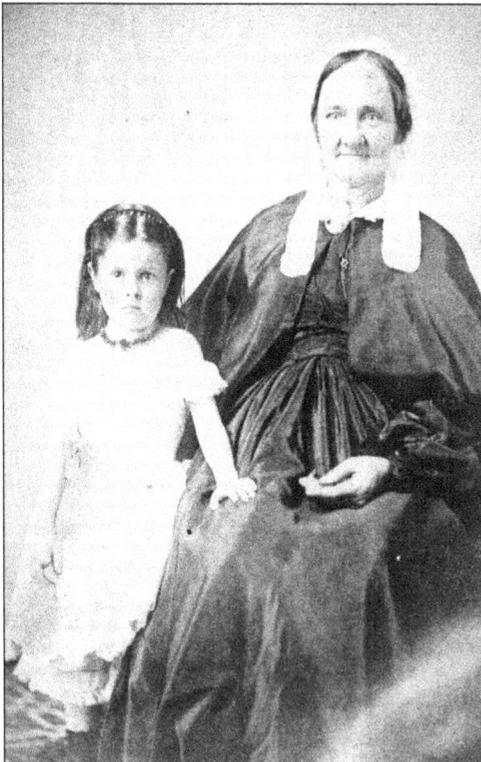

(*Above left*) Robert Reid was a deputy sheriff in 1901 and was killed by Harlan Buckles, a black man from the Glendale area. Buckles was lynched by an angry mob in 1902. (Courtesy of the Brown-Pusey House.)

(*Above right*) Dr. S.B. Merrifield was a local country doctor. (Courtesy of the Brown-Pusey House.)

Virginia E. Larue (left) was the child of Eliza Helm and Jacob Larue. Eliza Helm (right), sister of Kentucky governor John L. Helm, married Jacob Warren Larue. Eliza and Jacob lived in the Larue House, built in 1823 on the corner of North Mulberry and West Poplar Streets. (Courtesy of the Brown-Pusey House.)

114

Ann Brown lived in Elizabethtown. This photo was taken prior to 1922. (Courtesy of the Brown-Pusey House.)

Felix Stith sows grass seed with flowers in front of the Bush-Wathen House on the Pusey farm about February 1890. (Courtesy of the Brown-Pusey House.)

Mary Louise Ripley McGoodwin was born in 1887. Her mother, Malvina Hundley, married and divorced Garnett Ripley. Malvina then married Harry McGoodwin at the house of Bell Brown Pusey in 1890. Louise, pictured here, married Wallace Hunter McMillan from Canada in 1909 in Illinois. She divorced him and married Adolf G. Schleicher in 1927. (Courtesy of the Brown-Pusey House.)

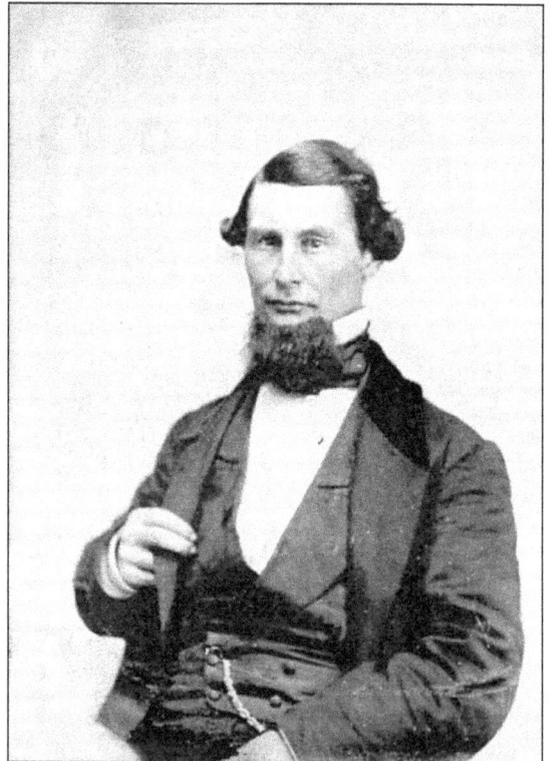

Alexander Adams died in 1860 along with three daughters during a scarlet fever epidemic. He was the first husband of Malvina Warfield, who was the mother of Sallie Cunningham Pusey. (Courtesy of the Brown-Pusey House.)

Edith Brown married Tom Hastings, and she died at an early age in 1874. She was the daughter of Alfred M. Brown and Mary Bell Stone Brown. Two of her siblings, Fannie and Willie Davis Brown, died young from the scarlet fever in 1859. Her sister, Bell Brown, who married Robert Burns Pusey, died in 1922. (Courtesy of the Brown-Pusey House.)

Pictured are Amelia, Bob, and Innis Brown, direct relatives of the family the created the Brown-Forman Company of Kentucky whiskies. The company was established in 1870 by John Thompson Street Brown Jr. and George Garvin Brown. Some memorabilia of the family is housed at the Brown-Pusey House. (Courtesy of the Brown-Pusey House.)

Sallie Cunningham, pictured in 1886, is dressed as a bridesmaid for Hundley C. McGoodwin's wedding. Hundley's wedding certificate can be found in a marriage book in the archives of the Brown-Pusey House. (Courtesy of the Brown-Pusey House.)

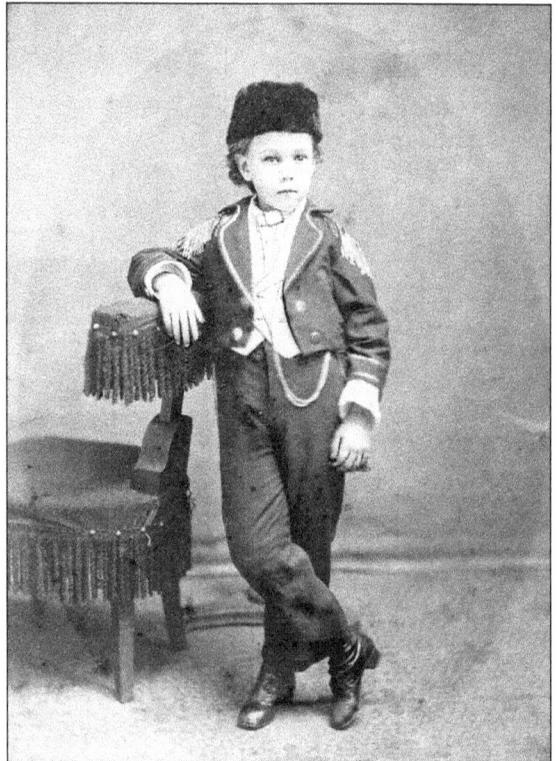

Sallie Cunningham is dressed as Tom Thumb about 1874 or 1876. The hat is made from sealskin. Tom Thumb weddings are mock weddings in which the bride, the groom, and their parties are all children. (Courtesy of the Brown-Pusey House.)

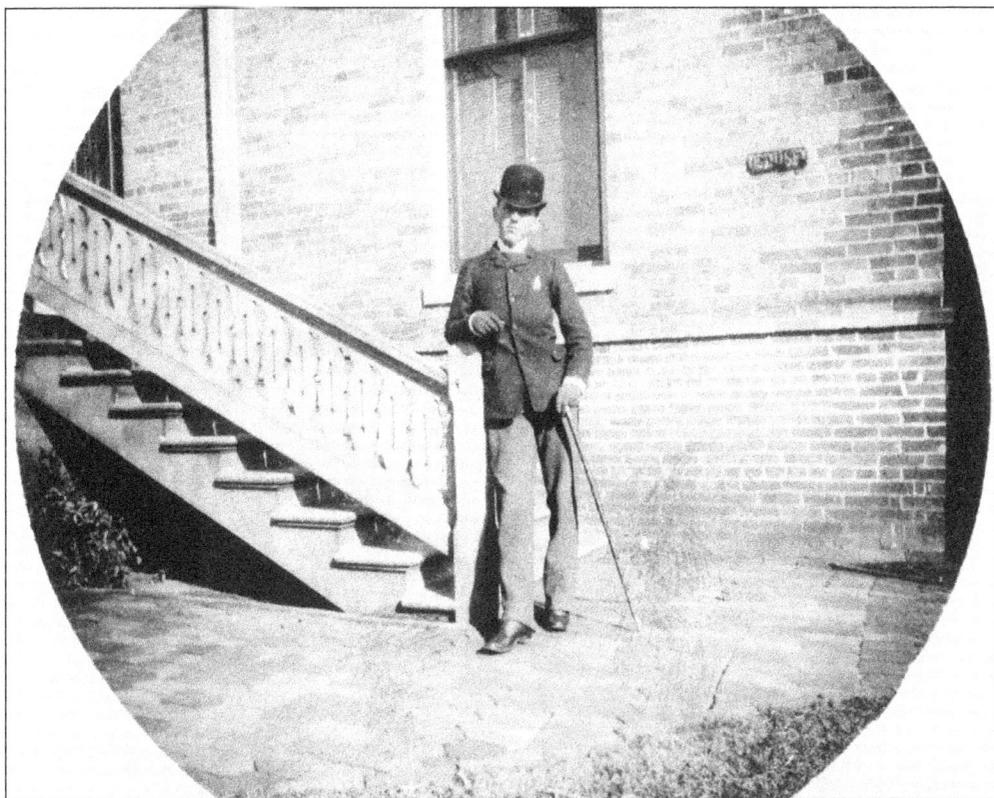

Dr. William Allen Pusey is standing in front of a building on North Mulberry Street. He became a famous dermatologist and published several textbooks, which are still used today. He and his wife, Sallie Cunningham Pusey, had no children. (Courtesy of the Brown-Pusey House.)

William Allen Pusey, the eldest child of Robert Burns Pusey and Bell Brown Pusey, was born in 1865. He attended Vanderbilt University and New York University, as well as European colleges and clinics, and he specialized in dermatology. He practiced medicine in Chicago before his death in 1940. (Courtesy of the Brown-Pusey House.)

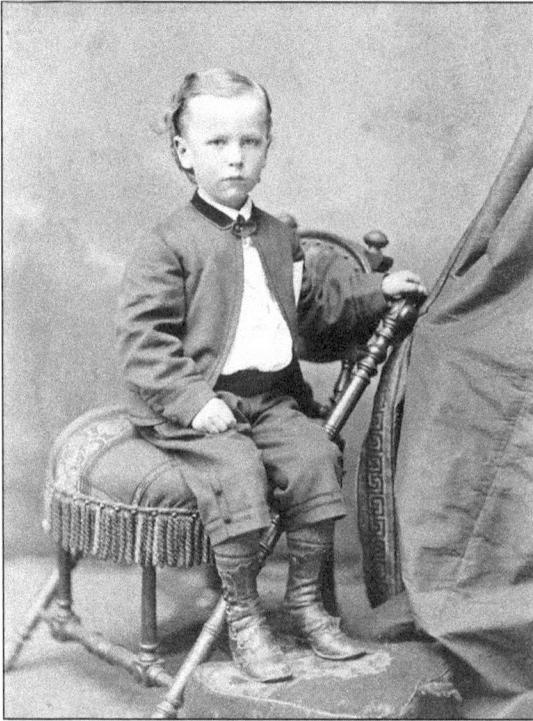

Alfred Brown Pusey was born in December 1869 in Elizabethtown. He served in the Naval Medical Corps in World War I and as an assistant surgeon in the United States from 1893 to 1896. He practiced in Chicago, Illinois, the same city where his brother, William Allen Pusey, practiced. (Courtesy of the Brown-Pusey House.)

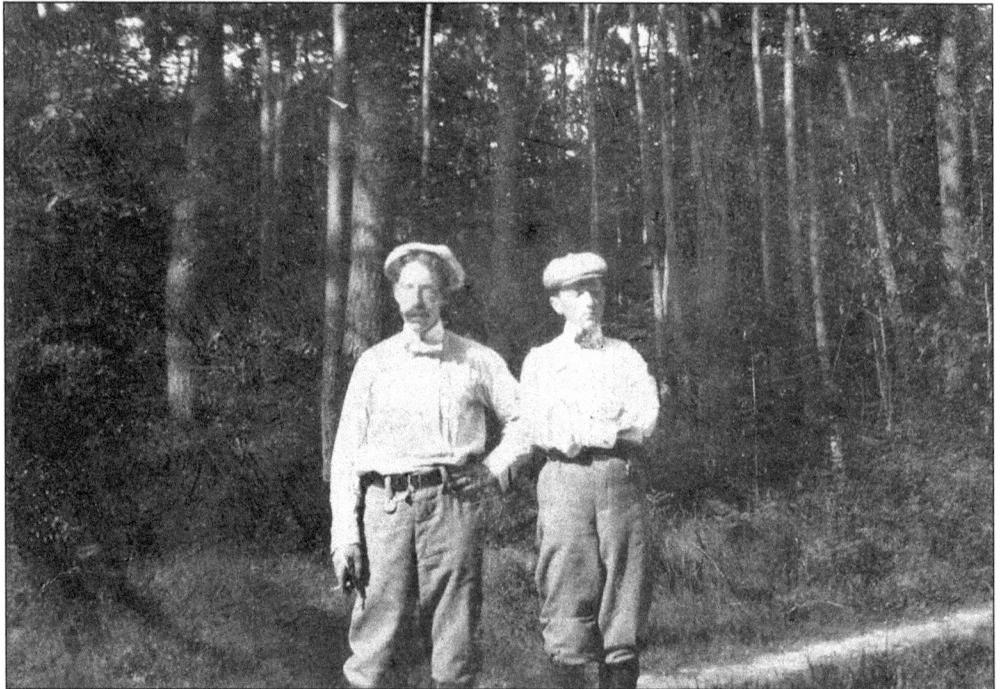

Alfred Brown Pusey, on the right, studied at Vanderbilt University and specialized in ophthalmology at the University of Pennsylvania. He practiced in Chicago from 1899 to 1940. He never married, and he died in 1953. The man on the left in this pre-1910 photograph is unidentified. (Courtesy of the Brown-Pusey House.)

Thomas H. Hastings rides on a bicycle in December 1896. (Courtesy of the Brown-Pusey House.)

This photo, taken in the late 1800s, shows a boy on a bicycle riding on one of the roads of Elizabethtown. On July 22, 2004, Cameron Crowe, the director of the upcoming movie *Elizabethtown*, shot some scenes of downtown. One scene was near the front of the Brown-Pusey House of a teenager on a bicycle. (Courtesy of the Brown-Pusey House.)

121

Helen Newlin Hastings, Dr. Hill Hastings, and their child lived in California for most of their lives. Dr. Hill Hastings was reared in Elizabethtown by Robert and Bell Pusey and Alfred and Mary Bell Brown. (Courtesy of the Brown-Pusey House.)

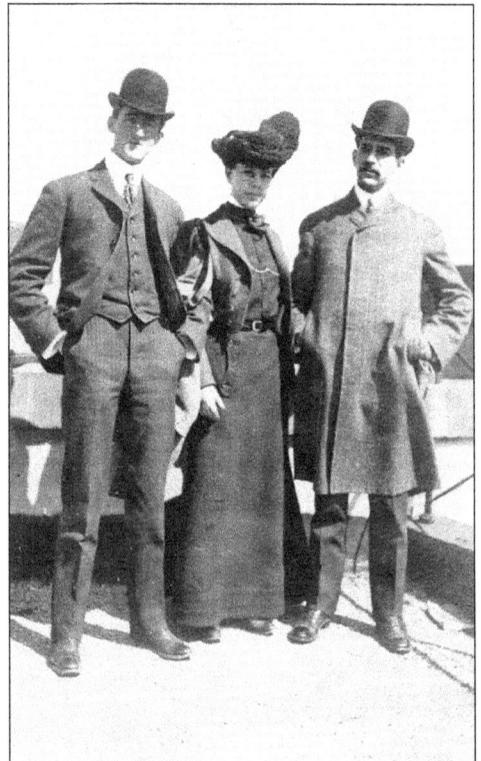

Tom Hastings, Sallie Pusey, and Alfred Hastings travel together in the early 1900s. Each was a major contributor to the restoration of the Brown-Pusey House. In 1922, Tom and Alfred Hastings donated funds to restore the 1825 Hill House and to add on a meeting room. Sallie Pusey, along with Chance Hill and Lincoln N. Hall, landscaped the garden of the Brown-Pusey House. (Courtesy of the Brown-Pusey House.)

Mrs. Mary Riddle was the daughter of Mary Adair. Mary Adair first married Mr. Stone, then Mr. Adair, and finally Mr. Morris. She was related to Benjamin Riddle, who operated a boarding house, called the Riddle House in the 1860s and 1870s, located on East Dixie Avenue. (Courtesy of the Brown-Pusey House.)

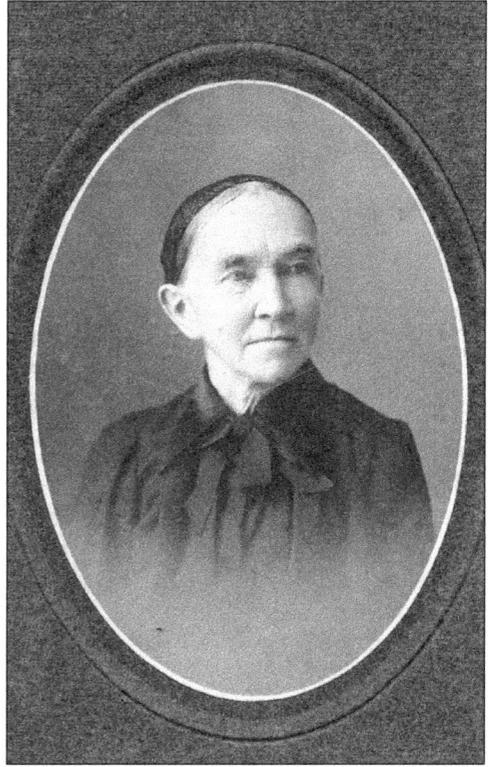

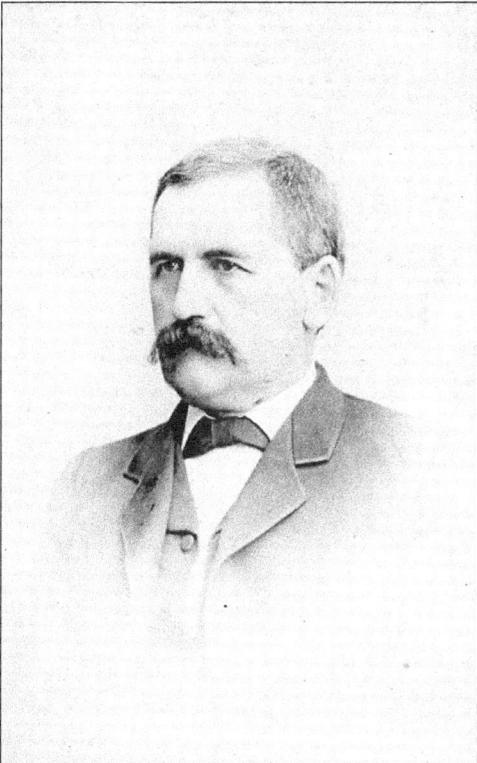

Franklin Fraize and his brother Christopher made saddles for the government during the early part of the Civil War. Franklin served in the Mexican War in 1846 and as a Confederate soldier in the Civil War. Frank Fraize was a guardian of Sallie and Hundley Cunningham. He was the husband of Cornelia Warfield and the brother-in-law of Malvina Warfield. (Courtesy of the Brown-Pusey House.)

This photograph, dated March 2, 1901, is of Robert Terry McMurtry. McMurtry attended Hardin Collegiate Institute prior to 1901. He was a teacher, studied law, ran a grocery business, and served as deputy sheriff in 1910. In January 1914, he was elected sheriff but was fatally shot on December 12, 1914, by Turner Graham Jr. (Courtesy of the Brown-Pusey House.)

Nellie Lee Bridwell married Robert Terry McMurtry on July 7, 1903, in Gallatin, Tennessee. They had two children, Melvin Bridwell McMurtry (died 1917) and Robert Gerald McMurtry. Robert Gerald McMurtry was a Lincoln expert in the first half of the 20th century; some of his books can be purchased from the Hardin County Historical Society. (Courtesy of the Brown-Pusey House.)

Mrs. ? McKay was the daughter of Dr. Merrifield, a local country doctor. (Courtesy of the Brown-Pusey House.)

This is probably Bell Brown (born in 1846) or Alfred Brown Pusey (born in 1869). (Courtesy of the Brown-Pusey House.)

Perhaps this man has soda drinks in his hand and is standing on East Dixie Avenue near the business of Showers and Sweets, across from the Stith House. This photo was taken about 1890. (Courtesy of the Brown-Pusey House.)

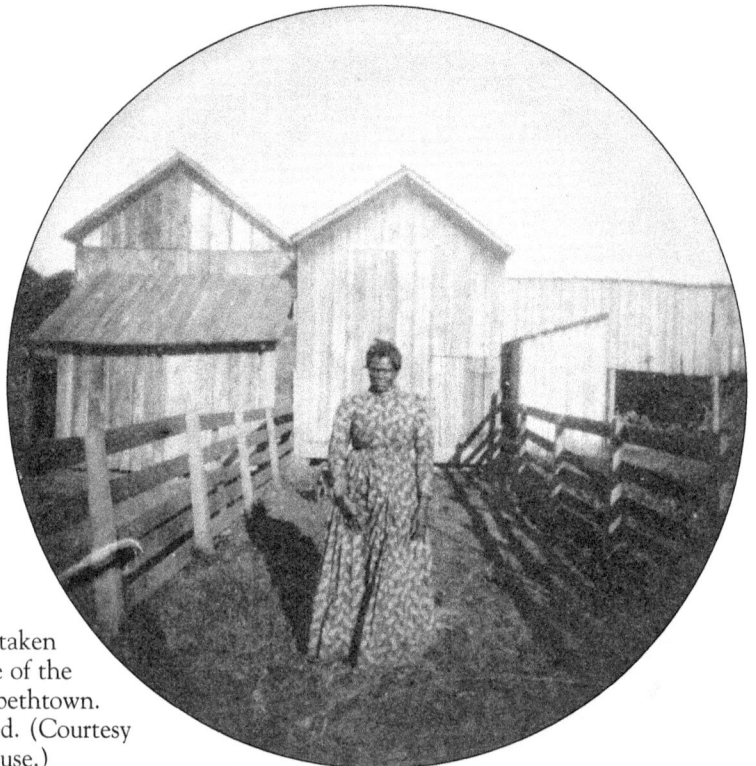

This photograph, taken before 1930, shows one of the Pusey farms in Elizabethtown. The lady is unidentified. (Courtesy of the Brown-Pusey House.)

On the far left in this 1901 photograph is Alfred Mackenzie Brown at Lincoln Sinking Spring Farm in Hodgenville, Kentucky, located at President Abraham Lincoln's National Birthplace. His father, William Brown, was one of the first pioneers in Kentucky. His powder horn, books, and letters from the 1780s are located at the Brown-Pusey House. William Brown, son of James and Mary Brown, received a land grant in 1784 about three miles north of Hodgenville, Kentucky. He kept a journal of his travel into Kentucky by way of the Wilderness Road with Daniel Boone. William married Hannah Street in 1792. Two of their eight children are more widely known: John Thompson Street Brown Sr. and Alfred Mackenzie Brown. The son of J.T.S. Brown, along with George Garvin Brown, formed the whiskey firm of Brown-Forman in 1870. (Courtesy of the Brown-Pusey House.)

Raymond Lee Miller served in the United States Marine Corps during the Korean War in 1953. He was the only surviving son of Margaret Alice Tharp Miller, who lived on Glendale Hill. Raymond received a commendation metal pendant with Combat "V" for saving the life of a wounded man in July 1953. (Courtesy of Meranda Caswell.)

The author's great-grandmother, Margaret Alice (Tharp) Miller (left), lived to the age of 93. William Alfred Miller (died 1945) and Margaret Alice Miller (died 1999) moved to Glendale Hill in the 1920s and lived in the house until they died. Margaret Miller was a charitable woman who reared her children and many of her grandchildren and cousins. No one went hungry. The man on the right is D. Russell Aubrey. (Courtesy of Meranda L. Caswell.)

Visit us at
arcadiapublishing.com

www.ingramcontent.com/pod-product-compliance
Lightning Source LLC
Chambersburg PA
CBHW080627110426
42813CB00006B/1617